main

Patrick Conrad, born 1945 in Antwerp, is a Flemish poet, painter, screenwriter, film director and novelist. He has published over thirty books, including ten thrillers and romans noirs. He wrote and directed twenty films for cinema and television, including – selected for the Cannes Festival – *Mascara* with Charlotte Rampling and Michael Sarrazin. He lives in Provence, in the south of France. *No Sale* won the prestigious Diamond Bullet Award for the best crime novel in Dutch in 2007.

NO SALE

Patrick Conrad

Translated from the Dutch
by Jonathan Lynn

BITTER LEMON PRESS
LONDON

BITTER LEMON PRESS

First published in the United Kingdom in 2012 by
Bitter Lemon Press, 37 Arundel Gardens, London W11 2LW

www.bitterlemonpress.com

First published in Dutch as *Starr* by
Houtekiet, Antwerp, 2007

The translation of this book was funded
by the Flemish Literature Fund
(Vlaams Fonds voor de Letteren - www.vfl.be)

© Patrick Conrad, 2007
English translation © Jonathan Lynn, 2012

A CIP record for this book is available from the British Library

ISBN 978–1–904738–97–8

Typeset by Tetragon
Printed and bound by CPI Group (UK) Ltd, Croydon, CR0 4YY

Flemish
Literature
Fund

No Sale

The cinema, like the detective story, makes it possible to experience without danger all the excitement, passion and desirousness which must be suppressed in a humanitarian ordering of society.

C.G. Jung

I owe my glory and my decline to my masterpiece, and my masterpiece is called Starr.

Victor Cox

The cinema: that temple of sex with its goddesses, its guards and its victims...

Jean Cocteau

Contents

Prologue

He sees himself crossing the Nassau Bridge next to her. Two faint shadows behind a sparkling curtain of rain. The racket of the falling water on the steel structure is deafening. They stand still. Is he embracing her? Strangling her? It's hard to make out. A grey car with headlamps like yellow flames drives on to the bridge. He watches as she tries to wriggle free from his grip, falls over in front of the car, flies through the air and flops on to the shining tarmac like a ragdoll, sees how the unseeing car continues on its way and vanishes into the darkness like a fish in muddy water. In horror he watches as he picks her up, drags her over to the railings, cradles her for a time in his arms like a crushed child, and strokes her shattered skull. Then throws her like a sodden bundle into the Bonaparte Dock and runs off.

Part I

Starr Mortensen

1

The Sponge

"People who live in elephants are never completely innocent."

Mrs Kountché, who is one of Professor Cox's neighbours, has a heavy Nigerian accent. She is wearing a garishly coloured rectangular swathe of cotton knotted around her broad hips, and as she leans over the railings of her balcony, she stares thoughtfully with eyes as big as a gazelle's at the back of the building where Professor Cox lives in a ground-floor flat.

"Very mysterious, that elephant," says Detective Inspector Lannoy, sitting down next to The Sponge in the Opel Vectra. The Sponge is what his mates call Chief Superintendent Fons Luyckx.

"It's an old African proverb. That's just the way people talk. With bits of exotic wisdom which have lost their meaning over the generations."

"Perhaps she meant Sani Abacha."

"Who?"

"General Sani Abacha, the president of Nigeria."

"You mean that big goon with the cool Ray-Bans."

"Yes."

"Why?"

"Because he died this morning. It was in the papers."

"Murdered?"

"Heart attack."

It was Monday, 8th June 1998. Luyckx and Lannoy had spent the whole afternoon questioning Victor Cox's neighbours about the disappearance of his wife Shelley, without much result. All they had heard was some gossip about Shelley, who did not go out much during the day and was sometimes dumped outside her front door in the middle of the night, blind drunk. They encountered vague clichés along the lines of: "We don't get involved in our neighbours' business", or: "What you don't know can't hurt you." The usual wariness of the cops. But the questions had to be asked, they were routine in a missing-persons investigation. Professor Cox had walked round to the station that morning to inform the police. His wife had not come back home on Saturday night. And since then there had been no sign of her.

The sun is beating down on the windscreen of the police car, which has been moving at a crawl round the ring road in a traffic jam for over a quarter of an hour. Dazzled, Luyckx gropes among the empty Coke cans for his shades in the recess behind the gear lever. The same shades as General Abacha.

"Mr Cox didn't look too shocked by the disappearance of his wife," says Lannoy, lighting a Marlboro.

"I had that impression too."

"He sounded almost relieved."

"Don't exaggerate. What does he do again?"

"He teaches at the Institute of Film and Theatre Studies. History of cinema…"

"History of cinema… What will they think up next?"

"Funny bloke, Cox…"

"What do you mean?"

"It's just hard to make him out. An absent-minded professor living for years alongside his wife but who doesn't

16

quite understand what's happening to him in the real world."

"Perhaps he saw it coming. From what you hear, Mrs Cox had a bit of a reputation."

"Maybe. She's probably just sleeping off the drink at a girlfriend's and'll show up again sooner or later with her tail between her legs. In fact I couldn't give a toss for this case. Total waste of time. How long have we been bloody stuck here crawling along with these idiots?"

"Long enough."

"Yeah, too long. Fasten your seat belts. Out of the way, everybody: here comes Dirty Harry!"

Luyckx opens his window, sticks the blue flashing light on to the car roof and swerves with a blaring siren on to the hard shoulder towards the first exit. As they drive past the National Bank, the first bars of Beethoven's Ninth sound from a mobile.

"Go on then, answer it."

"Lannoy here… The Sponge is driving… We're almost there, why… What? Where? OK, we'll be right there."

"Who was that?"

"Simons… An hour ago they fished a woman's body out of the Bonaparte Dock."

Luyckx smiles. At last things were moving. He switches on the radio and turns right. 'I Put a Spell on You' is playing. The version by Joe Cocker.

2

Shelley Cox

It is quarter to seven when Luyckx and Lannoy park their car in a cloud of dust right by the Nassau Bridge between the gendarmerie and fire-brigade vehicles. The air has a smell of burnt oil and tar, and screeching seagulls are circling in the pink sky. Two young gendarmes are holding back a group of curious onlookers behind a ribbon. From the Macumba bar on the corner of Londenstraat floats the voice of Peggy Lee, just like it has done ever since the pub opened in 1974. Luyckx knows the neighbourhood like the back of his hand. He shuts his eyes, listens hard, takes a deep breath, sniffs the atmosphere, shivers with excitement, rubs his hands and feels the presence of death. Nothing escapes him at moments like this. That's why they call him The Sponge.

He leans next to Lannoy over the bridge railings and waves to the divers who are hunting for more evidence among the oil slicks and floating garbage in the dark water. Inspector Simons, who is wearing a shirt patterned with blue smurfs, rushes up to him.

"Nice shirt," sneers Luyckx.

"Thanks boss! Got it on Offerandestraat. A real bargain."

"Have we identified the body?"

"Not yet."

Simons digs a dog-eared notebook out of his jeans pocket and reads aloud:

"Subject is a woman of around fifty with thin snow-white hair. Her blond wig was floating some distance away between two yachts. She was wearing a black lamé evening dress, rings on both hands, two strings of pearls round her neck, conspicuous make-up, and half her teeth were missing, a denture on the left side…"

"Perhaps she fell overboard during a party on one of these expensive yachts," says Lannoy.

"No. Her body is badly mangled. As if she fell under a car before falling into the water… Or was pushed. In fact we've found traces of blood on the bridge."

"Any ID?"

"Unfortunately not. But the divers are still looking for a handbag."

"How long was she in the water?"

"The preliminary estimate is one and a half, maximum two days. You couldn't see her because she was jammed under the jetty between the *Mary-Lou II* and the *Leviathan*."

"Nice. So let's go and meet our bald lady friend. Where is she now?"

"She's on the way to the lab. For an instant autopsy."

"And who decided to do that so fast?" Luyckx finds it hard to conceal his irritation.

"I couldn't reach you on the radio so I thought…"

"How many times have I said I don't want any thinking until I ask for it, Simons?"

"Fons, the radio wasn't on this afternoon," says Lannoy.

The Sponge pretends not to hear his partner's comment.

"Any witnesses?"

"No direct witnesses. Basically people who bumped into her on Saturday night in the bars around the docks. Including the boss of the Macumba, for sure…"

"Jos the Screw, an old friend. Simons, get in touch with the harbour police. I want a list of names of all the owners of sailing ships and yachts in this dock. By tomorrow. Lannoy, you're going on a pub crawl. I'm pretty sure our lady

friend wasn't unknown in Docklands. By the way, have you got Mr Cinema-History's number on you?"

"Here you go."

Luyckx pulls Simons's mobile out of his smurf-shirt breast pocket and punches in the number.

"Luyckx here from the detective CID. Mr Cox, sorry to go straight to the point, but did your wife have false teeth?"

"Yes."

"And did she wear a wig?"

"Yes, for a year now. Have you found Shelley?"

"Looks like it. I'll come and pick you up."

Luyckx hands Simons back his phone.

"OK, lads! There's no business like show business!"

3

Jos the Screw

It took Lannoy over five minutes to force his way through the crowd of noisy customers in the Macumba. On a normal day the pub was always filled with regulars at Happy Hour. But now that the body of a dolled-up posh cow had been fished out of the Bonaparte Dock it was twice as crowded as usual.

Jos the Screw is a dark giant of a man who was still playing for the Zaziko basketball team five years ago and was admired by everyone because, as rumour had it, his back was tattooed with the names of a dozen women he had screwed. He is standing behind the bar, lording it over the Macumba with a loud voice and the authority of a tribal chieftain. When he notices Lannoy, who he's never seen before in his bar, he knows for sure that he's a cop, thanks to that sixth sense that marks people with one foot in the underworld.

"Welcome to the jungle, Inspector. Will it be a gin, then?"

Annoyed by how quickly The Screw is on to him, Lannoy refuses the shot.

"Could we have a word outside where it's not so noisy?"

"I'd rather do it in the back kitchen," replies the bar-owner, who is all too often questioned by the police and knows he can't escape this conversation. "I can keep an eye on the girls behind the bar from there."

What The Screw calls the back kitchen is little more than a dilapidated storeroom piled high with beer crates, empty barrels, bottles of drink and cardboard boxes full of cans, cigarettes and peanuts.

"You've heard of course about…"

"Like everybody. That kind of news gets round quickly."

"Did she visit the Macumba on Saturday night?"

"Like all the cafés in the area, I guess."

"Did you know the victim?"

"She was a regular."

"What's her name?"

"Dixie."

Lannoy, not expecting the reply, hesitates.

"Dixie what?"

"Her real name was Shelley, Shelley Cox, something like that. But at night everyone called her Dixie. Drunken Dixie."

"Why?"

"That's what she called herself. Usually when she'd been hitting the bottle. Then she'd suddenly become a different person and start raving, coming out with all sorts of drivel. Like she was turning the words round and coming out with the meanings back to front. Everything was different – her voice, her behaviour, her expression. Sometimes it would happen really fast. One slug too many and bang, there was Dixie instead of Shelley!"

"And was she drunk on Saturday night?"

"Legless. I showed her the door because she was bothering the customers."

"What time was that?"

"About midnight."

"Was she alone?"

"She was alone more often than not. She came here to drink, not to party or pick up men. Anyway, she was in no fit state for that."

"Which way did she go when she left?"

"No idea. There was a thunderstorm that night. The gutter."

"So you kicked her out all alone in the pouring rain at midnight?"

"She was already soaked when she came in."

One of the waitresses, a Barbie doll whose age was anyone's guess, with unyielding silicon breasts in a tight Macumba T-shirt, came swaying into the room holding a mobile phone.

"Jos! Phone for you!"

"All right, that'll do for now," says Lannoy. "I'll be back when I need more information."

"Hello?… Hi pussycat… Right now? I'm in a meeting… Good… The *Pegasus*, pier three… Yeah, I can see it from here… In ten minutes, OK?"

Jos takes a can of deodorant off one of the shelves and sprays it liberally over his armpits and crotch. In a flash the storeroom smells of a mixture of cedar wood and washing-up liquid.

"Women who are getting on," he sighs, "sometimes it's like it's their last time," and steers his huge carcass like an icebreaker through the overflowing bar to the street. In the doorway he runs into old Cross-Eyed Carmen, who runs the Acapulco, the bar three doors down. She sniffs after him like Fay Wray after King Kong.

"Nice smell, Jos, are we going to have a quick screw?"

"Carmen, I'm always up for anything!"

4

Sax

Because he already looked old when he started working as a young coroner for the Antwerp Criminal Investigation Department twenty years ago, it seemed that time had no hold on Sax. His glasses were a little stronger, he was a little thinner and the crown of hair around his bald skull had dropped out. As for the rest, he did not eat or sleep much, shaved once a week at most and shuffled along with a stooped back, the back of a frustrated saxophonist as he said himself sarcastically. Because his passion for jazz had never abated, whenever he had the time he would still perform regularly in nightclubs and jazz cafés. Usually for free, as a respected amateur. His 'Mobutu Mambo', a piece he composed in 1997 after the rebels under Laurent Kabila took power in Zaire, had actually won a silver medal at the Merelbeke festival, but he comforted himself with the thought that even the best Flemish jazz musicians never became really popular outside Antwerp.

Luyckx steps through the dim light of the tile-lined corridor that leads to the lab. Jazz is echoing through the open door at the end of the corridor, so the forensic doctor must be at work.

"Ah, The Sponge, at last," says Sax, drawing a blood-soaked sheet over Shelley Cox's dissected body, pulling off his rubber gloves and throwing them into a little stainless steel bin.

"I thought it was you playing," said Luyckx flatteringly.

"If only. Then I would be Archie Shepp."

"So, what can you tell me?"

Sax, who in his career has come across every kind of injury and mutilation, turns down the volume and sighs.

"A total wreck, Sponge, fifty-three, fifty-four at most, but a wreck. Have you identified her?"

"Shelley Cox. Wife of a Victor Cox who teaches film history at the drama institute. Odd bloke."

"Odd family, I fear. She had 2.8 grams of alcohol in her blood. And that wasn't from just one night out, believe me. I've seen a good deal of cirrhosis of the liver in my time but this was really impressive. What's inside her isn't a liver any more, it's like the Rock of Gibraltar. Plus a badly inflamed pancreas producing insufficient insulin, with diabetes as the result. I haven't had the time to check it out properly, but it seems obvious to me that the central nervous system has also been damaged. In the stomach I couldn't find anything except a few peanuts and a double peptic ulcer. She hadn't eaten all day long. Arms and legs thin as a stick, but a swollen belly, bad teeth – to sum it up, totally kaput with booze. A lamb to the slaughter."

"So she was pissed out of her brain and fell into the dock and drowned?"

"No way. There was no water in her lungs, but she had three broken ribs, a ruptured spleen and a nasty wound to the head. Somebody probably ran her over while she was lying unconscious in the road, then panicked and chucked her body into the water. She must have died on the spot."

"Any idea of the time of death?"

"About midnight on Saturday night."

"And they have in fact found bloodstains on the Nassau Bridge. Nice work, chief. I won't keep you any longer."

Sax shuffles over to his workbench, takes a hermetically sealed test tube off a rack and holds it under the bright light of a desk lamp.

"Look what I found in her left Eustachian tube – in her ear, to put it simply."

Luyckx bends over.

"What's that?"

The test tube is teeming with tiny transparent creatures.

"A nest of baby spiders. A spider must have laid her eggs there, I can't see any other explanation. I found the remains of a silk cocoon in the auricular cavity, protected by a plug of earwax. Never seen anything like that before," says Sax. "A normal person would have gone stark raving mad."

"Perhaps she did too," sighs Luyckx. When he questions Cox later he will casually mention the problem of the spiders in his wife's ear. For now he just doesn't want to lose face and pretends that Sax's revolting discovery hasn't surprised him at all.

"Well I never liked spiders anyway. Oh yes, before I forget, can you give me one of her rings?"

Sax hands Luyckx a brown envelope.

"That's all her jewellery. It's not worth much."

"Thanks. Got any gigs coming up?"

"At eleven in the Blue Note in Mortsel. With Steve Lancing on piano and Sonny Spencer on drums."

"If I get a chance I'll drop in. There's no business like show business!"

5

Ma Mussel

"I felt sorry for her, officer. The way that woman wasted away over the years! Emaciated, that would be the word. She was on her last legs, Officer, still flirtatious, yes, but she was shagged out. And she knew it, because Dixie was no fool," sighs the sleek rotund woman, sliding a large glass of amber-coloured beer under Lannoy's nose.

Ma Mussel, as she was called, is the cheery landlady of the café of the same name on Godefridus Quay, which is well known for its draught triple brews and its jumbo mussels *à la provençale*. It's the seventh and last pub Lannoy has visited in the course of his investigation.

"Eleven years ago, Officer, when my Maurice was still alive, on the sixth of March 1987, the day that we opened up here and they were showing the ferry sinking off Zeebrugge, she was sitting there at the table eating mussels. Even then she could knock back two or three bottles of white without batting an eyelid. Later she would come just for the wine which you won't find any better anywhere else, you know, and not for my mussels. But recently she had gone crazy and would just drink anything. Anything except water. I think she drank water for the first time in her life last Saturday when she ended up in the docks. Poor Dixie."

"Was she always out on her own?" asks Lannoy, keeping one eye on the television behind her where the three

surviving Beatles are attending a memorial service for Linda McCartney.

"Yes. Or sometimes with some bloke she had run into somewhere who was as pickled as she was. She knew every boozer in the neighbourhood. They're a kind of family."

"She didn't have any regular boyfriend or anything?"

"I heard she was married. Or had been. But I never saw her husband. She said she'd had enough of the butterfly on her back."

"What?"

"She would talk about weird things that nobody understood."

"Did she come in on Saturday?"

"Yes, about seven or so. She was totally dolled up. 'Well Dixie,' I asked her, 'are you going to a ball tonight?' 'It's Saturday,' she said, and sounded really sad. She drank two vodka tonics and watched a bit of a film on her own about crocodiles in the Nile, yes, the TV's always on here. And then she said one of those strange things again. 'There's a big black shadow that lives inside me, Ma,' she said. And then she was gone. Into the rain, in her lovely dress. I never saw her again."

With the Macumba, Lannoy had visited more or less every well-known bar in the Bonaparte Dock: the Acapulco, Café Admiraal, the Nieuwe Zanzi Bar, Chez Rik, Sandra's Corner and finally Ma Mussel's. Everyone he had questioned about Shelley Cox agreed that what had happened to Dixie was bound to occur sooner or later. How many times had they fished her out of the gutter and called Ahmed of Islam Taxis, who knew where she lived, to take her home. The true regulars had known her so long that they couldn't remember any more when exactly she had first appeared in the area. She was such a part of their community that her absence registered more than her presence. "She was like a dark angel who drops silently to earth," said Sandra

of Sandra's Corner, who dabbled in poetry in her spare time. "She would appear, do her rounds, bum around for a few nights, and then she would disappear again for a couple of days. And apart from Ahmed, who's as silent as the grave whatever the language, nobody knew where she lived. Not a happy angel, no. After midnight, when she started babbling in her own little private language, the tears would sometimes stream down her cheeks. But everybody loved Dixie. And when she'd run out of money she would always find some victim to buy her another drink. Because she couldn't do without it any more, the poor old sod."

"Sometimes in the early hours she would stumble in," said Cross-Eyed Carmen from the Acapulco, "and start to drink up the dregs in the glasses on the counter. And then if I gave her a cup of coffee, she'd go crazy. With me, her best friend!"

"So how much is it?"

"Nothing, Inspector." Ma Mussel waves away the hundred-franc note Lannoy is holding out. Just come by one evening with your wife and have a plate of mussels. That would be a real pleasure. Say hello to The Sponge."

Lannoy realizes that apart from café gossip he has learnt nothing new today. Obviously there hadn't been any real eyewitnesses. No one had seen what had happened on Saturday at midnight on the Nassau Bridge. It had been raining so hard that there wasn't a soul out in the streets. Or perhaps nobody wanted to talk about it.

6

Victor Cox

Who is this withdrawn, exhausted man sitting with atrophied decency opposite Luyckx and staring at him fuzzily through his glasses? What is he hiding, sitting there so quietly? How many revolting stories have been piling up for years behind that impenetrable mask? Why does he not ask any questions, why does he sit there petrified, sunk in thought, as if he has guessed or knows what Luyckx is going to tell him?

In this kind of awkward situation, The Sponge feels more at ease than anyone else, and he takes his time. He studies every reaction, interprets the slightest movement, the smallest expression of the enemy. Because, given the circumstances, and until someone has proved the contrary, Luyckx considers him a suspect, and at this moment Cox is the living incarnation of the enemy.

"First of all I'd like to apologize for keeping you waiting so long. Do you smoke?"

"I'm trying to give up. Nowadays smoking is rather common."

First lie, thinks Luyckx. Given the tension, even someone who wants to give up smoking would accept a cigarette. With provocative slowness, he lights up a cigarette for himself, and leans back in his office chair with his hands clasped behind his head.

"Once there was something stylish about smoking," Cox continues quietly. "It was part of every seduction ritual. There was something sensual, almost sexual, about it. It was simply impossible to resist the fatal charm of a Dietrich, a Garbo or a Swanson when these divas drew on their cigarettes and the white smoke rose in elegant coils in the blaze of the spotlights. Try to visualize Humphrey Bogart or James Cagney without a cigarette, or Edward G. Robinson without a cigar. I cannot imagine it. Those fellows knew what smoking meant for style. But nowadays…"

The professor's voice sounds monotonous, thin, absent-minded. The voice of a priest who no longer believes what he preaches. This distinguished gentleman is more dangerous than he seems, thinks Luyckx, and comes straight to the point: "Mr Cox, I fear I have bad news for you."

Luyckx shakes the contents of Sax's envelope on to his desk: three rings, a pair of long, glass earrings, a double row of pearls.

"Do you recognize this jewellery?"

"Yes. This is the ring that Barrie Chase wore in *Cape Fear*. This one, with the little diamond, was worn by Ida Lupino in *High Sierra*. This is Veronica Lake's wedding ring from *This Gun for Hire* and the earrings belonged to Karen Morely in Howard Hawks's *Scarface*, in which Osgood Perkins, the father of Anthony Perkins, also had a role – not many people know that. The pearls are the necklace Tony Curtis wore in *Some Like It Hot*. Fake jewels, every one of them. Mere props. But nevertheless of value to collectors. I still recall every occasion when I bought them. Long, long ago."

"So Mrs Cox didn't wear her own wedding ring?"

The fact that Luyckx is talking about Shelley Cox in the past tense does not seem to have struck her husband.

"I made her a gift of Veronica Lake's ring as her wedding ring."

It is usually impossible to disconcert The Sponge, but he is now staring speechlessly at Victor Cox. A normal man would burst into tears if in this situation he was confronted with his wife's jewellery. What was simply a roundabout way of disclosing the brutal truth to him is not having the slightest effect on the imperturbable professor of cinema history.

Luyckx appreciates that it is going to be a long night and Cox is anything but easy prey.

"Mr Cox, if I just now kept you waiting, it was because I was down at the forensic institute, where they'd not yet finished with the material remains of your wife."

Cox does not budge an inch, stares ahead deathly pale and clears his throat. He takes off his glasses, wipes his eyes and then looks enquiringly at Luyckx, as if waiting for him to continue.

"Your wife is dead, Mr Cox. This afternoon we fished her out of the Bonaparte Dock."

"Shelley has been dead for years."

Outside the sky is turning purple and red. The lurid light of the setting sun is mirrored in the façade of the Boerentoren skyscraper. The carillon begins to chime. The noise of the traffic subsides. The city is drifting off to sleep. Luyckx shuts the window, draws the colourless cotton curtains and switches on his desk lamp.

"What do you mean: 'Shelley has been dead for years'?"

"Figuratively, I mean. Did she commit suicide?"

"Why do you think she committed suicide?"

"It's a long story."

"It's not suicide," interrupts Lannoy, who has been standing for a while in the doorway listening.

"Let me introduce you. Luc Lannoy, my partner."

"My condolences on the loss of your wife, sir."

"Had she been drinking?" asks Cox.

"You could say that."

"2.8 grams of blood alcohol!"

"Oh dear!" says Cox absent-mindedly, as if they are talking about someone he scarcely knows, "then she probably stumbled into the water."

"She was run over."

"Right," says Luyckx. "Sax has confirmed it. She was probably killed on the spot."

"After the accident someone dragged her to the docks and chucked her into the water," says Lannoy.

"Are you sure it's her? It was Shelley's birthday on Saturday. That's probably why she was wearing her prettiest dress – she'd turned forty."

"Shit. Forty!"

"How do you know she was wearing an evening dress?"

"I saw her leave."

"Do you own a car?"

"Of course I have a car."

"What make?"

"Ford Sierra."

"Colour?"

"Grey. But what's this got to do with my car?"

"Where's your car now?"

"At the Ford garage on Sint-Bernardsesteenweg. Minor repair. On Saturday afternoon someone damaged my right fender and headlight in the supermarket car park, and of course left without saying anything. You know what people are like nowadays."

Luyckx and Lannoy exchange glances.

"Does the name Dixie mean anything to you?"

"No... Why?"

"In Docklands everyone knew your wife by the name of Dixie."

"I've never heard that name before. How in Heaven's name did she end up there?"

"She practically lived there. Some of the bar owners had even started calling the district Dixieland."

"Mr Cox, where were you on Saturday night around midnight?"

Cox frowns, as if he does not understand the question. He is deathly pale. Beads of sweat form on his forehead. He takes out a white handkerchief with embroidered initials and blows his nose.

"At home."

"Alone?"

"Of course. Like always."

"Could you prove it?"

"I was sitting watching a film. *The Big Knife* by Robert Aldrich. In German, on a German channel. But still well worth it. You can check in the TV listings."

"That's not proof."

"Then I don't have any proof."

"And no alibi."

"And I don't need one! I haven't touched Shelley for ten years! Why should I do away with her? Because that's what you suspect, isn't it?"

"Because she was making your life impossible?"

"Whose life?" His voice sounds weak. He whispers almost inaudibly. "I continue to maintain that she committed suicide."

"Was she running around talking about suicide plans then?"

"Once she said: 'I'll make an end of it before my fortieth.' But as I've already said: it's a long story."

"We've got all night."

Cox reflects for a while then begins to sob gently. Almost like a child. Suddenly all his arrogance disappears. He sits opposite Luyckx and Lannoy, an aging kid – caught out and unable to find a word of explanation.

"It's not easy to strip naked before complete strangers."

"We're not asking that."

"I'd rather write it down, if I may."

"Sure. Luc, you can go home. And run round to the garage early tomorrow to check out the damage to the gentleman's car."

"Can I go too?" asks Cox, rising. "I'll bring you a detailed account tomorrow, without fail."

"You stay here. And your account will decide whether the investigating magistrate lets you go home tomorrow or not."

7

Shelley and Victor Cox

> "I started at the top and worked my way down," declared
> Orson Welles once in an interview. You could say the same
> thing about my marriage. And my life.

With these words, Victor Cox starts the account, which he
has typed on Luyckx's computer, sitting flanked by two of-
ficers, on the night of 8–9th June 1998. It's six-thirty a.m.
and so quiet that you can hear the horns of the ships coming
into the harbour in the distance. While Cox, exhausted,
lies asleep on a bench in a cell, Luyckx is sitting reading at
his desk, stirring a glass of Alka-Seltzer. He lingered until
five in the morning in the Blue Note, where Sax played
on top form to a half-empty room, and he's now fighting
a splitting headache.

> I met Shelley on 11th June 1979 at a fancy-dress student
> ball at the Drama Institute, where I had been teaching
> for four years. In homage to John Wayne, who had died
> that morning in Los Angeles, I was wearing the very same
> blue uniform worn by the Duke in John Ford's *She Wore
> a Yellow Ribbon*. Including a sword. She had come with
> one of my students, Tony Blanckaert, who was study-
> ing film direction and now works as a plumber in the

Antwerp zoo. With her stiff black wig, her light-green eyes, her broad laugh and her dazzling white teeth, and above all her Indian costume – a short dress of imitation deerskin with fringes – she reminded me instantly of Jennifer Jones in King Vidor's *Duel in the Sun*. Considering we were the only ones who looked as if we had stepped right out of a Western, it was not difficult to strike up a conversation. She was twenty-one years old and her name was Shelley Verdijck. She worked as an usherette in the Berchem Palace, that long-gone neighbourhood cinema in the Grote Steenweg. Through her job, waiting in the semi-darkness at the back of the hall for latecomers, she had seen a good deal of films, some so often that she knew the dialogue by heart. She sounded happy, smelt of patchouli, and in my eyes was the equal on the dance floor of Cyd Charisse. I was just emerging from a pretty chaotic relationship with a woman who preferred travel to film. I was ready for anything. My only fear was that she would quickly dismiss me as an old buffer as she was eleven years younger than I was. But the difference in our ages did not seem to bother her that evening. And when, pressed tight against one another, we were dancing to Harry Nilsson's *Without You*, and she whispered in my ear, paraphrasing Mae West, "Is that your sword I can feel or are you just happy to see me?" I was completely bowled over. "Both," I replied and asked her then and there to marry me – and felt the floor melt away under my cowboy boots.

We had both drunk quite a bit, so I cannot remember exactly what happened after the dance. But when I woke up the next morning she was lying naked beside me – and she was a blonde. Fortunately I did not have any classes on Tuesday. I carefully pulled back the sheets and sat down on the sofa opposite the bed. That morning I gazed with the eyes of a beggar at that warm, young creature that had landed like an undeserved gift between my sheets, and,

choked with emotion, I waited until, bathed in a golden pool of light like a shameless victim on an altar, she had slept off her intoxication.

Now and then she would groan, smile, stretch out her hand feebly, and feel around in the empty bed as if she was reaching out for me. I kissed her fingertips to relax her. I watched over her like an anxious dog inebriated by a sense of unending joy. I whispered loving, calming words to her, and she dozed off again, caressing her taut belly and the scorpion tattooed on the inside of her left thigh in her sleep. When she lay on her side her breasts lay against each other like two pale ripe little pears. The tender breasts of Montana Wildhack on the planet Tralfamadore in George Roy Hill's film of *Slaughterhouse-Five*. Six weeks later we were married.

Luyckx gulps down two aspirins with his Alka-Seltzer. It is as if Sonny Spencer is stuck drumming between his temples. The duty orderly who is getting ready to finish his shift brings him a plastic mug of weak coffee and asks if Cox's account is worth the trouble. "He worked on it for eight hours."

"You have the feeling that he's done his best," says Luyckx with a yawn. "He's trying to shake off something – but I still don't know what. I've only read a couple of pages so far. It's obvious that at first he was completely in love with his wife. But then who isn't?" Sipping his coffee he carries on reading.

Shelley and I went away on a week's honeymoon to Los Angeles. I had been dreaming for years of visiting the Mecca of film. It was between the W and the O of the gigantic Hollywood sign, on top of the hills, in the copper glow of a Technicolor sunset, that I made her a gift of Karen Morley's earrings. We were staying at the Chateau Marmont, where I had taken Suite 5D on the fifth floor. It was the suite that Vivien Leigh usually demanded when

she came to Hollywood and from where they took her away in a straitjacket in 1953 after she was replaced in William Dieterle's *Elephant Walk* by an Elizabeth Taylor twenty years her junior. Seven years later she stayed there once again for a month with her cat Poo Jones, while she was playing opposite Jack Merivale at the Hollywood Playhouse.

I don't know whether Miss Leigh's drinking problem was catching, but the fact is that Shelley and I drank an awful lot during our stay in the hotel. Especially Shelley, who every now and then would burst into tears if the mini-bar was empty and she had to wait too long for room service to bring up another bottle. I did not attach much importance to this because she claimed she had never been so happy.

Back in Antwerp we moved into the flat where I still live. I went to the Berchem Palace pretty frequently if she was working nights. Not because the programme was worth the trouble (although I discovered a couple of little-known science-fiction gems like *The Mole People* with Cynthia Patrick, or *Phase IV*, where Lynne Frederick is abducted by giant ants) but usually to make sure that she came home after the last screening instead of hanging around in the Vollen Bak, the café around the corner.

In early 1982 Shelley became pregnant. She did not follow her gynaecologist's advice to give up drink for a while, and lost the baby at five months. It was a girl that we would have called Romy, in humble tribute to Romy Schneider, who had committed suicide in her apartment on the rue Barbet-de-Jouy in Paris on 29th May. To add to her misery, she lost her job shortly after her miscarriage because the Berchem Palace closed down. Her vague attempts to find another position were farcical. She was usually too drunk to get to her interviews.

While I continued to lecture at the Institute, she spent the whole day shuffling around the apartment in her

dressing gown like a ghost. She hardly went out any more and cut herself off completely from the outside world. She never watched a film, never listened to music. She drank because she was bored with me, she said, and because I preferred dead film stars to her. Those were our *Days of Wine and Roses*. With the difference that I had developed an aversion to alcohol and refused to touch another glass of the stuff. I was busy with everything because she usually spent the day in bed with a bottle and was no longer able to take care of the housework. I suggested several times that she should go for detox. She agreed to give it a go and was admitted to Stuivenberg Hospital. But after three days I found her in the morning in the front garden, naked like Hedy Lamarr in *Ecstasy*, sleeping on the damp grass under a rhododendron bush. I know that I let slip to my colleagues at that time that I would have preferred her to be dead than to watch her slide into dementia and that I would feel a release once she had definitively drunk herself into the grave. They will confirm this. Nevertheless, that does not mean that I murdered her ten years later. For to this day I love the Sioux beauty who lit up that student ball like a dark sun on 11th June 1979. When she began to degenerate physically, I could not look at her any longer. And just as there are no known photos of Garbo in her advanced years, I have remained with that first image before my eyes. The image of eternal beauty, of youth frozen in time.

Luyckx puts down the papers and rubs his eyes dejectedly. The more he reads, the harder it is to find the answers he is seeking. Either the man is absolutely crazy and is living in a dream that is closer to the fantasy world of cinema than reality, or this is a diabolical plan, long in the making, to eliminate his wife. Or again he is as naive and hopeless as he acts and has nothing to do with his wife's death.

Luyckx gets up and is just about to call Lannoy to get him out of bed when his partner bursts in.

"Well, you're here early today!"

"I've already been down to the Ford garage."

"And?"

"His car really is there. With all the damage that he described. The man at the garage showed me traces of blue paint on the bodywork and agreed that it was the result of a collision. Given the colour, probably a Renault, he said. And what's Cox written down?"

"No confession so far. But I've still got to go through the last bit. Here, you can read the beginning while I'm doing that."

But before I go to sleep, I must still unburden myself of a couple of things.

I have no argument with people who drink a glass or two too much at a party from time to time. To each his pleasure. That used to happen to me too, and I could hold my own as well as the next man. But Shelley's problem was different. She did not enjoy drinking and when she was drunk her personality changed into something else: Faye Dunaway in Barbet Schroeder's *Barfly*. Dr Jekyll and Mr Hyde. At times like that she could talk nonsense for hours, as if she had bats in the belfry with a head full of spiders, that sort of thing. Or she changed into a terribly sad, terribly scared creature, who thought that humanity had turned on her, a nagging, vulgar monster who listened to no one and what's more was convinced that I was carrying on with all my female students. It is true that for some time we had had no sexual relations with each other. With time she had become anything but attractive. She lost weight, her hair began to fall out and her teeth became loose. I suggested that she take a lover and leave me in peace. And she did. I know that for a time she had a relationship with a professional sol-

dier, one Captain Aimé Butterfly, who was stationed in Brasschaat, and who drank as much as she did and – or so she told me in order to torment me – possessed Joan Collins's autograph. I let her do it. At least she was out of the house and didn't need to stuff her bottles behind my books or under the sofa. Whether she was still seeing him recently I would not be able to say.

She spent almost every night away from home in the last few years. I do not know where she was hanging around. And I never asked her either. To tell the truth, we no longer spoke to each other. She had her own room where she slept through the day, while I was at college or spent my time in the cinema or in my study, where I was occupied with my collection or my research into 'The Evolution of Desire on the Silver Screen'. I could not see any other solution. I admit that I was happy with her for a few months, twenty years ago. A time I will never forget. And that is already something that counts in a man's life.

I hope that you can now understand my reaction a little more clearly. It is not indifference. What happened to Shelley last Saturday is really awful. But it was written in the stars and perhaps it was for the best. Certainly for her. For her life was no longer a life, Superintendent, but a hopeless, endless crucifixion.

Luyckx hands the last three pages of Cox's account to Lannoy.

"He's innocent," he sighs. "A little otherworldly, but innocent."

"Still, he had every motive to get rid of her," replies Lannoy. "I would have killed her years ago."

"Exactly. Why would he have waited so long? He had the opportunity every day. He just needed to push her downstairs. As far as I'm concerned, he can go home."

8

Aimé Butterfly

After dropping a totally exhausted Victor Cox back home, Luyckx and Lannoy drove to the barracks at Brasschaat to pay an unannounced visit to Aimé Butterfly. After all, if Cox's statement was true, the captain was more or less the only person with whom Shelley had shared her life recently. He would probably be able to say more about her than her husband.

"Aimé," says Luyckx, as they drive into the camp, "the perfect name for a lover."

"Talking of which, Ma Mussel told me that Shelley would sometimes speak about a butterfly on her shoulder as if she was talking about a guardian angel."

"Well, I'm curious to hear what our guardian angel has to say."

Captain Butterfly was responsible for cultural services at Brasschaat camp. His office was in a booth next to the library, a tiny room with two IKEA bookcases crammed full of well-thumbed books about World War Two, dog-eared biographies of great strategists and generals, torn atlases, hobby guides on gardening, aquariums and miniature modelling, technical literature on tanks and artillery and a tome on Rubens and his age.

On the pale green walls, next to the framed autograph of Joan Collins and official portraits of King Albert and Queen

Paola, hang posters for forthcoming cultural events: a one-off concert with Marcel Schoeters and his exotic ensemble, an appearance by the international conjuror Abdul Ajax, a poetry recital by Warrant Officer Arno Serneels accompanied by flamenco guitar and a pedagogical evening devoted to family planning in the armed forces.

In the middle of the room, like at the dentist's, there is an oval three-legged coffee table made of orange Formica, the sort of 1950s antique that you can still find at second-hand shops like Spullenhulp. Three piles of magazines – about cars, pets and the royal family – are stacked on the table.

After a sloppy sergeant has informed the captain of their arrival, Luyckx and Lannoy are admitted to his office. Butterfly is sitting rigid in his starched uniform behind an empty desk. A little, desiccated functionary, a warrior without a war, a ruler without subjects, a hero without a story. His shoes shine like marble.

"You are lucky to find me here, gentlemen. Normally I only meet people by appointment."

When he speaks, Butterfly loses control of his right shoulder, which develops a twitch.

"Sometimes we're in luck, right?" replies Luyckx, barely able to suppress a smile as he tries to imagine Shelley and Aimé romping.

"Butterfly – is that your real name?"

"Yes."

"Like *Madam Butterfly*, the opera?"

"Yes. I suppose that's why they put me in the cultural service. Well, Chief Superintendent Luyckx… the name's familiar. Didn't you lead the investigation in the Donders case, that notary from Puurvelde?"

"That's right, yes."

"And the murder of that young nurse, Virginia Steiner, two years ago?"

"Yes, and that one."

"Still unsolved, if I remember correctly?"

"You have a good memory."

"You need to in the cultural service. But anyway, how can I help you, gentlemen?"

Butterfly pours himself a plastic cup of lukewarm Absolut vodka, filling it to the brim.

"Can I offer you anything?"

"It's still a little early for me. Luc?"

"No thanks."

The mahogany clock on the wall strikes nine.

"We won't hold you up for too long. Does the name Shelley Cox mean anything to you?"

"No. Why do you ask?"

"Because she knows you."

"Or rather, knew you."

Captain Butterfly looks enquiringly at them through the dark rectangles of his glasses.

"We guess that Mrs Cox knew you, because she told us that you own Joan Collins's autograph." Luyckx directs his gaze pointedly to the little frame next to the Queen.

"Indeed. But many people know about that. Miss Collins signed my invitation at a reception of the provincial governor's. On the ninth of December 1993, to be precise."

"And 'Dixie', does *that* mean anything?" interrupts Lannoy.

Captain Butterfly empties his cup in one gulp.

"Dixie? Dixie… Yes… She's a friend I see regularly."

"Her husband told us that she's your lover."

"Is Dixie married?"

"Shelley Cox and Dixie were the same person."

"Were?"

"We fished her corpse out of the Bonaparte Dock yesterday."

Aimé begins to tremble violently. He pours himself another vodka and drains it in one go. Then he runs out to the corridor and locks himself in the toilet. Luyckx and Lannoy can hear him throwing up loudly. When, propped up by the sergeant, he reappears in his office, he immediately

sits down behind his desk and wipes his mouth carefully with a paper tissue.

"Sorry about that. Dixie and I were indeed very… We… I really loved her. She was looking for someone who would understand and protect her. We met each other a couple of years ago at the sauna in Zoersel."

"That nudist camp where you can play bowls naked?"

"Dixie felt joyfully at one with nature."

"That's why she drank nothing but water, right?"

"I never claimed that."

"Captain, did the two of you have a relationship, yes or no?"

"Many officers go to the sauna. Dixie liked officers, their aura of power, the respect they command. I was not the only one, but I had more in common with Dixie than the others. We were both Scorpios. Like me she was very sensitive. Perhaps it sounds strange for a soldier, but yesterday I was moved to tears by a Japanese ice-skater on TV."

"When was the last time you saw Shelley Cox?"

"Last Friday. This is all strictly in confidence, I hope."

"Where?"

"In my caravan, right by the sauna. Our secret love nest, as she called it. She left at about eight to go back to Antwerp, where she had a meeting. I believe it was with someone from the film world."

"There's no business like show business."

"And how did you spend the next evening?"

"On Saturday night I was in the officers' mess, celebrating Colonel De Bruin's birthday until the early hours of the morning. I can give you the names of twenty colleagues who can confirm that."

"Did you ever go out with Mrs Cox in Docklands?"

"Absolutely not. I am the father of two children, gentlemen!"

Lousy bastard, thinks Luyckx.

9

Louise Vlerickx

Because Captain Butterfly had brought up the Donders case while he was being questioned, Luyckx was dreaming about the notary when the cries of jeering children in the narrow Pompstraat woke him at around four o'clock. Irritated because he had been on the point of solving the case in his dream, he shuffled into the kitchen to make some coffee. Tough case, that murder in Puurvelde. He had been fumbling in the dark for three years and every trail had petered out.

On 16th December 1995, The Sponge was sitting in that very kitchen over two fried eggs listening to the morning news when the telephone rang. It was Lannoy. The body of a young woman had been discovered in Puurvelde in the village notary's garage and the godforsaken village was just about in the goddamned province of Antwerp. He didn't have any other details. Ten minutes later they were on their way. On either side of the motorway the grass had vanished under a fresh fall of snow and the horses looked like ponies.

Jos Donders's chambers were located in his villa at 3A Dennenlaan. A building of whitewashed bricks with a gently undulating thatched roof from the beginning of the unstylish Eighties.

"What have you got for us?" asks Luyckx, shaking the hands of Gendarmerie Brigadier Peeters.

"A young woman. Suicide or murder."

"I hope nobody has touched anything."

"We know the rules, Inspector, even out here in the sticks."

A heavy man in a grey flannel three-piece suit walks awkwardly up to them over the crunchy snow. He carefully avoids the shapeless lumps that here and there betray the presence of a snow-covered garden gnome. With his thin, closely trimmed grey hair, double chin, purple cheeks and small round glasses he looks older than he probably is.

"Luyckx and Lannoy, Antwerp Detective Branch," says The Sponge curtly.

"Incredible fall of snow last night. The skies just opened," the notary sighs as if he is receiving a client with one of his polite formulas and has nothing more important to report. "Did it snow like this in Antwerp too?"

"No," snaps Luyckx, "it never snows in Antwerp." And thinks: if this fellow doesn't take communion every Sunday, I'll have the crucifixion tattooed on my chest.

"Typical," says the notary.

"Where did it happen?"

"Follow me. A particularly tedious situation."

At the end of the large garden, Mr Donders had had a stylish hangar built for his collection of old-timers.

"By international standards, my collection is nothing special," he cries excitedly as he dashes on ahead. "But in local terms I'm not to be sniffed at." He counts on his fingers: "A 1961 Borgward Isabella coupé, a 1958 Ford Edsel Citation, a 6-cylinder Humber Super-Snipe from 1953, a 1929 Pierce-Arrow "Straight Eight", a 1936 Triumph Gloria Southern Cross Sports, a 1935 Lincoln convertible V-12 KB and a 1951 Packard Patrician 400 with the revolutionary Ultramatic connecting rod. Each and every piece in perfect

working order. Showroom-quality restorations! I think of them as my daughters."

"Do you have any other children?" interrupts Lannoy.

"Four. Our Ken, our Sven, our Frieda and our Lieveke. The school is closed today because of the weather conditions. They're sitting upstairs with their mother watching *Flipper*. I don't want them to see this."

Before opening his office at nine o'clock, the notary checks his cars every morning. On this particular day he had immediately noticed that someone had been messing around with the lock of the pen where the Lincoln was parked. It must have happened the previous evening because he had not seen any fresh tracks in the snow. At first he thought the thieves had not managed to open the garage door. It took him quite some time to squeeze the key into the damaged lock.

"You couldn't breathe the air inside. The engine had obviously been running for much of the night until the petrol ran out. There was a thick cloud of carbon monoxide but I could see that the left-hand car door was open. I managed to open the garage door with a good deal of effort in order to let in some fresh air. And then I saw her. Quite embarrassing. I haven't touched a thing."

The victim's wrists and ankles had been tied up with wire. Her head was resting on the ivory steering wheel. Her eyes and mouth were wide open. She was very young, within a year or two of twenty at most. She had nothing on but a hand-knitted jersey of dark-blue wool that was much too big for her. She had probably already been unconscious when she was dragged into the garage and left in the car. Otherwise she would have woken up the whole neighbourhood with her screams. But she had vomited up blood. That was a reliable indication that she had died of carbon monoxide poisoning.

"I did not recognize her at first," whispers the notary to Lannoy, while Luyckx examines the car floor with a pocket torch.

"Do you know her?"

"Not personally."

"Everyone knows her," adds the brigadier smugly.

"That's why it's so embarrassing. Do you understand? Once this leaks out, the entire Belgian tabloid press will be at my door. Fortunately the car hasn't been damaged."

"Who is she then?" asks Lannoy with irritation.

"Louise Vlerickx," says The Sponge. "She played Francesca, the daughter of the lonely hearts agency manager, in *Wedding*, that soap that half Flanders is watching every evening at seven thirty. There's no business like show business."

That evening the papers led with an account of the theatrical murder of Louise Vlerickx. Lode Merels, the wonderboy from Ghent who wrote and directed *Wedding*, said Louise had not appeared on set for three days. But it wasn't the first time she'd been a drama queen, so he hadn't found it necessary to alert the police or anyone else. The next morning every paper flaunted the photos of the actress and the garage of the "Beast of Puurvelde" on its front page. The impact on the local community was indescribable, especially because the notary, who for personal reasons had refused to say where he had spent the evening of the murder, was led away by gendarmes in front of the cameras with a sack over his head. His wife insisted in complete dismay that he had attended a meeting of the Chamber of Commerce, but no one had seen him there. After twenty-four hours in custody, he finally confessed that he had been in bed with his girlfriend, the landlady of the Flamingo, the roadside café on the Beversesteenweg, until two in the morning. The lady in question confirmed this without blinking and he was released. But the damage was done and, without

knowing why, no one really believed that he was innocent. One week later, because he could not cope with the media pressure and the stress of the scandal, he abandoned his chambers, his cars, his wife and his children and disappeared without a trace. Madam sold the house and his collection and moved with her offspring to the coast where she lay low with her parents. Months later some Flemish tourists discovered Donders in the Philippines, where he still lives, earning his keep as a medium.

Louise Vlerickx's funeral was attended by thousands of mourning fans, and the memorial park in Antwerp's Schoonselhof cemetery was too small to hold the crowd. The Minister of Culture displayed his appreciation of her life in an emotional graveside eulogy, which caused Louise's mother to burst into tears. In Puurvelde, the Friends of Francesca Association organized a silent march in memory of their fallen idol. The empty garage became a place of pilgrimage, where every weekend a pack of devoted admirers came to light candles in silence. The week after she was buried, the three episodes of *Wedding* in the can, in which she still appeared, were broadcast. The viewing figures were phenomenal. After that the series was terminated. No fewer than twelve detectives were entrusted with the investigation. Virtually the entire world of show business was questioned. A dozen suspects were arrested and then released again for lack of evidence. One side-effect of the probe was that a cocaine ring was broken up. But three years on the mystery remained unsolved, and still no one knew how or why the actress had ended up in the notary's Lincoln.

10

Virginia Steiner

In the half-filled church, two worlds have come together that have nothing in common and which perfectly illustrate Shelley's split personality. On the left, the world of night: the inhabitants of Docklands, the pub and café owners, the faded revellers, the knights errant of darkness, the ghosts and shades that rarely brave daylight and who had accompanied Dixie to the bitter end of her insoluble quest. On the right, the world of light: Victor Cox, pale and overcome by emotion, surrounded by his students and the complete faculty. Even his former colleague, Poels, had shown up, probably out of *schadenfreude*. And then what was left of Shelley's family: her parents, a brother who had flown in from Curaçao and some distant aunts and cousins whom she never saw. Also a few senior officers, including Aimé Butterfly in civilian dress, who fits in everywhere – and therefore nowhere – and does not know which side he should choose.

Luyckx, who out of principle as well as because of the hypocritical nagging of priests never attends religious ceremonies, waits outside until the mass is over. He does not rule out a single possibility. In his time he has even seen the murderer attend his victim's funeral. As soon as the cortège emerges, he will stamp the face and behaviour of every individual that he cannot identify on his memory.

The little Moroccan who hides behind reflective shades and whom he calls The Rat is his oldest informer. He knows everyone and should be able to shed some light on every suspicious individual for The Sponge.

"Number three," says The Rat.

Luyckx turns round, but the church doors are still closed. "What do you mean?"

"First Louise Vlerickx, then Virginia Steiner, and now Shelley/Dixie Cox."

"I can't see any connection."

"But I can. None of these three cases has been solved."

"Shelley Cox had an accident."

"That's what I heard too. Run over, then chucked in the water. By who? No idea. I wouldn't call that an accident."

"Maybe it was a hit-and-run."

"And Virginia Steiner with her lovely teeth – was that an accident too?"

Luyckx was still lying comfortably in bed when he was woken up on 10th September 1996 at half past six by the phone ringing. It had to be important since he had expressly asked Lannoy not to hassle him before midday after two sleepless nights in a row.

"Luc, I need a coffee and a cold shower to wake up. I can't open my eyes, man!"

"Sax and I will be at your place in a quarter of an hour. You won't be sorry."

In the car Luyckx perked up as he sat on the backseat listening to Lannoy's story. As he had said it was worth the trouble and his fatigue was disappearing by the second.

At six fifteen Dr Albert Verdonck, chief surgeon of the St Maria Clinic in Mortsel, had found the naked body of one of his nurses dying in the building's underground car park. He had spent the whole night in the operating theatre and was about to get into his Porsche when he saw her lying in a pool of blood at the entrance to the A&E.

"She was lying in a foetal position with her face turned towards the wall. But I recognized her by her magnificent head of hair which all the other nurses were jealous of. Virginia Steiner. She was twenty-five and had been working for me since last December. A real treasure. Not just beautiful but always cheerful, ready to help day or night. Yesterday was her day off."

"Was she still alive when you discovered her in the car park?"

"She'd lost a lot of blood. I immediately had her brought into the operating theatre for a transfusion. But it was too late. She was dead within ten minutes."

"Did she say anything before she died?"

"She was already in a coma when I found her."

Dr Verdonck, who after eight years of traumatology can handle a shock, is clearly suffering and having trouble hiding his discomfort and distress.

"What were her injuries?" asks Sax gravely, as if talking among professional colleagues.

"Mainly internal injuries. With a camera I was able to establish that her bladder and uterus had been perforated. But her vagina and labia also presented numerous lesions. As if she had been violated with a sharp object."

"The autopsy should be able to determine that."

Virginia Steiner is lying on the brightly lit operating table, her legs slightly apart, her arms by her side. Her abundant black hair hangs over the edge of the table, almost reaching the floor. At first sight her milky-white, flawless skin does not reveal any wounds. She seems to be asleep. Apart from Katia, the Polish hooker in the Verversrui in the middle of Antwerp's red-light district, whom he visits three times a week, Luyckx has never seen a woman's body that affects him so much.

"There's something old-fashioned about her," he says with a lump in his throat, "like women in dirty postcards from the 1920s."

"That's her tiny breasts and small nipples," says Lannoy, whispering so as not to wake her. "And her small lips and the heavy, straight eyebrows. She reminds me of Katia."

"Who?"

"Katia. A Polish friend of mine you don't know."

Meanwhile Sax has pulled on transparent, plastic surgical gloves, and bending over the luxuriant jet-black triangle covering her swollen mound of Venus, is carefully spreading the labia.

"Jesus," he sighs. "Talk about a butcher." He turns to Dr Verdonck. "Can you make sure that she is transferred to the forensic institute today?"

"No problem. But can we deal with the rest of the formalities in my office? I'm finding it really difficult here."

With her half-opened mouth, Virginia seems to be smiling at The Sponge one last time before he leaves the operating theatre.

"What lovely teeth she has," he says.

"Yes," replies Verdonck. "And she was always laughing."

The doctor is sitting slumped in a sugar-pink sofa under a large Pol Mara canvas in which three naked glamour models are staring at the blue rectangle of a swimming pool in Provence.

"It's so well painted that you can hear the crickets," he sighs.

Luyckx sips his coffee and takes out a cigarette.

"Is smoking permitted here?"

"I'm a smoker," replies Verdonck.

Luyckx offers him his packet.

"Was she married?" The Sponge had noticed that Virgina did not wear a wedding ring.

"No."

"Did she have a steady boyfriend?"

Hesitating briefly, the doctor replies that she had recently started a relationship with someone at the clinic.

"Who?" asks Lannoy, who has pulled out his notebook.

"With me." His chin trembles. His eyes fill with tears.

Lannoy, embarrassed, tries in vain to catch Luyckx's eye, who is staring dreamily at the painting above the sofa. To break the uncomfortable silence he asks if Verdonck is married.

"No," replies the doctor, weeping. "But Virginia and I had vague plans to get married. She was going to let me know today."

Dr Verdonck's initial observations turned out to be right. Furthermore, Sax had found the cork from a champagne bottle in Virginia Steiner's uterine cavity. That indicated that the victim had been violated with a champagne bottle and from being shaken about its cork had gone off like a bullet.

After a long and careful investigation, it turned out that the members of staff of the St Maria Clinic had nothing to do with this abominable murder. The fingerprints on the evidence found by the detectives in the car park – an empty packet of Camel filters, a Brussels Airport parking ticket, a paper handkerchief, a torn medical certificate – did not yield much. How Virginia had spent the second half of the night of 9th September was difficult to establish. She had gone to dinner at her parents' at half past seven and discussed her marriage plans. She sounded cheerful when she left her parents' house at around ten. She had then gone to the Cartoons cinema in Antwerp to see *Bound*, the lesbian thriller by the Wachowski brothers with Jennifer Tilly and Gina Gershon. Witnesses had seen her leave the cinema at midnight. According to the cashier, she was in conversation with a distinguished middle-aged man when she left the building. But it was not unusual in this little neighbourhood cinema for the audience to discuss the film with each other. Her neighbour, who had the key to her apartment to take care of the cat, knew that

she had not been home that night. And at that point the trail disappeared.

The bells of St Rombout's begin to toll as the sexton opens the church doors and Albinoni's *Adagio* resounds from within. The dignified cortège follows the coffin and wreaths borne by undertakers to the hearse. As they walk past, Jos the Screw, Cross-Eyed Carmen, Rudy Poels and Ma Mussel nod discreetly at The Sponge. Victor Cox leaves the procession and runs over to him.

"Superintendent, I'm really touched to see you here. Did you attend the funeral mass?"

"Unfortunately not."

"What a turnout! I had no idea Shelley had so many friends."

"For professional reasons I have to wait outside."

"Pity. You really missed something. The blind priest was the spitting image of Harry Dean Stanton, the preacher in John Huston's *Wise Blood*. Any news?"

"I'm afraid not. Perhaps this isn't the right moment, but I have a question. Shelley was often gone for a few days. Why did you call the police this time?"

"Because it was her birthday. I've already told you. Last Saturday she turned forty and before my fortieth she said…"

"Exactly. I understand now. Sorry."

Victor Cox looks ten years younger. Shelley's death has obviously done him a power of good.

11

Frances Farmer

Even less than today, Hollywood had no room for rebels during the glorious 1930s and 1940s. In this period the stars were the property of the big studios, and counted for little themselves. The studio bosses, the so-called moguls, lent them to each other or sold them like cattle, sometimes for enormous sums, rarely consulting those concerned. And anyone who was not popular, did not bring in the money or was just awkward, found herself sidelined or cast into oblivion. On the other hand a young actress who won a local beauty contest could, thanks to these same tycoons, earn her place from one day to the next in the highly select circle of the film divas.

That is exactly what happened to Frances Farmer in 1935, when Paramount lifted her out of obscurity as the new Garbo and offered her a seven-year contract.

On Wednesday 28th June, Victor Cox is marking student work at his desk, listening to the *Concierto de Aranjuez* played by Miles Davis. In front of him lie the papers of the second-year directing class. The subject of the dissertation: 'A Portrait of My Favourite Actor/Actress'. It is late and the windows are open. The night is sultry. In the copper beech a nightingale is singing. It is almost a hot summer. Sipping a Southern

Comfort, he gazes at the framed photo of Shelley, laughing in the lobby of the Chateau Marmont in 1979. He misses her posing there as Betty Grable with her long legs in her white shorts. This was the Shelley he can never forget. Shelley before she turned into Dixie and was left for dead two years ago by some coward who is still running around at liberty.

Most of the essays are not up to scratch. Even the subjects they have chosen are predictable: Di Caprio, Johnny Depp and Brad Pitt for the girls; Uma Thurman, Julia Roberts and Jennifer Lopez for the boys. The choice of Frances Farmer is at least original. He had not expected anything less from his best female student.

Farmer immediately took the lead in five films: *Come and Get It* for Goldwyn, *Son of Fury* with Tyrone Power, *Ebb Tide* with Ray Milland, *The Toast of New York* with Cary Grant and *Among the Living* with Albert Dekker.

You're forgetting one more, my girl, thinks Cox, *South of Pago Pago* with John Hall. But it's not serious and he carries on reading.

But Frances was not happy with the system. She had everything in Hollywood except money. She considered herself a fully fledged actress and not some shop-window mannequin to be disposed of by others. She quarrelled with everyone, even with Zukor and other moguls.

And when her problems surfaced on the night of 9th October 1942, there was no one left to help her.

It all began with a trivial traffic check on the Pacific Coast Highway. She was sitting at the wheel drunk and was pulled over. After a furious row she ended up in a cell in the Santa Monica jail. She was sentenced to 180 days in jail on probation, provided she reported to a justice of the peace three times a week, which she of course forgot to do. One week later she was arrested again in Holly-

wood's Knickerbocker Hotel, after she had been seen by passers-by walking along the Sunset Strip drunk and with her breasts bared. After another furious row with the police, she was dragged naked out of the hotel through the lobby. She looked terrible and at the police station no one recognized her. When the duty officer asked her profession, the new Garbo replied: "cocksucker".

A mass of reporters and photographers followed her trial. Judge Hickson, whom she insulted and at whom she hurled an inkpot, was not generous. When she left the courtroom under escort, she turned to Hickson and asked: "Have you never had a broken heart?"

"Of course her heart was broken," says Cox to Shelley in the photo. "After her divorce from Leif Erickson she had a chaotic relationship with Clifford Odets, who had run out on her a couple of weeks earlier. And Paramount had fired her. At least *she* had reasons to drink."

Instead of helping her in her misery, her new employer Monogram Pictures gave the leading role she was to play in *No Escape* to Mary Brian. After exploiting her blatantly the world of Hollywood turned its back on her. Frances is alone. From her cell she cries for help, but no one hears her. Even her own mother, who had her declared insane and blamed the whole thing on the international communist conspiracy.

Cox is not so sure about this last point, or the way Starr sums up the last years of Frances Farmer's life. But it makes no difference. Although the essay has little to do with film, he is captivated by the fascination that this story of decline and downfall exercises on his young student.

Because she refused to work in prison, Frances was incarcerated in a sanatorium. There she was forced to undergo

a course of insulin for three months, a barbaric treatment to shake off drink that nowadays is banned. After that she was moved to the state loony bin in Steilacoom, a pathetic madhouse near Washington, where, far from the glamour of Beverly Hills, she spent the final ten years of her life in degrading circumstances.

I chose Frances Farmer not just because I admire her talent as an actress but to demonstrate that an insignificant incident on a highway can lead to the most appalling nightmare. That a life full of glitter and glory can be overturned, from one day to the next, through an act of stupidity if no one offers a helping hand. Indifference can prove fatal if everyone averts their gaze. Just like Clara Bow, Veronica Lake, Gail Russell or Gene Tierney, Frances Farmer died utterly alone, consumed by alcohol and suffering, the victim of the ignorance and cowardice of the dream world that surrounded her.

Who is guilty? Those who end up in the maelstrom crying and howling, until, in the end, they drown? Or those who, neatly dressed, stand on the waterside and watch, unmoved and deaf to their entreaties? For me she was a saint.

Perhaps Shelley was too, thinks Cox, stroking her legs in the photo with his forefinger. Perhaps I did not hear her cry out, and stood neatly dressed on the waterside, while she drifted away among the pleasure boats and the trash.

12

Starr Mortenson

Victor Cox was discussing the unsuccessful return of Clara
Bow in *The Wild Party* and *Call Her Savage* in his series on
comebacks, when she appeared in his class at the end of
October. She murmured a relaxed "Hello everybody!",
snuggled up onto a bench at the back of the classroom like
the It Girl, grinned at Cox and stared at him with her big
dark eyes. The resemblance to the actress who had died in
1965 was so disconcerting that he was unable to continue
with his lecture. He asked her to stay and sent the other
students home.

She was just nineteen, but with her finely delineated
eyebrows, crimson lips and short-cropped black hair, all
accentuating her pale make-up, she appeared five years
older. Her father was cultural attaché at the Belgian con-
sulate in New York, where she was studying film direction
at Colombia University. He had recently been recalled to
Belgium; she did not know how long it would be but so as
to lose no time she had enrolled at the Drama Institute as
an external student.

"Do you know who you look like?" mumbled Cox, as dizzy
and uneasy as that evening twenty years earlier when Shel-
ley had entered his life in her Indian costume.

"Louise Brooks. That's what my fellow students called me
in New York. I admit that I do act like her."

"Wrong," mumbled Cox again. "Clara Bow."

"Wow! The hottest Jazz Baby in film!" she laughed. "That's something new!"

Her name was Starr Mortenson.

"Starr with a double R. It was Daddy's idea."

"Not a bad idea if you're called Mortenson."

"What do you mean?"

"That was Marilyn Monroe's real name."

"I thought it was Baker. Norma Jeane Baker."

"Baker or Mortenson." Cox dreams on. "Perhaps you are distantly related?"

"I'd be surprised. My father's family was originally Swedish and my mother comes from Antwerp – 'the place where girls go wrong!'"

She came from another planet – a planet where every woman resembled Clara Bow and every man wandered among white concert grands on disorderly sets, driven mad with suppressed desire. She was not only eerily beautiful – she knew it. Not one of the callow donkeys he lectured to had ever heard of Louise Brooks or Norma Jeane Baker. Sometimes he wondered in a fit of despondency why he was still taking the trouble in the autumn of his life to initiate this pimply crew into the magic of cinema. For twenty-five years, he had tried fruitlessly, bar a couple of exceptions, to communicate his passion for the Seventh Art. And now he was weary, disillusioned and yearning for retirement. Then Starr had slipped radiantly into his class, a belated and unexpected gift. She was the light in the darkness, the embodiment of the redemption to which he would devote himself utterly in the time that was left to him.

Because his attention was now directed exclusively at Starr, her fellow students felt neglected and had filed a complaint. After a couple of months, he was summoned to see the director of the Institute who pointed out that Cox's class comprised twelve students, who all deserved to

be treated in the same way. He did not deny that Mortenson was probably his best acquisition, but he reminded Cox that she had enrolled as an external student and that she was not obliged to sit the exams. Cox protested that she had every intention of doing so. "But just for the hell of it", he said, because actually she had nothing more to prove.

Starr attended the course erratically. Sometimes she stayed away for days, and then he found it difficult to concentrate on his lecture. Because he could not conceal his anxiety during her absences, the wildest rumours started to circulate in the Institute corridors. When she stayed away in May for a whole week he decided in desperation to go and look for her at home. "Victor!" she cried when she opened the door. "What a lovely surprise!" She had called him Victor. "In the States," she said, "it's normal for students to call teaching staff by their first name." In answer to the question why she was no longer coming to school, she said she was working on a paper about Clara Bow. Just for him. She saw that his eyes were starting to water and invited him in. Her parents were out and she had the whole house to herself. He sat pressed against her until late into the night, feverishly reading her manuscript: the lines about the pathetic court case that Clara Bow launched against her secretary Daisy DeVoe, who had sold the story of her secret relationships with Eddie Cantor, Gary Cooper, Bela Lugosi and John Wayne (who at that point was still called Marion Morrison) were simply brilliant. But when he read the final chapter, in which La Bow and Buster Keaton died together in a sanatorium, he could no longer control his emotion and kissed her on the cheek. Fleetingly. After all, she was only nineteen. She smelt of Chanel No. 5, Marilyn's perfume.

She finished the year at the top of the class. It surprised no one. Evil tongues still maintained that her good marks were undeserved, to which Cox tirelessly replied that she was miles ahead of the others and had a natural gift. And that was it.

At the end-of-year student ball she asked him to dance. Let them gossip, she whispered in his ear, I prefer dancing with you to those pimples. Barely able to speak, he asked her what her plans were for the vacation. She said that she was going to New York for two months to visit friends.

"I'll send you a postcard of the Statue of Liberty. Promise."

"You won't come back. I can feel it."

"Don't nag, Victor. In September I'll be back at your door again."

During the endless summer months Victor Cox stayed in Antwerp organizing his collection of cinema props and curiosities. He even bought a couple of new pieces over the Internet, including the little black hat with a lace veil that Clara Bow wore at her wedding to Rex Bell. A present for Starr when she came back.

And come back she did. On 3rd September she called him. Half an hour later they were sitting outside a café by the cathedral. "You've turned quite grey," she said, "you're even more attractive than before." He gave her the hat. She put it on, curled up in his arms and kissed him slowly on the mouth. Cox could not let go of her. He was confused and embarrassed but he hoped everyone was watching them. He could not remember ever being so happy, not even when he had stood on the dance floor with Shelley twenty years before.

The new academic year passed as if in a dream. Starr did not often show up at the Institute, but Cox saw her almost every day outside class. They went to the cinema together or watched old films on video at home. It was better that way. Both of them understood that something was growing between them which was best not exposed to scrutiny. During the Christmas vacation she went away with her parents, which reassured Cox, back to New York to see in the new year and celebrate the new millennium

on Times Square. This time she sent him a postcard. Not the Statue of Liberty, but a photo of Louise Brooks in Pabst's *Lulu*. On 31st December she called him at midnight to say that she missed him. Over the phone he could hear the fireworks in the background, the sirens of the ambulances and fire engines, and the music of the bands and he cried: "Me too! I miss you too! I love you, Miss Mortenson! Come back quickly!" Later she told him there had been too much noise and she had not been able to understand him.

He had often asked her why a pretty girl like her preferred to spend her time with an old professor rather than with boys of her own age. "Because they're vacuous, clumsy prigs, because they have no style, because they're lousy at conversation, lousy at drinking and most of all lousy at making love and I don't know what I could share with them." She smiled irresistibly. She had so much in common with him that the difference in their ages meant nothing. Shelley had maintained the same thing too at first. But with her he had gone to bed, while in all these months he had barely dared to touch Starr.

Once, when they had each drunk a bottle of Chablis, sitting among the palm trees on the veranda of the Café Mozart in Antwerp's art-deco district, and she was stroking him on the shins with her bare foot under the table, he asked her whether she missed it.

"What do you mean, *it?*" she asked, with the glassy look of Mary Astor in *The Maltese Falcon*, staring at the Milky Way above the veranda.

Cox pulled on his cigarette, inhaled the smoke deeply and waited. Just as Bogart would have done at such a moment.

"Don't be so sure I'm as crooked as I'm supposed to be."

"Bogie in *The Maltese Falcon*."

She was unbeatable. Cox blew out his cigarette smoke, coughing.

"You know what I mean."

"What you don't know, you won't miss. But I have all the time in the world."

"Of course. You're young."

"You too."

"I've been around so long I can remember Doris Day before she was a virgin."

"Groucho Marx?"

"Right. And what's more you're much too beautiful."

"The arrangement of the features in your face is not entirely repulsive to me."

"Greta Garbo to Melvin Douglas in *Ninotchka*."

"Well done."

"Starr, we should stick to our innocent little games. You would only be disappointed."

"I'd be surprised."

"You are the daughter I never had."

"Close your eyes. What can you see?"

"I can see you."

"Always?"

"Always."

"Then it's time to come and see what's on the other side of the mountain."

Cox could not place the quote. She had won and laughed so loud that the restaurant fell silent and the waiters, laden with Dame Blanche sundaes and chocolate mousse, turned to stone.

After the death of his wife, Victor Cox had discovered the Docklands district, where she had passed the last years of her double life. At first he would go and stroll there by day out of curiosity to see the spot where she had died. Later he ventured out there at night too, so as to meet her friends, some of whom looked as if they might have stepped straight out of a film noir. No one really knew who he was, and on several occasions, during a nostalgic conversation about Shelley, he had the impression he

was only now getting to know her. What struck him in particular was that everyone missed her and agreed that Dixieland without Drunken Dixie had lost much of its panache.

Tonight he has arranged to meet Starr in the Macumba at eight. The pub is peaceful. The happy hour regulars have all toddled off home and it's still too early for the night owls.

Cox is sitting on the terrace from where he has a view of the dark carcass of the Nassau Bridge and the swaying masts of the sailing ships in the Bonaparte Dock. The weather is still as balmy as yesterday when he sat at home correcting papers by the open window.

Ten minutes late for their appointment she walks over the bridge waving. Gay, seductive, dangerously innocent. She sits down opposite him, and, like a ritual, takes her mobile, lighter and cigarettes out of her bag and lays them on the table next to the file containing her paper on Frances Farmer. Naturally, Jos the Screw notices her, hurries out and bows to her like a mahogany giant.

"What would your daughter like to drink?"

"Daughter? Granddaughter more like! What are you drinking, grandpa?"

"A dry Martini."

"I'll have the same."

Starr bursts out laughing. Cox does not find it so funny.

"Come on Vic, it's a joke! What did you think of my paper?"

"It doesn't have much to do with cinema. Apart from that, it's well documented, as usual. Fourteen out of twenty."

"Is that all?"

"I would have preferred you to discuss her films rather than her life."

"Her life made me think of your ex's, that's all."

"What do *you* know about Shelley's life?"

"Everything. Like all of us at college. I realize what you went through for all those years. It must have been terrible.

68

But I also tried to imagine the kind of hell Dixie found herself in."

"It was all a long time ago."

"Don't tell me you're sitting here by chance. When I came over the bridge just now I imagined she was lying there and I had to wade through her blood to get to you."

"It is a bit like that."

"Some people have blood on their hands. I have blood on my shoes. What do you think of my new boots by the way?"

"Cute."

13

Alfred Hitchcock

Today I turned sixty and started the latest chapter of my story in this belated and unexpected diary. A chapter devoted entirely to Starr – because nothing else matters any more and a world without her has become unimaginable. Starr Mortenson – my star, just as Dietrich was the star of von Sternberg or Harlow was the star of Capra. Now that I am starting retirement, a time of turmoil has dawned and I can finally give expression, without hesitation or shame, to my most secret dreams. I have always behaved as a docile, patient man, lost among the anonymous spectators of my countless theatres. All my life I have fed on the dreams of others. A kiss was nothing but four lips six feet wide barely touching in close-up, or two gigantic mouths intertwined on a screen in the night. But from today I choose life over the imitation of life. Because from today I consider my life to be the film in which I immortalize, for myself, the fleeting beauty of her thousand faces. With the same passion, the same undisguised desire, the same complicity that Chaplin shows when he takes Paulette Godard by the hand at the end of *Modern Times* and, on a country lane leading to nowhere, turns

his back on what has passed. The infatuation of Rossellini for Ingrid Bergman in *Stromboli*, of Orson Welles for Rita Hayworth in *The Lady of Shanghai* or of Cassavetes for Gena Rowlands in *Love Streams*.

The entire faculty has gathered in the ballet room of the Institute to celebrate Victor Cox's departure and birthday. In his valedictory address, the director did not only talk about his exemplary career. He also praised the professor for the courage and steadfastness he had shown after the dramatic disappearance of his wife. And he ended on a humorous note, mentioning his friendship with Starr, who he said would undoubtedly stay and look after him like a grateful daughter, at which the company burst into hearty, liberating laughter. The Councillor for Culture handed him the medal of the City of Antwerp and a book about Hitchcock, which he had already had on his shelves for ten years.

"As you are retiring," whispers Starr, who is accompanying him at the ceremony, "so will I. You don't think I'm coming back to this crappy school in September if you're not here to lecture."

"OK, but then stay with me for the vacation."

"That's what I was planning. A lifelong vacation without end. Happy birthday, Old Vic!"

Afterwards they toast Victor with sparkling wine, a blanquette de Limoux that Starr refuses to drink, and his colleagues come up one by one to say goodbye. The same way you greet the family after a funeral.

The director: "We'll miss you, Victor. You're irreplaceable."

The professor of theatre studies: "I hope you'll come and see us now and then. If your girlfriend gives her permission!"

The sports teacher: "So what are your plans, old man? Or should I ask Miss Mortenson?"

The elocution teachers: "Life begins at sixty. But I don't need to tell *you* that, it seems."

The janitor: "You should write a book, Mr Cox, now that you've got the time."

The professor of photography: "I think Victor had more time before he retired."

Rudy Poels, who also used to teach film history: "It seems that men who stand in the limelight come across as sexy to women. Is that the case, Miss Mortenson?"

"Some men don't need to," snaps Starr.

"Come on Rudy," Cox replies. "That's an old cliché that has nothing to do with me. Let's take this opportunity to smoke the peace pipe."

"I don't smoke," says Poels bitterly.

The professor of English literature intervenes. "The minute you feel you have given a faultless performance is the time to get out."

"Charlton Heston," says Starr. She cannot take the hypocritical compliments and veiled allusions any longer and tugs at Victor's sleeve. "Come on, we're off. I need some fresh air."

Sunday, 2nd July 2000

Once again there is a woman in the house, which smells of love and coffee. She is sleeping in the room next door, her knees pulled up, and is sucking her thumb like Carroll Baker in Elia Kazan's *Baby Doll.*

Last night she cooked for me. And she brought two bottles of Dom Pérignon from her father's cellar and a lemon tart with sixty candles.

"I didn't buy you a birthday present," she said. "The present is me."

I found it comforting that she was with me, because no one from my distant family had thought of my birthday. After dinner she stretched out on the sofa and began to flick through a book about Hitchcock. I suggested that we watch one of his films.

"Not on your birthday," she said. "Let's play a game."

I opened the second bottle and asked what she had in mind.

"A strip quiz."

I filled the glasses.

"We choose a subject and ask each other a question in turn. If you don't know the answer you take off a piece of clothing. Like strip poker, but with questions. When I lived in New York it was all the rage with the students. Everyone played."

"You too?" I asked, and could hear her call my name in the cellars of Brooklyn, naked and powerless like the prey of panting oiled demigods.

"Of course."

"With my advanced years I think I'm a little too old for that kind of game."

I had not undressed in front of a woman for years. Even when, in a fit of absolute despair after the death of Shelley, I had brought one of the boozers home from the Candy Bar.

"Nonsense. Anyway, you'll win."

"Who says?"

"Let's smoke a joint. It will help you relax."

She lit a self-rolled cigarette and handed it over to me excitedly.

"Breathe in deep."

I drew on the cigarette. The smoke burnt my lungs.

"Have you thought of a subject?" I asked, coughing with streaming eyes.

"Hitchcock's appearances in his own films. For example *North by Northwest.*"

"Then my answer is: just after the opening titles he runs up to catch the bus but the doors shut in his face. And I keep my clothes on."

"That was an easy one. You can also give the answer and then the other player has to guess the title. OK?"

I handed over the cigarette and thought for a while.

"*To Catch a Thief.*"

"At the back of a bus Cary Grant looks at Hitchcock who's sitting next to him. My turn now. A small crowd is listening to a political speech when a drowned person is fished out of the Thames. Hitchcock, wearing a bowler hat, is standing among the curious onlookers who are trying to get a glimpse of the body."

"*Frenzy.* Now for a harder one. Hitchcock is winding a clock in a musician's flat."

Starr drew on the joint and frowned as she sucked the smoke into her lungs.

"No idea," she said and pulled off her sweater. She was wearing a white lace bra under which her dark nipples were visible. Her skin was pale white, with a beauty spot here and there. I took a drink of champagne, spilling some.

"*Rear Window.*"

"How stupid of me. *Strangers on a Train.*"

"When Guy Haines, played by Farley Granger, steps off the train he passes Hitchcock who is trying to get on with a double bass."

"See, you are winning!" she laughs. "And what's more my glass is empty."

I refilled her glass. She was flushed with excitement and her eyes were sparkling.

"Your turn," she said.

"*Rope.* Not easy."

In reply Starr fell back on the sofa, pulled off her new boots and socks and unbuttoned her jeans.

"In the background, against the façade of a building in the right of the picture, the famous drawing of Hitch's profile is flickering as a neon sign."

"I think I had better get used to being undressed! Another drag?"

I was feeling pleasantly light-headed and took the glowing butt.

"Wait… You got the double bass… Oh yes… which film is he carrying a cello in?"

"In *The Paradine Case*. He leaves the station next to Gregory Peck with a cello under his arm. Do you really want to carry on playing?"

"Of course. It's just starting to get interesting!"

"I know. At the start of the film he comes out of a pet shop with two little dogs."

"*Marnie?*"

"*The Birds*. Sorry."

"Here we go!"

She bounced up and wriggled out of her tight-fitting jeans. She spread her arms out and started to spin round the room on her toes. Her thong disappeared between her round, firm buttocks. Just like the advertisements in the bus shelters. I could not keep my eyes off her. She was even more beautiful than in my wildest dreams. There I stood with all my clothes on, embarrassed but trembling with desire after this perfect seduction, like Glenn Ford peeping at Gilda over half a century ago. Two more difficult questions and she would be standing there stark naked.

She stopped dancing and leant dizzily against the book-case.

"My turn. The film," she said breathlessly, "where he appears twice."

This time I didn't know the answer.

"*Under Capricorn*. The first time at the governor's reception, the second time on the terrace of his palace. You lost!"

I couldn't wait any longer. As I undid my shoe laces, I quickly asked the following question.

"In the newspaper that William Bendix is reading, he appears in an advertisement for the slimming tonic Reduco."

She undid her bra and let it slide slowly off her breasts.

"Come on Starr, you know the answer," I said, as I pushed off my shoes. "William Bendix only made one film with Hitchcock."

"I really don't know," she said defiantly, and flung her bra into a corner of the room.

I could hardly concentrate. My mouth was dry. Gasping for breath I stammered: "*Lifeboat*."

She refilled her glass, dipped her finger in the champagne, caressed her erect nipples and sighed: "I'm out of inspiration. You ask the next question."

"His profile appears as a silhouette behind a glass door at the Registrar of Births and Deaths and he makes an obscene gesture. Like this."

I stuck out my middle finger. She stuck it deep in her mouth – the mouth of Linda Lovelace – then pushed me on to the sofa. She came and stood before me.

"You must pull off my panties. It's the rules."

"First the answer."

She shook her head, smiling.

"*Family Plot*," I heard myself saying from afar, as I slipped her tiny panties down her legs. She had shaved her pubic hair. Full of emotion, I gazed at the gentle curve of her belly and lower down at the swollen apricot between her slightly parted legs. How had I deserved this divine spectacle? I who, married to loneliness, had my life behind me, who survived my fears and doubts from one day to the next as an exile somewhere on the frontier of banality and mediocrity, with nothing more to offer, for whom tomorrow had become a meaningless concept, for whom women had never been more than unapproachable apparitions, fleeting shadows on a taut linen cloth? There I sat, stoned and grey-haired in my drink-sodden body, dumbfounded and paralysed, and all I had to do was stretch out my hand to touch this flawless, shameless child of flesh and blood with my trembling fingers. God is a woman, I thought, and she looks like Clara Bow.

"You can take a bite," she said, softly stroking her groin. "No one else."

Then she walked over to the bedroom, turned round in the doorway and said:

"OK, Mr Cox, I'm ready for my close-up now."

I switched off all the lights and put on the soundtrack of *9½ Weeks*. I undressed in the dark and slipped into bed beside her.

"Admit you were cheating just now," I whispered.

"What did you think?" she replied and disappeared under the sheets.

To describe with the right words what happened last night in the room next door, you would have to be a writer. And I am not. The only thing I can say is that I wept for joy like a child under a Christmas tree.

14

Marion Mees

In the last week of August the Film Museum organized a retrospective entitled *Possessed by the Devil* devoted to expressionism, a spellbinding *tour d'horizon* of twenty years of German cinema. Starr and Victor attended several open-air screenings in the courtyard of the former Royal Palace. Tonight Georg Pabst's *Die Büchse der Pandora*, better known as *Lulu*, was on the programme. When they left the building, a lot of people turned round to look at Starr in amusement.

"You see how I look like Louise Brooks?"

"Especially tonight."

"In that scene where Lulu is gazing at herself in the mirror in the wedding dress as Dr Schön comes in to shoot her, I saw myself standing there."

"Well, Cox, are you with this young lady?"

Cox turns. Poels is standing behind him, extending a clammy hand to Starr.

"I can't see anything wrong with that," Cox replies coldly, preparing to move on.

"I was quite touched," continues the projectionist, unperturbed, "when I saw the two of you sitting there like lovebirds."

Poels turns his dull eyes on Starr, and stares at her penetratingly from behind his thick glasses.

"I'm an ex-colleague of your boyfriend. We have met before. At Victor's farewell at the Institute."

"I don't remember you," says Starr, omitting to shake his hand.

"Your girlfriend suffers from loss of memory. Not drink problems again, I hope?"

"Leave us alone, Poels. And don't be so pathetic."

"Me? Pathetic? You're the poor fool around here, Victor." Poels turns away and disappears into the crowd.

"What an awful guy," says Starr, shivering. "Bastards like that make my skin crawl."

"Just forget him, Starr. He's just frustrated because I became a professor while he's still a projectionist."

There's a brief pause. Then Cox says: "Are you hungry?"

"Whenever I see myself on screen."

"Feel like mussels? I know a restaurant where they serve mussels all year round. They must come from China."

It was a warm evening and Antwerp resembled Rome. They walked beneath an indigo-blue sky across the Meir to the Groenplaats, where they took a taxi to Docklands.

They sat down at a table at the back of the room. Starr lit a cigarette and looked at the collection of framed photos of partying guests to her left on the wall. She pointed at a black-and-white group portrait of Ma Mussel and her friends, posing next to the jukebox in sparkling paper hats, with their glasses raised.

"They don't look very happy," remarked Starr. "Just a collection of castaways. Especially that one in the black dress. Do you know her?"

Victor nodded, and Starr understood.

"Shelley?"

"No, Dixie."

"Well, darlings, looks like you enjoyed that," says Ma Mussel, clearing away the empty plates.

"They were delicious," says Cox. "Shall we have another bottle of Riesling?"

"My treat," says Starr.

As he watches the imposing behind of Ma Mussel disappear into the kitchen with the dirty plates and bowls of empty shells, he glances at the mirror behind the bar and catches the eye of The Sponge, who has stepped into the restaurant in the company of an extravagantly made-up blonde. The inspector walks over to his table and claps him on the shoulder.

"Mr Cox! Long time no see!"

"Some time last century."

"Who would have expected it? And at the scene of the crime, too."

Luyckx looks enquiringly at Starr, who is touching up her lipstick in the reflection of her knife blade.

"Let me introduce you," says Cox. "Starr Mortenson, one of my ex-students. Chief Superintendent Luyckx."

"And my name's Katia," says the blonde next to Luyckx, tugging down her extremely short strawberry-pink dress.

The restaurant is crammed full and there is not a table to be had.

"Come and join us," says Starr, moving her chair over.

Luyckx hugs Ma Mussel and orders a bottle of champagne.

"We've already eaten," he says, "I can't look at another mussel." He winks at his girlfriend. "Well, Professor, I have the impression that young people are having a positive influence on you. You look ten years younger since we last met."

"I'm doing my best to enjoy my retirement."

"And I'm looking after him," laughs Starr.

"I wouldn't doubt it for a moment."

"We went out tonight to see one of Pabst's films."

"There's no business like show business."

"I put on *The Seven Virgins of Draculanus* for Fons. It's still giving him a hard-on."

"Katia's from Poland," says Luyckx, as if that explains everything.

Ma Mussel brings the champagne and white wine and asks: "Will you really not eat anything, Spongey?"

Luyckx shakes his head and pours out the champagne.

"Superintendent Luyckx led the investigation into the death of Shelley," Cox says to Starr.

"I gathered that."

Luyckx raises his glass. "To your new-found youth!"

The opening bars of Beethoven's Ninth sound from his inside pocket and he apologizes.

"Hello? Yes... What?... Wait a minute, I can't hear you, it's too noisy here... Hang on a second."

The music coming from the jukebox – Lee Dorsey's 'Ya Ya Twist' – is so loud that he is forced to go outside to continue the conversation.

"That's better. Yes... The motel on the old motorway? I know, yes... Right now? At Ma Mussel's... Yes... I reckon half an hour... See you there."

Luyckx reappears in the restaurant and slaps a five-hundred-franc note on the table.

"Got a problem, Fons?" asks Katia.

"Just routine. You carry on without me."

"I wouldn't like to have your job," says Cox.

"You don't. Shall I drop you home?"

"No," replies Katia. "The weather's fine. I'll walk and maybe pull a few tricks."

The Babylon Motel was built in 1958 in the amusement park of the same name on the Antwerp–Brussels highway, and initially enjoyed enormous success. The promoters had managed to buy up for a song what was left of the monumental sets of D.W. Griffiths's 1916 film *Intolerance* and had it shipped over from Hollywood. If you set off from Antwerp for the capital it was impossible to miss the gigantic elephants, Persian columns, winged bulls and

Egyptian deities that stood by the road a little beyond Londerzeel. Tourists visiting the World Fair who did not want to spend a fortune on a hotel room in Brussels could spend the night there for a reasonable price. Despite that, after four years the business went bankrupt. It remained closed until the mid-Eighties. The abandoned estate was then purchased by a company from Maastricht and patched up. The new clientele consisted mainly of people from the Netherlands passing through the region, who could eat their own sandwiches in the dining room and park their caravans and mobile homes for a night among the ruins in the overgrown gardens. But for the last few years it had more or less been kept going almost exclusively by lorry drivers from Eastern Europe and strange travelling salesmen.

Nowadays there is little left of the amazing decor. And the motel is just a rusting carcass of glass and iron next to a long line of tumbledown bungalows. The blue neon sign over the entrance gate is broken except for the first four letters. In the distance Luyckx can see the word 'Baby' flickering in the night. He slows down, turns off to the right and drives carefully over sagging slabs of concrete to the poorly lit reception area where Lannoy and Sax are waiting for him.

"I hope we didn't interrupt your dinner," says Sax.

As he was driving to the Babylon Motel, Lannoy had given him a couple of details over the radio. The body of a young woman had been found at around half past twelve in the shower of bungalow no. 17 by the cleaning lady. Given the advanced state of decomposition, she must have been lying there according to Sax for at least seven days or so. She had been murdered with a kitchen knife. A real butcher's job. Sax had been able to count at least fourteen wounds on the visible parts of her body. All the evidence seemed to have been wiped away and they had not found a single item of clothing

in the bedroom. Luckily her notecase, with her personal documents, was lying under the bed. Her name was Marion Mees. She was single, a teacher and twenty-three years old.

"Is anyone in charge around here?" asks Luyckx.

"Yes, me," says an old, unshaven man hiding behind the bar clutching a bottle of brandy, whose belly is bulging out of an unbuttoned green-and-orange-striped nylon shirt.

"Are you the owner?"

"No – the nightwatchman… and the porter and receptionist. The owner lives in Maastricht and doesn't show up here much, hardly ever."

"But you're the one who registered the victim last weekend?"

"We don't have a register. The guests pay in advance and choose a room that's free. I give them a key and when they go past I can see them driving off from my booth."

"So you don't take down their names?"

"Definitely not when it's a couple, if you know what I mean."

"But you remember Miss Mees, I assume?"

"Who?"

"Marion Mees. The victim."

"Never saw her. Just the man who was with her. More or less. I'd had a glass or two too much and was lying there snoring when they came in."

"When was that?"

"Last Saturday. Don't ask me what time. But it was late."

"Were any of the other bungalows taken?"

"No."

"Could you describe the man?"

"I don't look too hard at the guests any more. He was pretty normal, I think. Not young. Not old either. We didn't say anything. He paid cash, I remember that. And because I find it hard to get up, he took the key off the table himself. An hour later I heard him drive off."

"Without bringing the key back?"

"They never do that."

"And you didn't go and check if everything was all right?"

"In the middle of the night? I'm not stupid."

"What sort of car did he have?"

"No idea. I only heard the engine."

"You managed to hear that," interrupts Lannoy. "But you didn't hear her crying out. She must have been screaming the place down."

"The telly was on and I was out for the count after my drink, like I said."

"Drop it, Luc. Have you been working here long?"

"I live here free of charge. Since I left the Foreign Legion."

"What's your name?"

"Mertens, Jos."

"If I've understood correctly, Mr Mertens, the room was locked all week?"

"Right. We've had a total of three guests since last Saturday so there was no need to open up number seventeen."

"Not even to clean it?"

"The cleaning lady only comes twice a month. Things are different nowadays."

"At night?"

"Yes. During the day she works at the soap factory."

"She's the one that found the body," says Lannoy.

"Where is she now?"

"She's lying down in number twelve. Her kids and old man are with her. She's in a state of shock. I couldn't get a word out of her."

"She doesn't say much anyway," says Mertens. "Her name's Turia Abdelkader." He winks at Luyckx. "Name says it all. I'm not a racist, don't get me wrong, but that tells you something, right? You want me to come with you?"

"You stay here, Mr Mertens, until I give you permission to move your fat arse."

* * *

84

"Do you suspect him, Sponge?" asks Lannoy as they go over to bungalow no. 17 with the gendarmes.

"A man with the brain of a dead sheep who buys his shirts in Albania is by definition suspicious."

"We've opened the windows because of the smell and to get the flies out," says one of the gendarmes. "Apart from that we haven't touched a thing."

Luyckx shivers with excitement and looks around. At the desolate landscape, at the rainbow patterns in the patches of oil on the tarmac, at the reflection of the blue neon sign in the puddles, at the overgrown ruins of the amusement park, at the highway where the traffic is rushing by.

"The fellow who lured her out here knew this place," he says and goes inside.

Despite the handkerchief he holds to his nose, the stench of rotting flesh grabs him by the throat. The bed has not been touched, indicating that the murderer's only intention was to lure her to the most forgotten place in Flanders and kill her safely and unseen.

The swollen corpse has fallen back into the shower. Her left foot has been gnawed to the bone by rats. Her back and right side display gaping, dry lacerations crawling with carrion flies. White maggots are creeping out of her open mouth.

"Not much blood," mumbles Luyckx into his handkerchief.

"It's as if he washed away the traces of blood with the shower before he went off," says Lannoy. "An absurd reaction."

"And no sign I suppose of the murder weapon?"

"No."

"Not outside either?"

"The technical service people can only get here tomorrow morning," says Sax.

"Lazy bastards."

"I'll take a few photos before they take her away."

"Please yourself. Did she have any family?"

"I wired through her identity. Still waiting for a reply."

"She wasn't a prostitute. But she followed the murderer here willingly. Which shows that she knew him."

"Shall we carry on the discussion in the fresh air?" asks Lannoy, gagging.

"The fucker must have left behind some finger prints when he tidied up the mess and took her clothes," says The Sponge, turning in the doorway. "What else did you find in her notecase?"

"Some money, a tram ticket, a receipt from the laundry, a couple of photos."

"Showing her with a man?"

"No. At first sight with her parents. And one with a young-ish woman in the Alps."

"Too bad. Where's the cleaning lady again?"

"In number twelve."

Turia Abdelkader does indeed look as if she has been struck dumb. She is lying trembling on the bed, staring with blank eyes at the ceiling. She is not even answering her children or husband. Luyckx says she should be sent to hospital for the night.

"She isn't sick," protests her husband.

"No, but she needs psychological attention. Do what I say, Mr Abdelkader, take your wife to the nearest hospital. I'll ask a gendarme to go with you and explain everything."

"And what shall we do with Mertens?"

"Have him stuffed and stick him in the entrance."

"Could you drop me at the Blue Note?" asks Sax. "If I don't play I can't get to sleep."

"Good idea," replies Luyckx. "I'll come and have one more drink with you. Luc, will you stay here until they clean up the mess?"

"Guess I'll have to."

"Do you know what we say in our country?"

"No, Mr Abdelkader. What do they say where you come from?"

"The first shall be last is what we say."

"We say the same thing in our country too," replies Lannoy.

15

Janet Leigh

Sunday, 27th August 2000

Last night saw *Lulu*, that gem of Georg Wilhelm Pabst's, for the umpteenth time. A magical open-air performance in the courtyard of the Royal Palace with live piano accompaniment by Sven Lambrechts. It was as if in a dream Louise Brooks was walking on the screen through the dark sets of Ernö Metzer lit by Arno Wagner while simultaneously sitting next to me caressing my knee under the sensuous star-lit sky. Brooks is the most beautiful, mysterious, sensual film diva of all time. Her lips incite you to murder, her eyes to revenge on ugliness, her breasts to the annihilation of everything that has nothing to do with love. The slightest hint that her nostrils are flaring or her eyelashes fluttering is like the promise of that fleeting moment of mental self-mutilation that precedes ecstasy. What man would not plunge into eternal damnation for one glimpse of her legs? Starr is right when she says that she would rather look like her than Clara Bow.

Cox is interrupted by the telephone ringing. It is Starr, asking excitedly if he has listened to the morning news.

"No. I was writing. Why?"

"Have you had breakfast?"

"Not really."

A quarter of an hour later she rushes into Cox's study with currant buns and the Sunday paper. He reads the banner headline: GRUESOME KILLING AT BABYLON MOTEL.

"Babylon Motel... That old heap in Londerzeel?"

"Yes."

She sits down on the edge of his desk, crosses those legs that go on for ever and starts to read out loud:

"The body of a brutally murdered young woman was discovered last night at the Babylon Motel in Londerzeel. The victim was naked and displayed numerous knife wounds over her entire body. She was discovered at about 11 p.m. by a chambermaid in the shower of bungalow no. 17. Initial findings indicate that she died a week ago. The Antwerp Criminal Investigation Department has identified her as twenty-three-year-old lecturer Marion Mees from Antwerp..."

"What!? Marion was one of my colleagues! She taught elocution at the Institute! You had classes with her in the first year!"

"I know. Feel like a currant bun? I bought them at Goossens."

"We were talking to her at my farewell bash, you remember? She had a warm voice and enunciated every syllable."

"I never liked her. I thought she was a pretentious cow."

"She was strict, Starr, and a little old-fashioned, that's all. But what was such a serious young lady up to in that godforsaken place?"

"Come on, Vic, everyone has their dark side, don't they?"

"Not Marion. I just can't believe it. Is there a picture of her in the paper?"

"Yes, here, on page three."

"Yes, that's her. How appalling... Have they any idea who was with her?"

"Of course not. Just like with the other girls, your friend Luyckx is fumbling in the dark."

"Now I understand why he had to leave so suddenly last night."

"Doesn't anything about it strike you as strange?"

Cox looks at her, shaking his head.

"What film does it remind you of? Motel, shower, knife wounds…"

"*Psycho?*"

"I'm amazed you didn't think of it right away."

"It must have been a random killing, perhaps, no… I just can't imagine it… I can still see her standing there in front of me."

The doorbell rings.

Starr gives Victor a currant bun, which he begins to chew on.

"You expecting anyone?"

Starr walks along the passage lined with old film posters and opens the front door.

"Superintendent! We were just talking about you!"

"That's nice. So Mr Cox is at home?"

"Yes. He's in a state of total shock."

Following Starr down the passage, The Sponge asks if she is living with Cox.

"No," she replies without turning. "I came round to bring him the paper."

Cox starts when he sees the policeman. It's as if time has stood still and events are repeating themselves. That strange feeling of déjà vu. The last time he had been in this room was 8th June 1998. It was about a dead woman that time, too.

"I see you already know all about it," says Luyckx. "So my visit will come as no surprise."

"On the contrary."

Luyckx looks at Starr, who stretches out on the sofa, and then at her photo, which is displayed on the desk next to Shelley's.

"I'm not interrupting anything, am I?"

Starr smiles, shakes her head and lights a cigarette.

"Good. I've just been speaking to the director of the Drama Institute, who referred me to you. It seems you knew Miss Mees well."

"No better than my other colleagues."

"It seems she had a bit of a crush on you. Apparently she was literally pursuing you after the death of your wife."

"You know, if you believe all the gossip you hear in class... Marion and I respected each other... on a professional level."

"Do you know if she had a relationship with anyone else?"

"We didn't speak about that kind of thing. But since she lived with her sister, I would be inclined to say the answer's no."

"A real goody-goody," interrupts Starr. "Why don't you tell the inspector about the resemblance to the murder in *Psycho*? It could be a clue."

"I'm not following you. Sorry, I haven't slept all night and..."

"Ever heard of a film called *Psycho*?" asks Starr.

"Yes, vaguely."

"Well," says Cox, "there are, as Miss Mortenson correctly observes, certain points of resemblance between the murder in the Babylon Motel and the manner in which, in the film, Perkins barbarically dispatches Janet Leigh in his motel. But it could be coincidence."

"Coincidence?" Starr jumps up. "In both cases the murder took place in the shower of bungalow number seventeen. There were twenty-eight knife wounds, exactly as in the film. And what was the name of the character played by Janet Leigh? Marion! Marion Crane! Coincidence?"

"A memorable scene," says Cox staring dreamily at the patterns in his Persian rug. "Janet Leigh was the star of the film, yet Hitchcock decided to have her killed at the beginning of the story, because the surprise effect on the audience would be all the greater. In his conversations with François Truffaut he told how Leigh did not want to take

her clothes off. That's why she keeps her bra on in the scene where Norman Bates spies on her through a hole in the wall, which today comes across as a little ridiculous. And for the sequence in the bathroom a stand-in was called in. We only see Leigh's face, hands and shoulders. And then to be sure that the private parts, the breasts, come into the frame, some shots were filmed subsequently. Hitchcock had a fake woman's torso made of rubber and filled with ox blood. But he never used it. In reality the knife never touches the actress's skin. It's all a question of montage. The shots took seven days. Seventy different camera angles. And all for forty-five seconds of film. A textbook example."

Luyckx turns yawning to Starr.

"So what you're saying is that Miss Mees's murderer deliberately copied the murder from this film?"

"Yes, obviously."

"But the question is: what did he intend by doing so?" says Cox, back in reality.

"I was just going to ask you that, Mr Cox. You're the specialist."

"I'm a film historian, not a psychiatrist."

"Right. And where was the film historian on the night of Saturday the 19th of August? Just a routine question."

"In my bed," replies Starr for him. "Or rather, I was lying in bed with him. In the bedroom next door."

Victor nods in embarrassment.

"My compliments, Professor. Just as well that Miss Mees never knew that," says Luyckx. He thanks Cox and takes his leave.

"I'll just see you out," says Starr.

Luyckx turns in the doorway. His look is icy. His breath smells of whisky.

"Whenever I talk to your boyfriend I come away having learnt something," he says quietly. "I bet you never get bored together."

"Never."

"Does he still talk about his first wife?"

"Sometimes. Her death affected him more than you think."

"I don't think anything. They call me The Sponge. And sponges don't think."

"They soak up the liquid they're dipped in... and swell up."

"And when they're full..."

"... you squeeze them dry again. To the last drop."

"Exactly," mumbles Luyckx.

"Why did you tell a lie just now?" asks Cox when Starr appears again in the room.

"To get rid of him."

"False witness. That can have serious consequences."

"He suspects you."

"That's just a professional disease. These people suspect everyone."

"He wanted to know where you were on the night of the murder."

"They check that automatically."

"He didn't ask me anything. What were you up to actually last Saturday?"

"Like Howard Hughes, I was lying with Janet Leigh in a king-size bed in the Chateau Marmont."

"Don't be silly."

"Everyone has their dark side, don't they?"

16

Debbie Marchal

Saturday, 13th October 2001

I'm staring at Starr. Or rather, at her framed photo on the table by the open door to the balcony through which you can hear the rumbling of the waves in the distance. Because she went to her grandparents' in Sweden a fortnight ago, I decided last Saturday to take a large room with a sea view at the Astoria Hotel in Koksijde. The building dates back to the late Twenties and has lost much of its former splendour. But what remains of the original decor still recalls the sets that Fred Hope and Hobe Erwin, the inventors of the "white telephone" look, designed for Jean Harlow and Wallace Beery in films like *Dinner at Eight*. I've always liked the coast in autumn, when the tourists have disappeared and I have the promenade to myself, and, like Dirk Bogarde in *Death in Venice*, I can drift aimlessly through the quiet streets of the abandoned resort. When Shelley was still alive I used to come regularly to this hotel, far from our domestic hell, for the weekend to gather my thoughts in peace. At that time I sought a kind of fulfilment in my unhappiness rather than baying for my lost happiness like a mad dog. Just like then, I can sit on my balcony at low tide staring at the ballet of the

seagulls on the endless beach and the grey breakers in the distance, until the horizon starts to dance before my eyes.

Starr and I have been together for one year now and this is the first time that we have been apart for so long. I miss her so badly that I have sprayed her unused pillow with Chanel No. 5 so that I can fall asleep each evening with her scent. She calls me every day and talks to me enthusiastically about the Deborah Kerr retrospective that she is visiting with Grandpa Mortenson at the Stockholm Film Museum. She says she misses me too. Tomorrow she will return. On the phone she sounded overjoyed when I suggested she should come and join me in Koksijde to enjoy the last tepid rays of this Indian summer together.

When Cox arrived at the hotel the previous Saturday, only a few other rooms were occupied. At this time of year the restaurant was closed in the evening, but for loyal guests like the professor, a fresh prawn sandwich was always available in the Bogart Bar, said Monsieur François, the concierge whom Victor had known for more than fifteen years.

"I think I would rather eat in my room," replied Cox, as he filled in the registration form.

"That's also possible, Professor."

He had his laptop and two bags – one with clothes, and another much heavier one with books – brought up to the room, and stretched out in a hot bath. As he was getting dried, he absent-mindedly watched the trailer for *Moulin Rouge* on television, then rang down to room service at about half past eight for scrambled eggs, some ham and cheese, and a bottle of Chablis.

When he had left the hotel the previous evening to have a snack at the Pearl of Peking, the Chinese restaurant just along the promenade, Monsieur François had reminded him that he had been there for a whole week without eating once in the bar. Nick the barman had even asked whether he had done anything wrong. Cox would have preferred to

wait until Starr was there before having dinner in the bar, but, so as not to offend his old chum Nick, he decided to go in and say hello.

Cox had to adjust to the semidarkness. All the lights in the bar had been switched off, apart from a copper lamp with a red shade at a rectangular table where two aged, deaf and dumb couples were playing cards together. A couple of candles were burning on the bar counter, their flickering light reflected in a silver ice bucket full of champagne corks. A cassette of the broken voice of Billie Holiday set the mood. Cox went to the bar and sat down on one of the velvet stools.

"The usual, Professor?"

"Yes please, Nick."

"The usual" meant a dry Martini with a green olive in a tapering glass. He never drank anything else in the bar of the Astoria. Not because he liked this cocktail more than any other, but because the drink went with the decor. Since taking early retirement, Cox felt increasingly at home in a fantasy world that evoked the bygone charms of the Twenties and Thirties.

"I was beginning to wonder," said Nick. "The Professor's been staying a whole week in the hotel and I still haven't seen him. That's not typical of him, I thought."

"Absolutely inexcusable of me."

Cox was just about to order a prawn sandwich when a woman of indeterminate age placed her mink stole on the stool next to him and sat down a little farther along the bar. He had never seen her before in the hotel. Her wavy dark-brown hair tumbled down over her bare shoulders. She was wearing a tight bodice in wine-red silk, pushing up pneumatic CinemaScope breasts, and a long evening dress in black organza, slashed high, so that he thought he glimpsed the curve of a thigh in the half-light. She removed an ivory cigarette case from her handbag, flicked it open, took out a Winston and turned enquiringly to Cox. She was

holding her cigarette just like Gloria Grahame, he thought. He could not imagine a more delightful introduction. Suddenly he was sitting in a chiaroscuro decor by Thomas Little opposite a femme fatale who seemed to have stepped out of a thriller by Henry Hathaway like a living cliché. A film noir icon who asks an unknown, mysterious stranger for a light in order to make his acquaintance. The sort of woman you could only imagine lit from behind and wreathed in plumes of smoke. He slipped off his stool, as lithe as Rick in *Casablanca*, and lit her cigarette.

"Thanks."

Her voice was deep and seductive. She inhaled with her eyes closed, threw back her head, pursed her shining lips and blew the smoke out in perfect rings towards the ceiling.

"You smoke just like Gloria Grahame," he said. "May I introduce myself? Victor Cox."

"Debbie. Debbie Marchal."

"Mr Cox knows everyone in Hollywood," said Nick.

"Really?" asked Debbie.

"I would be telling a lie if I maintained the opposite," replied Cox. "May I offer you a drink? Unless you are waiting for someone?"

"A whisky sour, please."

The prawns were forgotten.

"And I'll have another dry Martini. But as dry as you can. The way Buñuel liked them. So, Miss Marchal…"

"Debbie."

"Well… Debbie, what brings you to the Astoria Hotel in Koksijde out of season, all alone like this?"

"Which version would you prefer, the long or the short one?"

"We have all night."

She sipped her whisky and hesitantly, as if she had difficulty remembering the details, began an incoherent account of her failed career as a singer. She insisted it was because of her choice of repertoire, as she had a beautiful

97

voice and undoubtedly had some kind of stage presence. Her problem was that her songs were too sad. Even sadder than Billie Holiday's. In Spa, where she had performed for a time, they called her *La Chanteuse Cafardeuse* – the singer with the blues. What really put an end to her career occurred after she brought out her single 'Que c'est triste l'amour'. The disc was withdrawn from sale on the advice of the Ministry of Health because both men and women had been committing suicide after listening to the song.

"That doesn't explain why you are here this evening."

"I don't know… Perhaps, attracted by strangers who listen when I pour my heart out, I am unconsciously seeking out the most depressing places on earth. I'm probably trying to heal the wounds of the past…"

"Who knows, maybe the Professor with all his connections can do something for you," Nick blurted out, as he put a dish of peanuts on the counter.

"How come you know so many people in show business?"

"Oh… as an author, scriptwriter, and occasionally even actor you come across almost everyone in those circles."

"How strange to bump into a man like you in Koksijde."

"I often retreat to this hotel to write or think about new projects."

"That's why we call Mr Cox 'Professor', right Professor?" says Nick.

"What films have you been in?"

"They were just small roles, you know, to please friends."

"Go on."

"In Paul Schrader's *American Gigolo* for example I open the door of Richard Gere's Mercedes. In Mark Rydell's *The Rose* I play one of Bette Midler's roadies, and in *Elvis, The Movie* by John Carpenter I'm there in the band."

"Did you really play with Elvis?"

"Pretended to, of course… It wasn't the real Elvis. But that was in 1980, when you were still in kindergarten."

"Flatterer."

"Will you have something on the house?" asked Nick.

"What about a bottle of champagne?" Debbie suggests.

"Then it's on me," insisted Cox.

Debbie put her cool hand on Cox's. She was wearing loud, fake jewellery. Her long nails were varnished. Dark red like her bodice.

"You have warm hands."

"I always do."

"Perhaps they'll bring me luck. Stroking a hand that has touched so many famous hands. If I had met you before I would now be at the top," she sighed. "I assume you're living with a film star or something."

"Yes. Distantly related to Marilyn. I'm expecting her tomorrow."

"Does she look like her?"

"No, she looks like Louise Brooks."

"I don't know her."

As Nick was pouring the champagne, he waved with his free hand at the deaf and dumb card players who were leaving the bar.

"I don't expect we'll have anyone else in this evening," he said. "But if you prefer me to stay, no problem."

"No need on my account," said Debbie. "The Professor will look after me, won't you, Victor?"

"You are in safe hands, Debbie. Are you staying in the hotel?"

She takes another cigarette from the ivory case.

"I don't know yet."

Sunday, 14th October 2001

Last night I dreamt that I had landed in a film by Hathaway or John Sturges. I was sitting in a dark bar that resembled the bar of the hotel and met a mysterious woman in an evening dress posing as a singer. She claimed to know the saddest song in the world. I asked if she could sing it for

me but she refused. Too dangerous, she said. A number of people had committed suicide after listening to it. After sharing a bottle of Veuve Cliquot with her I could not resist the impulse to hear the fatal song and asked her again if she would sing it for me. It was late and the bar was empty. The barman and the last customers – four dwarves playing cards in the corner – had disappeared. She let her fur slip to the floor from her shoulders and stepped on her high stilettos over to the white piano. I sank back into one of the Chesterfields and lit a cigarette, perhaps my last.

As soon as the intro began I felt a lump in my throat. It sounded like the first 'Gymnopédie' by Satie, but more wistful. And then she started to sing with an incredibly deep voice. I can remember the first verse: "Much of what my heart yearns for today belongs to bygone days…" My eyes started to water. It was the most beautiful song I had ever heard. Through my tears I could see her mistily, rocking on the piano stool. I heard my heart beating loudly in time to the music. I had never felt so powerless, empty and miserable. Then the room began to tilt. I clung convulsively to my armchair, which seemed to be sinking away in quicksand. I felt nauseous and gasped for breath. It was as if I had ended up in a viscous whirlpool and was slowly drowning. I begged for forgiveness and mercy. But she sang on as if no one could hold her back now. After all, she had warned me. I had asked for it and now it was too late. I heard myself cry that I would rather die than listen to any more. Then I felt a sudden cold and woke up shivering.

It is half past nine. If Cox still wants to make breakfast he must hurry downstairs. Later he wants to reserve a table in Ostend at Mario's, an Italian restaurant on the promenade. Because tonight Starr will arrive, and life will begin anew.

In the lobby the atmosphere is charged. The entire hotel staff is present and despite the fuss it's really quiet. Chambermaids and waiters are standing around in little groups, talking softly to each other. Like in a museum or at a funeral. Gendarmes have been posted at the door. On the promenade several station wagons are parked with blue flashing lights. When Cox steps out of the lift everyone looks at him. The general manager of the hotel, in conversation with the concierge, gestures at him politely.

"What's going on?" asks Cox. "Are you expecting Sharon Stone?"

"If only," sighs the general manager. "Have you had breakfast?"

"I was just planning to."

"That's good. This way, please."

Cox does not understand. The GM takes him on to the veranda, where two men are chatting to the barman at a table.

"May I introduce Professor Cox," he says, "one of our oldest and most loyal guests."

"Superintendent Lejeune, Ostend Criminal Investigation Department. My colleague, Inspector Fontyn. Sit down, Mr Cox."

The superintendent remains on his chair like a beached whale as Cox shakes his hand. A cold, clammy hand.

"What can we serve you, tea or coffee?" asks the GM.

"Coffee please. Milk and sugar."

The GM walks over to the buffet, pours a cup of coffee, fills a tray nervously with croissants and *boterkoek* shortbread, which he sets down in front of Cox, and then takes his place at the round table.

"Thank you," murmurs Cox. "May I ask what all this is about?"

"We ask the questions, Mr Cox," says Lejeune in a tone of icy calm, chewing on a cigar that has gone out. "I know

that we are not in Antwerp, but that does not matter. Even on the coast the questions are asked by the police and not the other way round."

With his twenty-two stone, designer stubble beard, hippopotamus eyes and stains on his tie, he resembles Inspector Quinlan in Orson Welles's *Touch of Evil* and seems to belong more in Marlene Dietrich's dubious brothel than in the decorous breakfast room of the Astoria in Koksijde, thinks Cox.

"I never asserted the contrary," he says.

"Good. Nicolaas Vermeir, the barman here who is better known to you as Nick, told me that you spent yesterday evening in the hotel bar. Is that right?"

"I did indeed drink a couple of dry Martinis in the bar last night. I had planned to eat there too, but changed my mind."

"Alone?"

"Yes, alone. There was another guest sitting at the bar with whom I exchanged a few pleasantries, but I was alone."

"A beautiful middle-aged woman?" asks Lejeune, wiping the sweat from his forehead and neck with a dazzling starched napkin.

"She claimed to be a singer. Nick probably knows more about her. He talked to her for longer."

Cox holds Nick's eye as if to make him understand that he should keep quiet.

"She hadn't made it as a singer," says the barman hesitantly. "And because the Professor knows everyone in Hollywood, I thought he might be able to help her. But I saw that he wanted to be left in peace so I didn't insist."

Beautiful. Nick was the perfect barman. Discreet, an accomplice, deaf and blind.

"So you know many people in the film world?" asks Inspector Fontyn in an unexpectedly high voice.

"What on earth is this all about?" Cox asks the general manager.

"May I?" the GM asks Lejeune.

"Do as you please," mumbles Lejeune, trying to relight the stump of his cigar with a match and nearly burning his fingers in the process.

"Well… at about half past six this morning, before the dustmen came to empty the bins in the area behind the hotel, a certain…"

"Stan Larsky," says Fontyn.

"A tramp who regularly comes and looks for food in our dustbins smelt something in one of the containers. At first he thought it was a dead animal in a smouldering bin bag. To cut a long story short it was a dead woman wearing nothing but an expensive fur coat. Strangled. Half of her face had been burnt, as if the murderer had tried to set the contents of the container on fire, probably with the aim of making the body disappear and removing all the evidence."

"How awful," says Cox. "Was she one of the Astoria's guests?"

"No. But she was not unknown here. She worked as a high-class prostitute in the big hotels in the Ostend area. And last night she was sitting with you in the bar."

"Deborah Marchal, thirty-two years old. You are the last person to have seen her alive, Mr Cox. You're in deep doo-doo."

"She was sitting at the other end of the bar! Nick, tell them that I exchanged at most a couple of words with the lady."

"You're not going to pretend to me that she didn't try and pick you up, Professor," says Lejeune, scratching his unshaven cheek with long, yellow fingernails.

Cox starts to feel dizzy. It is as if he were being pursued by fate. For the third time in four years he is being interrogated by the police in connection with the murder of a young woman.

"Did you leave the bar together?"

"No! She was still sitting there when I went up to my room!"

"Is that right, Mr Vermeir?"

Nick hesitates and ponders. Now he must carry on with his lies. Anyway it was just to help his old chum Cox out of trouble – Cox, who wouldn't hurt a fly and whose girlfriend was arriving today.

"Well, I had just gone into the storeroom when the Professor was leaving and… When I got back to the bar again… he was gone."

"What about her?"

"Her too. That's normal. There weren't any more guests so no more tricks. Why would she stay?"

"Who paid for her drinks?"

"She did. There was a two-hundred-franc note on the counter."

"May we see your room, Professor?" asks Lejeune.

While Lejeune and Fontyn carefully search the bed, cupboards and even his bags, Cox sits in a wicker chair on the balcony and watches a mailboat in the distance approach Ostend harbour over a sea of quicksilver. He shuts his eyes and imagines Starr, leaning over the railings on the top deck, looking towards Koksijde at the Astoria Hotel, at the balcony of room no. 22.

"Professor?"

Cox recognizes Fontyn's icy girlish tone.

"We're done. At least for now."

"For now? But you were able to ascertain that I slept here alone last night."

"It smells of a woman's perfume."

"Chanel No. 5, yes. That's my girlfriend's perfume. I spray it on her pillow when she is not there beside me. To feel less alone."

"How romantic."

"It was also Marilyn Monroe's perfume."

"Another one of your glamorous girlfriends I suppose? For the time being you may not leave the hotel."

"How long for?"

"Until I have the results of the autopsy," says Lejeune, "and found out what perfume Deborah Marchal used to wear."

17

Deborah Kerr

"You could at least have met me at the station," says Starr, bursting into the room and chucking her travelling bag on to the bed. "I had to come all the way from Ostend by tram."

Cox explains that he is not allowed to leave the hotel because they found the half-charred body of a strangled whore in a dustbin in the car park behind the hotel that morning.

"You don't say."

"A high-class tart who picked up her clients in chic hotels along the coast."

"And what's that got to do with you?"

"Nothing."

"I hope you've got a solid alibi. I can't cover you this time."

"I ate in the room while I watched *Too Much, Too Soon* in which Dorothy Malone plays an alcoholic. But she reminded me too much of Dixie and I turned it off."

"That's the first time you've called her Dixie."

"Because the image of Shelley is fading away while I can see Dixie's more and more clearly. Perhaps because Shelley personifies life while Dixie means death."

"And what did you do next?"

"Then I fell asleep in your perfume and dreamt you were lying next to me."

"You call that an alibi?"

"Whatever it is, it's the truth."

Starr goes out to the balcony and turns her back to him. Cox gazes at her silhouette, framed against the pink sky. He walks over to her, puts his arms around her and kisses her on the neck.

"I've missed you so much," he whispers.

Starr turns round, looks at him with penetrating eyes and sticks her tongue out. Cox kisses her again, long and greedily on her young mouth.

"It's even better when you help," he sighs.

"Bacall to Bogie in *To Have and Have Not.*"

Cox calls down to room service and orders smoked salmon and prawn sandwiches and his traditional bottle of Chablis.

"Tell me about the Deborah Kerr retrospective in Stockholm. Was it worth the trouble?"

"Oh, Grandpa Mortenson has been secretly in love with her, I think, since he discovered her in 1950 in *King Solomon's Mines.*"

"Did you know that's the first film I saw as a child in the cinema? I was so excited that I peed in my pants and screamed the place down."

"It comes across as rather old-fashioned nowadays."

"Like me."

"Exactly, Old Vic."

"But you sounded quite enthusiastic on the phone."

"That was because Grandpa was standing next to me and I was hearing your voice. But I don't find Miss Kerr a particularly exciting actress. A bit of a cold fish."

"She does come over as rather detached. Until she surrendered to wild and unrestrained passion like in the beach scene in *From Here to Eternity.*"

"When she's making out with Burt Lancaster in the surf? Yes, that's something else. Shall we go swimming too? Look at the sunset! In a quarter of an hour it will be dark and the tide is right out. We can repeat the scene without anyone seeing…"

There was a knock on the door. An ancient waiter clearly suffering from Parkinson's disease shakily placed a laden tray on the coffee table and left the room like a twisting crab.

"And then we'll have dinner in bed. Shivering, with blue lips and knees, and sand between the toes, and salt on our skin, just like when we were kids, right?"

"I can't go out. The police are on duty. But if you want to, go ahead. I'll watch you from the balcony."

"I do really feel like it."

Starr goes into the bathroom, pulls on an oversized white bathrobe, and reappears with a bundle of towels under her arm, like an excited child that has never seen the sea.

"I'll be right back. Don't forget to watch!"

Cox gets his binoculars out of his bag, pours a glass of Chablis and takes his place on the balcony like a captain on the bridge of his ship. He watches her dance over the promenade and down the bluestone steps leading to the beach. The last time he had felt his heart beating so hard was when Harriet Andersson in Ingmar Bergman's *Monika* unbuttoned her cashmere jumper to reveal her Swedish shoulders.

Koksijde is famous for its sunsets, but he cannot remember as dramatic a sky as this since he presented Shelley with Karen Morley's earrings on the Hollywood hills in the previous century. He turns his binoculars on Starr, who is running to the sea through golden puddles on the abandoned beach. It's as if she can feel him spying, because at precisely that point she turns, flings her bathrobe and towels on to the ridged damp sand and waves broadly, with both arms like a windmill. She is so close and yet infinitely far, and the thought that this naked, carefree, young woman, bathing her perfect form in the dying rays of the sun, belongs to him and to none other, and that soon, between the scented sheets, he will be licking the salt from between her legs while the hotel falls asleep and the moon is reflected in the dark sea, fills him with an overwhelming feeling of undeserved happiness.

At the very moment that she ventures carefully into the foam of the waves, the sun is snuffed out on the horizon and it begins to grow dark. He can still see her indistinctly as she hops with her elongated body through the first billows and then dives into a large wave. And then her head comes up, and then a beckoning arm. And then nothing. It's too dark now to follow her any longer with the binoculars.

Cox leaves the balcony, lights the candles on the sideboard, slips the soundtrack of *Manhattan* into the CD-player, goes into the bedroom, stares at the old man in the mirror, and desperately sprays some aftershave over his hollow cheeks, wondering yet again whether this is all a dream and whether Starr really exists. But her panties and bra are unmistakably there, lying next to the toilet on the tiled floor.

When Starr still has not returned after quarter of an hour, Cox starts to feel uneasy. From the balcony all he can see is blackness. He can hear the terrific roar of the sea in the distance and, in the room that awaits her, softly, Gershwin's 'Rhapsody in Blue'.

I'll just wait another five minutes, he thinks, and then… Then what? He cannot leave the hotel. And it doesn't seem quite the right moment to tell the police downstairs that another woman has disappeared. He goes and stands on the balcony and calls her name into the night. The policeman pacing to and fro in the light of a streetlamp on the promenade looks up surprised.

"Anything wrong, Professor?" he calls.

"No," replies Cox. "I thought I saw a falling star. A falling star! A star!"

He goes back into the room and closes the balcony door and the curtains, as if to hide his confusion from the outside world. He breaks out into a sweat. He pours himself another glass of wine, sits down on the edge of the bed and tries to concentrate. It is now twenty minutes since Starr

disappeared. Why in God's name did he let her go? Just so that he could spy on her through his binoculars, like the eye of a camera, and possess her all himself. That's all. Because nothing gives him more pleasure than to look at her. "Don't forget to watch," were in fact her last words before leaving the room. She had provoked him and now he was to blame. No one goes swimming like that so late in October. Because no one can take more than ten minutes in that ice-cold water. But had he ever been able to refuse her anything? Perhaps Cox was worrying unnecessarily and she was long back, sitting frozen at Nick's bar with a mug of mulled wine. Starr is so unpredictable. That's part of her irresistible charm. There's no point in waiting for her up here any longer and he decides to go and look discreetly to see whether she is hanging around downstairs in the lobby or the bar.

18

Stanislas Larsky

Cox comes out of the lift, turns right and walks without looking up past a row of palm trees in copper pots to the Bogart Bar. The four card players from yesterday evening are sitting over a rubber of bridge at the same table in absolute silence, while Nick is buried in the crossword in *Het Laatste Nieuws* behind his empty bar. No sign of Starr: not in the bar, nor in the lobby where a couple of hotel guests are chatting in a desolate, wintry atmosphere as if nothing unusual had occurred in the last twenty-four hours. When he goes up to reception, Monsieur François puts down his book on bacterial infections in sea-water aquariums and asks what he can do for the professor. Cox asks whether the pretty young woman who left the hotel half an hour or so ago in a bathrobe has returned.

"I haven't seen anyone in a bathrobe, Professor."

"That's impossible," protests Cox, "I saw her myself from my balcony crossing the promenade and walking down the beach to the sea."

"I'm sorry, Professor. I was probably reading. But I would certainly have noticed a guest in a bathing costume in October."

Cox walks in confusion to the entrance. He must go out, down to the beach, with or without permission. He really doesn't care any more.

At that moment Lejeune and Fontyn appear in the hall.

"Mr Cox, I have good news for you." The superintendent takes him by the arm. "Shall we go to the bar? We'd be more comfortable there, I think."

Cox follows as if he is in a film but doesn't understand the screenplay.

"Two cold triple brews! And what will you have, Professor?" asks Lejeune.

"The usual," mumbles Cox.

"So one dry Martini and two Trappists, then," repeats Nick, disappearing behind the bar.

Cox looks at the clock hanging on the wall between two tempestuous seascapes. Starr has now been gone for more than forty minutes.

"You seem particularly nervous, Mr Cox."

"Nervous, me? No. Why?"

"Your hands are shaking."

"I've been confined to the hotel since yesterday."

"I owe you an apology and a drink. I was going to have you called in, but then I thought it would be more correct to come along myself. You have indeed not left the hotel, just as I asked, and we appreciate that. By the way, you have nothing more to fear. We have arrested the murderer of Deborah Marchal."

"And what's more, the victim wore a different perfume," says Fontyn. "Opium, by Yves Saint Laurent."

"And who murdered her?"

"Larsky, Stanislas Larsky, the tramp who claimed to have found her body."

"Stan?" asks Nick in astonishment, as he puts three glasses and a bowl of peanuts on the counter. "He was always a friendly chap. Last week, with the approval of the management, I gave him half a bottle of champagne that we were going to throw away."

"A friendly chap, but not with such a friendly past. Both the Hungarian and Austrian police have been after him and there was an international warrant out for his arrest."

"He was always perfectly pleasant to me," says Nick. "I felt sorry for him. He might have lived among the rubbish bins, but he was always well turned out."

"Yes, a real predator. Two gruesome murders of streetwalkers in Budapest, and three in Vienna. And now Deborah Marchal."

"And who knows how many other victims. This fellow has been sighted all over the country since 1995. Charleroi, Mechelen, Puurvelde, Antwerp…"

Cox empties his glass with a grimace and glances anxiously at the clock.

"They called him the Butcher of the Carpathians," adds Fontyn with a certain note of respect in his voice, "because as a rule he used a cleaver on his victims."

"And has he confessed?"

"We're working on it."

19

Federico Fellini

The moon is cardboard – a pale, pimply, pockmarked disc hanging by a slender thread over the surface of the sea as in the films of Méliès. Cox carefully descends the worn steps of bluestone leading to the beach and takes off his shoes and socks to walk across the loose sand. He feels dizzy after the seven dry Martinis he has drunk on an empty stomach in the Bogart Bar. Not having to pay for anything at the Astoria, Lejeune was having the glasses constantly refilled. It had been difficult to leave the super-intendent without awakening suspicion. He had finally used the lame excuse that he always enjoyed a stroll along the beach alone at night.

Lurching past a row of white-painted bathing carriages with large wooden wheels, he suddenly finds himself face to face with two little boys staring at him suspiciously in the moonlight. The smaller is about five years old, the bigger barely a year older. They are both holding on tightly to a shovel. The bigger one is wearing a short, white bathrobe, the younger has a similar one in dark blue with a white pattern and cuffs. They both look alike: the same jet-black hair combed forwards, the same dark eyes, the same fur-rowed brows. Too drunk to wonder what the children are up to so late at night all alone on the beach, Cox asks whether they have seen a lady coming out of the water in

a bathing costume an hour and a half ago. The children shake their heads.

Starr is an excellent swimmer. Moreover, she grew up in Sweden and is used to larking around in ice-cold water. So an accident can be ruled out, and Cox wonders whether she really did come to see him in Koksijde. But when he shuts his eyes he can see her standing on the balcony, coming out of the bathroom, running over the beach, waving at him from the waves, he can hear her warm voice, feel her tongue and smell her perfume. He cannot report her disappearance because just now in the bar he lied to Lejeune out of fear. They would suspect the worst for the umpteenth time, just as when he knocked on Luyckx's door on Monday, 8th June 1998 to tell him that Shelley had not come home. He opens his eyes again.

The two little boys have not budged an inch. Just like a photo from the Twenties. Apart from them he cannot see another soul on the beach. So they would have had to see her go by.

"A pretty lady with long legs and big black eyes and towels under her arm."

The older boy shakes his head again, without lifting his penetrating gaze from Cox.

"How long have you been here?" asks Cox.

"Don't know," says the older one.

"What's your name?" he asks the little one.

"Riccardo."

"Is that your big brother?"

"Yes."

"What are you doing on the beach so late?"

"We're playing."

"And what are you playing?"

"We're playing at being two little clowns who live in a sandcastle…"

"… And who save a rhino."

"And where are your parents?"

"In the Fulgor."

The name sounds familiar but Cox cannot place it.

"And where is the Fulgor?"

"In Kos… Ko… Koksijde."

"Did Mummy and Daddy ask you to wait here for them?"

"Yes."

"And are they coming to fetch you soon?"

"After the film," says the older child.

Suddenly, Cox realizes that he can no longer hear the waves breaking. In deathly silence he looks in the direction the roaring has been coming from. But the sea has disappeared, replaced by an endless, rippling plastic sail sparkling in the cold rays of a spotlight. He breaks out in a cold sweat.

"The sea in *Amarcord*," he mumbles.

He feels the eyes of the older little boy boring into him.

"And what's your name?" asks Cox hoarsely, although he already knows the answer.

"Federico."

The beach starts to spin, along with the blank façades on the promenade, the fake sea, the horizon, Cinecittà's plaster star-filled sky and the Méliès moon. Cox feels the world toppling over. He tries to turn and flee, but falls over flat on the fine sand, which fills his nostrils and mouth. The sand of the beach in Rimini. All his life he has dreamt of meeting Fellini, *il maestro*, the magus, the greatest director of all time. But not young Federico with his angry little mouth who is waiting with his little brother Riccardo for their parents Ida and Urbano until the show at the Cinema Fulgor is over!

He picks himself up and stumbles back to the bluestone steps. He staggers across the promenade and runs panting on his bare feet into the hotel.

"My goodness, Professor!" exclaims Monsieur François. "What's happened to you?"

"Nothing… I fell down the bloody steps. You can't see a thing out there."

"But it's a full moon. And what's happened to your shoes? Where are your shoes?"

"I'll go and get them tomorrow. Is the bar still open?"

"It should be. I haven't seen the card players come out yet."

"My goodness, Pro—"

"I know, Nick, I know. And I also know where my shoes are."

"No offence. Will it be the usual, Professor?"

"Actually I'll have a San Pellegrino and two aspirins."

"That should perk you up."

"You're not going to believe me, but I've just seen two children five years old or so playing all alone in the sand."

"Oh yes, Richard and Freddie. They're the children of the projectionist at the Meteor, the cinema just up the promenade. Their father works in the evening so they insist on going to the beach in the evening too. Our nightwatchman keeps an eye on them."

"What's the cinema called again?"

"The Meteor."

So why had little Federico been talking about the Fulgor then? The Fulgor was the cinema in Rimini where as a boy Fellini had devoured the films of Laurel and Hardy, Harold Lloyd and the Marx brothers every afternoon. Or had Cox just misheard? And why did they claim not to have seen Starr? And in that case who was the young woman he had seen disappearing into the waves?

He suddenly feels bushed. He swallows his pills and empties his glass.

"I'm going to bed."

"It's been a long day, Professor."

What immediately strikes Cox as he enters the room is that Starr's travelling bag has disappeared from the bed. The clothes that she dropped on the bathroom floor have gone too. And the bathrobe is hanging neatly on the hook

next to the mirror again. She probably came to pick up her things while he was downstairs in the bar with Lejeune and Fontyn, gnawing away at his fears. She must have been cross that he hadn't waited for her, and decided to leave the hotel behind his back by the service entrance to catch the last train back to Antwerp. She was already out of sorts because he hadn't met her at the station. Starr was capable of anything.

Exhausted, but relieved that she is still alive, Cox drops on to the bed. He clutches her pillow and falls asleep with the taste of iodine in his mouth.

That night Cox dreams of Sylvia, the monumental woman bathing in an evening dress in the silver cascade of the Trevi Fountain in Rome while Guido Anselmi sits behind the misted-up windscreen of his car in a deafening traffic jam while La Saraghina in an extremely obscene gesture spreads her superb dark thighs and squatting among the rubble behind a bunker pisses on the ground while Encolpio fights the Minotaur in broad daylight while Toby Dammit blind drunk crashes in his blood-red Ferrari while Zampanò in the depths of despair murders the lover of his wife Gelsomina while Wanda dresses up as a slave girl out of love for the white sheikh while a gnarled Holy Father appears as a neon icon in the sky above Los Angeles while the liner *Rex* with its sirens bellowing looms out of the mist on its return voyage from America while Casanova sodomizes Sister Maddalena in the musty corridors of her convent while the ashes of the deceased opera diva Edmea Tetuo are scattered in the sea off the island of Erima while Ginger and Fred dance one last convulsive step while Orlando, in a lifeboat, tries to rescue a rhinoceros after the shipwreck of the *Gloria N* on an ocean of plastic, just like the children of the Meteor's projectionist on the beach tonight.

20

Farley Granger

When Cox wakes up the next morning with a headache, he is lying across the bed, still fully clothed. He rubs the sand out of his eyes, hauls himself up laboriously and looks around in a daze. Starr has left nothing behind, no farewell letter, no short message in lipstick on the bathroom mirror like she used to do. If the belt on the bathrobe had not been missing he might have thought that she had never set foot in this room and that everything since his fatal encounter with Debbie Marchal had been a dream. To tell the truth he hadn't really looked. Perhaps the belt was already gone when he arrived at the hotel.

There is no point in hanging around Koksijde any longer. He calls reception to ask for the bill and leaves a message on Starr's mobile saying that he is not cross, that he understands, that he was worried yesterday that she had been gone for so long, that he had gone to look for her, that he was coming home and that he loved her.

"Are you leaving us already, Professor? I hope it's nothing to do with that awful business," asks Monsieur François as he hands Cox his bill.

"No. My girlfriend couldn't stay any longer and asked me if I wanted to come to Antwerp to help her with an audition."

"Is she going to be in a film?"

"There's a good chance."

"I'm really sorry I wasn't able to meet her."

"You must have seen her walk past a couple of times yesterday. A very young woman with a Louise Brooks hairstyle."

Cox pays with his Visa card and waves to Nick, who is rinsing glasses.

"I'll bring the car round," says Cox.

"And I'll have your bags brought down. Don't forget your shoes on the beach, Professor."

His socks have blown away but his shoes are still lying in the spot where he came across the two little boys the previous evening. The sea is out again and before he returns to the hotel he strolls across the expanse of sand to the breakers where he saw Starr walk into the water. In the distance a rusty tanker slides across the horizon.

Five minutes later Cox is standing in the hotel car park with his shoes in his hand. Apart from a Scandiafish rental vehicle the area is empty. His car, which he parked here the previous week, has disappeared.

"That's never happened before," says the concierge in dismay. "It's as if somebody up there doesn't like you, Professor. If I was you I would report the theft to the police right away. For the insurance. Unless..."

"Unless what?"

"Unless your girlfriend went off with the car."

Why hadn't he thought of that before? When they went out together it was usually Starr who drove; he had given her the spare key himself. But she must have been in a really bad mood to do something as mean as that. It was time to sort all these things out and make up.

"I don't know what's the matter with me lately," says Cox, "but I'm beginning to forget things. I did in fact suggest that she should take the car."

Cox just manages to catch the crowded 11.43 train and finds a seat opposite a suntanned man aged about thirty.

He is immediately struck by his old-fashioned black-and-white shoes. Buried in the *Sunday Times* sports pages, he doesn't even look up when Cox jostles his feet as he sits down. As the train sets off sluggishly, Cox tries to remember where he has seen him before. Because those smooth features, that rugged chin, that straight nose, those chiselled lips and that shiny combed-back hair do seem familiar. On the seat next to him are two tennis rackets in a grey cover embroidered with the initials G.H. Cox runs through every famous tennis player in his mind but cannot think of any whose name would correspond to the initials G.H. It's not that important, he thinks, and looks out of the window at the polders, the reclaimed land of the Low Countries, covered in mist and sliding past like a painted set. Again and again the same willows, the same brickwork farmhouses, the same ponds in the same pastures with the same dappled cows. Nothing will send you to sleep faster than the Flemish polder landscape viewed from the Ostend–Antwerp train. Just before the train reaches Jabbeke, Cox nods off.

He has barely shut his eyes when he suddenly realizes who the man opposite him is: Guy Haines, the English tennis champion in Hitchcock's *Strangers on a Train* whose wife Bruno Anthony offers to murder if Guy kills his father in exchange. He looks exactly like the actor Farley Granger and the initials on the cover match too. The train slows down and stops at the little station in Jabbeke. Cox pretends to be asleep and hardly dares move. Around him he can hear the bustle of travellers leaving and entering the compartment. As soon as the train sets off again he half-opens his eyes. Opposite him, where Guy Haines had been, a nun with round glasses and plump, veined cheeks is sitting, looking at him with a friendly smile.

* * *

"Hello Mrs Kountché," says Cox, happy to be back in the real world.

"Hello, Mr Cox. How was it in the elephant?" asks his Nigerian neighbour.

Cox smiles. The fantasy about living in an elephant has obviously made an impression on her.

"I'm not coming from the elephant, Mrs Kountché. I went to the coast for a few days to do some writing."

"That's what I thought. Our neighbour's been gone a long while this time, I thought."

"You haven't happened to see whether my girlfriend has brought my car back, have you?"

Normally nothing in the neighbourhood would escape Mrs Kountché. If Starr had come by she would surely have noticed.

"I haven't seen anything, no. But I haven't had much time because my family has come to visit. My sister and her husband and her six children."

"Well then, you've got your hands full! Take care," says Cox, collecting the bills and junk mail from the overflowing letterbox.

The house smells of old books and Cox opens the windows in his study to let in some fresh air. Then he listens to the answering machine in the hope of hearing Starr's voice. But there is only one message. The chairman of the High Noon Film Club is asking him to get in touch about a lecture on eroticism in the works of Hitchcock.

21

Sandy Misotten de Landshove

For days, for months there was no sign of life from Starr. Cox was inconsolable and virtually stopped seeing anyone. Because she did not answer the phone, he went to her door every day for the first few weeks. But it was as if the apartment was empty and the whole Mortenson family had left the country in haste. He sought out every cinema, café and restaurant where they had passed the most beautiful hours of their lives together, but to no end.

On Thursday, 14th March 2002, precisely five months after Starr had disappeared, he received a phone call from the police station in Hoboken to enquire whether his car had been stolen recently. He replied that he was not sure and so he had not reported it. The inspector did not understand and asked him to explain.

"It's possible that my girlfriend took the car," Cox mumbled into the phone.

"What do you mean, don't you know whether she did?"

"The problem is that we have lost touch with each other."

"Well, the border police recovered your car in a depot. It was with dozens of other stolen cars waiting to be loaded on board. You can pick up your vehicle from today from the Antwerp police pound in Hoboken."

And that's what he did. He climbed into his car and saw her, sitting radiant with happiness in her place at the

wheel. It was as if he were diving down once again into the twilight of his inevitable dream. As he drove home along the quayside he thought back to that day when he stood in the Astoria Hotel car park in Koksijde and could not find his car. The day when his life had collapsed again into loathsome mediocrity.

The lurid setting sun slanted across the filthy windscreen. Turning a corner, he thought he could decipher a message scraped in the muck on the glass just as you sometimes think you can make out a face in the clouds, white letters on a dull grey background. *I'm asking you to marry me, you little fool.* The words spoken by Eugene Pallette to Margery Wilson in the silent film *Intolerance.* The words he had wanted to whisper in the ear of Starr if she had woken up beside him on that fatal Monday morning.

This decrepit old car, scratched and filthy, was his last absurd link with the woman who had made him forget the hell he had been through with Shelley, and also his only hope of ever seeing her again. But instead it turned out to have been no more than an ordinary theft, and as a result Starr's disappearance suddenly seemed irrevocable. Irrevocable and incomprehensible. Nothing had suggested that their relationship would end so brutally. He found it hard to imagine that the trivial quarrel about his not picking her up at Ostend was a reason for them to part. Sometimes he wished that she was dead. Nothing was more unbearable than the feeling of betrayal, than the doubts and uncertainty with which he had been living for months.

On the night of Thursday, 16th May 2002, after sitting up late and working hard on his lecture on eroticism in the films of Hitchcock, he was lying numbly on the sofa with a bottle of port watching William Dieterle's *Love Letters.* In the middle of the scene in which Jennifer Jones murders her lover Roger Morland after discovering that he is anything but the charming man his love letters imply, there was a ring at his door. For months now he had not received any

visitors and was not expecting anyone. Who else but Starr would come to visit him unannounced in the middle of the night? That's what she used to do. At impossible times. She would creep, silent as a cat, between the sheets and he would pretend he was asleep and had not heard her slip in. Until he felt her tongue on his neck and she stroked him awake and he turned over moaning to embrace her in the darkness.

He springs up, knocking his glass over, runs with beating heart down the hallway and opens the front door. Luyckx and Lannoy are standing there. This is it, he thinks, they've found her. He prepares for the worst.

"Sorry to bother you so late, Mr Cox, but we saw the lights were on and thought…"

"No problem, I was up working. Come in."

The Sponge and his partner follow him through the hall to the living room and sit down next to each other on the sofa. On the television screen Allen Quinton, the true author of the letters, is visiting Jennifer Jones in prison. Cox switches off the video player and asks if they would like a drink.

"Just a beer."

"Me too," says Lannoy, looking at the spilt glass of port.

Cox fetches two Stellas from the fridge and starts trembling violently. They don't dare tell me the truth, he thinks.

"Are you alone?" he hears Luyckx ask in the living room.

"Yes, I'm alone," he replies, handing them the bottles. "My girlfriend and I don't really live together. Young people nowadays are more prudish than you think."

But Luyckx's question reassures Cox somewhat.

"Did you watch the news tonight, Mr Cox?"

"No. I was working on a lecture. On eroticism in Hitchcock. What strikes me is that he stages love scenes as murder scenes and vice versa."

"Interesting," says Lannoy.

"So you probably don't know why we're here?"

"No."

"Does the name Sandy Misotten de Landshove mean anything to you? Baroness Sandy Misotten de Landshove, to be precise."

"A baroness? No. Why?"

"Because we found your name and telephone number in her address book."

"It must be a mistake. I don't mix in aristocratic circles."

Lannoy digs out a black leather address book and opens it at the letter C.

"Here. Professor Cox – tel. 03 233 0976. That's your number, isn't it?"

"That's right."

"They found her body this morning in the greenhouse of her chateau."

"I have never heard of the baroness."

"Right. But of five women murdered since 1995, you knew three of them: your wife, Marion Mees, Deborah Marchal. And now Sandy Misotten."

Nothing had suggested that they would end up at Cox's again that night when Luyckx and Lannoy drove through the impressive gates of the mist-wreathed estate of de Landshove at around ten o'clock on Thursday morning. Baron Frans Misotten de Landshove, the owner of the Multipress & Co. media empire, was standing on the steps of his chateau as straight as a poplar tree waiting for them. He was a tall, elegant man of about seventy, with silver-white hair and ochre-coloured hawk eyes. The sort of personality who, even as he steps out of his helicopter, seems to have been born in the wrong century. In fact he had landed in his private plane just an hour earlier on the field behind the stables after spending the past week chairing a conference in Barcelona on the regulation of Chinese paper imports. He was extremely well-bred, spoke with few words and was finding it difficult to hide his emotion, despite his

self-control. He led Luyckx and Lannoy in silence over the spotless gravel paths between rows of rhododendrons to the greenhouse, where the gardener had discovered the body of his wife when he went to pick up his tools at about half past seven. In the distance, on the edge of the forest of oaks, a flock of sheep was grazing in the mist. On a lake somewhere wild duck were quacking.

"You must excuse me, gentlemen," he said in a weary voice, "but I would prefer to remain outside. I fear I do not have the strength to see her a second time."

"We understand, Baron Misotten."

"When you need to sign the papers you'll find me in my cabinet of curiosities. The butler will show you the way. Our family doctor, Dr Leenaerts, who has certified the death, is waiting for you in the greenhouse. Together with Jules who found her this morning. I'll see you later."

When the de Landshove family doctor, choking, draws back the sheet from the naked body, The Sponge remains lost for words. The main thing that strikes him is the age of the victim. She could not have been more than twenty-five or so. Dr Leenaerts noticed Luyckx's confusion and said: "Sandy was Frans's second wife. They had not even been married for one year. My God, what have we done to deserve this! The world has gone mad, Superintendent, quite mad!"

"How old was she?"

"Nearly twenty-six. I know the difference in age shocked some people, but you will have noticed that Baron de Landshove is a man of exceptional character. The two were really in love. He hasn't given any sign, because the de Landshoves do not display their feelings, but I fear he will not survive this drama. There are injustices in this life that can fell even a mighty oak like Frans, believe me."

She was not only young, but strikingly beautiful. The type of woman you only see in glossy magazines and wonder whether they really exist. She was lying on a bed of rotting

127

leaves, with her arms and legs spread. Her mouth, her cheeks and her forehead had been smeared with haphazard, brutal smudges of lipstick. The murderer had drawn two circles around her nipples with the same lipstick and on her taut belly a red arrow pointed from the navel, where a diamond sparkled, to her close-shaven pubic hair.

"What are your initial conclusions, Doctor?"

"I'm not a pathologist, but the blue welts on the neck suggest to me that she was strangled. Probably with the garden hose."

"Raped?"

"There's not the slightest doubt about that."

"Any trace of her clothes?"

"I found madam's clothes behind the greenhouse in the rhubarb," said the gardener, who up until then had been standing some distance away with his hat in his hands. "I think that… it… must have happened in the kitchen garden because a whole lot of plants have been trampled there. Leeks, parsley, radishes. The kitchen garden was madam's domain. She was busy there every day. This year she planted fennel for the first time."

"How long has she been dead?"

"I'm not an expert," replied the doctor carefully. "But I would say about six or seven hours. I saw Frans's first wife go, Superintendent, bone cancer, she suffered terribly and was not even sixty. He was with her up to the last minute and was inconsolable when she died. Instead of shutting himself up and pining away, he threw himself into his work. Ten years later he met Sandy, and rediscovered his zest for life."

"I guess anyone would," remarked Luyckx laconically.

"It is Frans's wish that this case should give rise to a minimum of publicity. The family cannot permit a scandal, not to speak of the need to protect the shareholders of Multipress."

"We will do the best we can," sighed Luyckx, "although we cannot avoid the normal procedures. Lannoy, call the

duty officer and the technical service and ask Sax to come down. No one must touch anything. Including you, Doctor. With all this coming and going we've lost every footprint as it is. Jules, have you by any chance found the lipstick?"

"No, Superintendent, but I did find something. Come and have a look."

Luyckx and Lannoy followed the gardener outside. He pointed at one of the rectangular windows of the greenhouse, on which someone had written in lipstick: CATCH ME OR THERE WILL BE ANOTHER MURDER.

Luyckx, who until now had not succeeded in establishing any logical connection between the different murders of the young women, was now certain that he was dealing with a serial killer who had been striking since 1995 and who was now becoming uneasy because he had still not been exposed. It was the first time the perpetrator had made an attempt at dialogue. Fairly normal behaviour for the sort of psychopath that wants recognition and needs a game of cat and mouse with the police to enjoy their atrocities to the full.

"Where were you last night?" Lannoy asks Jules.

"At home. I don't live on the estate and only get here around seven in the morning."

"Do you live alone?"

"No. With my brother Romijn."

"Do you have any further need of me?" asked Dr Leenaerts.

"Not for now, Doctor."

"Shall I have her transferred to the funeral chapel?"

"No thank you, our people will be coming along to pick her up and take her to the lab for the autopsy."

"An autopsy, how awful... I don't know whether Frans will agree to that. Just the idea that her body is going to be cut open..."

"I'm afraid that it's not up to him to decide."

Luyckx has another quick look at the kitchen garden, while Lannoy starts to work his mobile. Three or so beds

had been destroyed and the soil churned up. That showed that Sandy Misotten had resisted the rapist desperately and that there had been a violent struggle. Her clothes – a loose white cotton Ralph Lauren skirt and a beige T-shirt – had been torn to shreds and were lying a little farther away, stuffed among the rhubarb. Her Gucci boots lay on the dung heap, as if her attacker had flung them away. However, Luyckx could not find a single trace of underwear. Either the murderer had taken her knickers and bra with him as trophies, or she had been wearing nothing under her clothes.

Luyckx asked Lannoy to wait for their colleagues in the greenhouse, while he talked to Frans Misotten. The press baron was waiting for him in his cabinet of curiosities. He was standing motionlessly behind an overflowing desk in a dust-filled beam of light, staring out of the window. The cabinet stood in the west wing of the chateau. It smelt of beeswax and camphor and was filled with the most diverse objects that Misotten had inherited from his father and grandfather, had brought back from his travels or acquired from antiques dealers or at auctions. Stuffed apes, tigers and birds of prey, the empty, waxed shells of giant tortoises, the bleached skulls of rhinoceros and hippopotamuses, jars full of strange shells, foetuses, serpents, frogs and salamanders in preserving fluid, bowls full of petrified eggs and fossils, baskets full of coral, ostrich feathers, heaps of minerals and crystals, display cabinets full of butterflies, beetles and dried sea horses, an enormous illuminated globe, hunting trophies, old copper measuring instruments, a human skeleton, herbaria, exotic fabrics and jewels, animal skins, weapons, microscopes, daggers, bows and an outsized photograph of the baron himself in a tropical uniform standing among pygmies.

"This is the place where I savour my triumphs in silence and can hide my tears," he said when The Sponge was led

in by the butler. He did not turn round and remained for a while gazing out of the tall windows at the oak trees swaying in the wind. "The room where I guard my treasures, my secrets and my sorrow."

The decor reminded Luyckx a little of the Africa Museum in Tervuren which he had visited years ago on a school trip.

Frans Misotten turned and said: "Sandy never came here. She loved life, and in this room everything is dead. Now she too will be part of my collection. Just like the old nobility, the genuine old nobility, which now belongs only in a cabinet of curiosities."

"You have my sympathies, Baron Misotten."

"I do not expect any feelings from you, Superintendent, but I do expect you to find the monster who murdered Sandy and destroyed my life. Nothing more, nothing less. I am at your disposal."

"I won't trouble you for long. Just a few routine questions."

"Go ahead."

"Did you and your wife receive any kind of threat recently?"

"Not that I'm aware of, no."

"And did madam have any personal enemies? Out of envy, for example?"

"Sandy had only friends."

The Sponge studied the slim old man, who with dignity and a minimum of visible emotion was praising the *joie de vivre* of his murdered wife. It was clear that Sandy Misotten had many friends. She was young, beautiful, rich and, for good measure, had a pleasant character. In a word, she was suspiciously perfect. But why had she married this press baron, who lived like a fossil among his fossils, unless it was for his fortune and title? Something or someone was missing from her too happy story.

"Where and when did you meet her, if I may ask?"

"Three years ago. At the Raamtheater in Antwerp, at the premiere of Arthur Miller's *A View from the Bridge* in which Sandy played the role of Catherine. The production was sponsored by the Multipress Foundation, of which I'm the chairman. After the performance I went to congratulate her with a few prominent members of the foundation. I felt immediately attracted to her, but she was so young, so fresh, so flawless that I dared not imagine that it could be reciprocated."

"So Sandy was an actress?"

"After our marriage she gave up her career to devote herself completely to the management of the estate. She is irreplaceable."

"Did she remain in contact with artistic circles?"

"Of course. At our receptions. The de Landshoves are well known as disinterested patrons of the arts and sciences."

"Have you any idea what she was doing in the kitchen garden last night?"

"She lived, as it were, in a symbiosis with nature. She spoke to the plants. The scent of dew on young spinach, the softness of a young pea in the palm of her hand, could move her to tears. Sandy was an exceptional being. A gift of the gods. There won't be an autopsy, I hope."

"We can't avoid that. It would only create suspicion."

"A de Landshove is above all suspicion, Superintendent."

Luyckx found it unnecessary to prolong the conversation with this arrogant old bore. He quickly and politely took his leave and asked him not to leave the country for the time being.

"As if I feel like travelling now," came the curt reply.

Lannoy was downstairs waiting for him. Under Sandy's rumpled clothes he had found her handbag with her mobile and address book.

"Two items that are absolutely necessary when you go gardening at night," said The Sponge, clearly out of sorts

after his discussion with the baron. "Is there anything in them that's worth looking into?"

"Hundreds of names, addresses and phone numbers. We've got our work cut out."

"It's not that late, Mr Cox. I do have a couple of questions," says Luyckx. "But can I first take a slash? I'm bursting." He is visibly clenching his buttocks. It's not the first time in his career that The Sponge has used this trick.

Cox shows him the way to the bathroom.

On the mirror above the basin Luyckx sees the words NO SALE in red lipstick. The Sponge takes out his penknife and scrapes a few centimetres of the letter L off the mirror, smears the lipstick on to a piece of toilet paper which he folds carefully and puts in his trouser pocket. He flushes the toilet and searches the cupboards. In a drawer he finds a pair of black lace knickers, which he also puts in his pocket. There's no business like show business, he thinks, and makes his way back to the living room.

"To get back to the address book…"

"How many times do I have to tell you that I have no idea how my name and telephone number ended up in the address book of some elderly baroness."

"Elderly baroness, you say? Sandy Misotten was barely twenty-six."

"A real babe, believe me," adds Lannoy.

"Some young women fall for more mature men – you should know."

"She used to be an actress."

Cox frowns.

"Do you know her maiden name?"

"I've noted it somewhere," says Lannoy. "Here you are: Michiels, Alexandra Michiels."

"But I do know her! I had an Alexandra Michiels in my class. She was in the Department of Theatre Studies. She

graduated in 1997. Very talented. Very attractive too. A real 'babe', as you say. But I didn't know she had got married to this old Misotten."

"Did you ever meet her again after she had finished her studies?"

"I saw her acting a couple of times. She would sometimes invite me to a premiere. That's why she had my number, I assume."

"When was the last time you saw her?"

"Two or three years ago. When Starr and I went to a performance of *A View from the Bridge*. Alexandra played a brilliant Catherine. Less melodramatic than Carol Lawrence in Sidney Lumet's film version. Couldn't her husband be the murderer?"

"Baron de Landshove was in Barcelona last night. And where were you, Mr Cox?"

"Here."

"Alone?"

"With Hitchcock."

"And did Hitchcock write those nice words on your bath-room mirror?"

Luyckx notices that his colleague is looking at him mysti-fied.

"In lipstick, if I'm not mistaken."

"That was my girlfriend. She always used to do that."

"*No sale*. What did she mean by that?"

"I haven't been able to make sense of it so far. It's a game. It has something to do with a film."

"She didn't happen to leave her lipstick here?"

"She never left… she never leaves anything here."

"Whose are these then?"

Luyckx produces the lace knickers.

"You're really going too far now! You've no right to go nos-ing around in my cupboards without a warrant! Give them to me! That's a personal memento! A present from Starr."

"We'll have to look into that."

Luyckx presses the knickers to his nose and sniffs.

"But in any case they don't smell of Chanel No 5."

"I can file a complaint about this."

"You'll get them back, Mr Cox, but for now I'm adding them to the evidence in the Misotten case."

"What in God's name does Starr's underwear have to do with the Misotten case?"

"We couldn't find Sandy's knickers," says Lannoy, as if he has known the young baroness for years. The first bars of Beethoven's Ninth sound from his jacket pocket.

"Lannoy here. To who?… Yes he's sitting next to me."

Lannoy hands the mobile to The Sponge.

"Luyckx speaking… Yes… What?… When… Yes… You don't say!… Are you already there?… Good… Make sure no one touches anything… Twenty minutes."

"Who was that?"

"Dr Leenaerts. Misotten has shot himself through the head with a hunting rifle in his cabinet in front of his life-sized photo while listening to the national anthem. The good family doctor was woken half an hour ago by the shot and discovered the bloodbath. And wait for this: Leenaerts was in bed with the butler who'd been his lover for years. Mr Cox, you can go to sleep now."

22

Gloria Wandrous

On Thursday, 6th June, Cox is watching a panel discussion in which Superintendent Luyckx, a gendarmerie colonel, an American criminal profiler, two legal experts and the Minister of Justice are talking about the five unsolved murders for the first time. He learns that since 1995 in connection with these cases more than one hundred suspects have been questioned, including three priests, a so-called "Flemish celebrity", a leading member of Amnesty International and people from the underworld who had connections with the Royal Court. He also learns that Stanislas Larsky, who has long been suspected of the murder of Debbie Marchal, has never confessed. The profiler is convinced that there is a single perpetrator, especially since the latest murder when a message to the police was left behind. Which logically means that Larsky is innocent. He describes the serial killer as a relatively educated person in middle age, with a strong power of imagination, who like most psychopaths looks quite normal, and who, between attacks, leads a peaceful life with his wife and children. The minister promises solemnly to have the perpetrator arrested before the next elections. The legal experts talk about textbook examples from abroad. The colonel says nothing.

Cox switches over to another channel and selects a film in which Elizabeth Taylor is riding around in a Sunbeam

Alpine. He cannot quite place the Metrocolor images and looks up the film in the TV programme. It is Daniel Mann's *BUtterfield 8*, a 1960 adaptation of the novel of the same name by John O'Hara. Cox remembers having seen the film once at the cinema. It is the story of Gloria Wandrous, a call girl with a murky past. As a child she was sexually abused and plunged at a young age into the underworld where she was employed by the most notorious bars in Manhattan. Weston Liggett, played by Laurence Harvey, is a dissolute, unfeeling lawyer unhappily married to the fabulously wealthy Emily, played by Dina Merrill. When they meet, Liggett is just one of Gloria's anonymous clients, but their relationship rapidly evolves into something more profound and romantic. The question is whether this tender affair can change their futile way of life for the better or whether, on the contrary, it will result in them destroying each other implacably. Cox knows how the story ends: Gloria dies in a car accident. So hardly an unforgettable masterpiece. Rather a carefully chosen commercial vehicle for the disconcerting beauty of Liz Taylor, who picked up an Oscar for her portrayal.

Cox rolls off the sofa, makes his way with a yawn to the kitchen and opens the fridge. He's out of beer. Once Starr would have made him some tea. He misses her penetrating commentary and her critical view of the films that they would watch in the evening, snuggled up together under a blanket, until their eyelids drooped. He misses her goodnight kiss. It is now nearly eight months since she disappeared from his life. The shutters on the house where she lived with her parents have remained closed since then. No one talks about her any more and he no longer asks any questions. Even the sound of her voice is fading and it is as if she never really existed. Sometimes he thinks that he just dreamt that Clara Bow or Louise Brooks appeared to him from the hereafter to look him up like an old lover and thank him for the unconditional love he had shown for both stars. Because sometimes life is like a film.

He strolls back to the living room to turn off the television, but waits for the sequence in which Gloria Wandrous wanders around Liggett's flat in a beige satin nightgown. She gives a disapproving look to the banknotes that the lawyer has left on the dressing table in the bedroom and writes on the mirror in lipstick. Cox holds his breath as he reads the first word: NO. He shuts his eyes, he dares not look. Waits a couple of seconds. He holds his hands to his face, then peeps through his fingers and reads: NO SALE. He runs to the bathroom. Even the handwriting matches: just as in the film the o that Starr has left is not completely closed.

Part II

Starr Faithfull

23

Starr Faithfull

The next morning Cox phones the police station and asks to speak to Luyckx. After a couple of minutes he is put through.

"Luyckx."

"This is Victor Cox."

"Mr Cox! You must be calling because you saw me yesterday on TV."

"I did follow the debate, but that's not why I'm calling."

"They said I came over rather well. According to my colleagues I reminded them of an American actor. Any idea who they could be talking about?"

"It doesn't immediately spring to mind. Anyway, I just wanted to let you know that I have deciphered my girlfriend's message in the bathroom. You know, NO SALE. It was a joke. She had seen Liz Taylor write precisely those words with her lipstick on a mirror in a film. And I had to guess the film."

"And what was the film then?"

"Daniel Mann's *BUtterfield 8*."

"Never heard of it. So what did she mean?"

"Not for sale."

"My English is good enough to figure that out. But what did she mean by that message?"

"Nothing."

"Sounds like a great game."

"By the way, my girlfriend was asking about her knickers."

"What knickers?"

"Her panties that you took away that evening."

"Oh, right! I'll get them back to you. Sandy Misotten never wore underwear."

He did not go out all day and let the spring weather waft in through the open window as he put the finishing touches to the lecture on Hitchcock that he had to give the next evening at the High Noon Film Club. His text ended with the image in which the Master merged Eros and Thanatos in a morbid ballet: the murder scene in *Dial M for Murder* from 1954. He read the closing lines out aloud.

"Captain Swann Lesgate, played by Anthony Dawson, is engaged by Tony Wendice, played by Ray Milland, to murder his wife Margot, played by Grace Kelly. When he throws himself on to the victim to kill her in the darkness of her flat, she falls back on to her husband's desk. She is wearing a transparent, light-blue nightdress. The scene is filmed in a way to suggest that they are making love, that the murderer is her lover who has come to see her while her husband is out and in his ardour does not even take off his raincoat. As he strangles her with a silk stocking, she manages to grab a pair of scissors lying amidst the clutter on the desk and stabs her assailant in the back. He collapses with his head between her heaving breasts with his eyes wide open. Like after an orgasm – the orgasm of death.

"And in conclusion I would like to quote Hitchcock's favourite scene to prove my thesis. In his conversations with François Truffaut he declared that this was a sequence from *Rich and Strange*, his 1932 film, better known in the United States as *East of Shanghai*, with Henry Kendall and Joan Barry as Fred and Emily Hill. While they are swimming, Emily taunts him: 'I bet you can't swim between my legs under water.' She is standing in the middle of the

swimming pool, with her legs apart. He dives down, but unexpectedly she snaps her knees together. His head is clamped between her thighs and you can see bubbles of air escaping from his mouth. After a moment she lets him go and he appears on the surface out of breath, panting: 'This time you nearly murdered me!' And she replies: 'And wouldn't that have been a lovely death?'

"In Hitchcock every murder is sexual. In fact, in *Shadow of a Doubt*, from 1943, he cites a quotation of Oscar Wilde's, which in my opinion harbours a profound truth: 'Yet each man kills the thing he loves.'

"Thank you for your attention."

Cox was not displeased with his efforts given the unusual circumstances in which he had been working on the text. He slipped the twenty-five pages into a grey folder, on which he wrote LECTURE 8TH JUNE 2002 – HIGH NOON FILM CLUB in block letters with a thick felt-tip pen. Then he looked at the photos on the desk of his two women: one of Shelley in her brief but irresistible Betty Grable period in the lobby of the Chateau Marmont and the other of Starr, in which she looks at him over her bare shoulder against a dark background, and that strangely was starting to fade.

His original plan that evening had been to go to the Kinepolis to see Roman Polanski's *The Pianist*, which had just won the Palme d'Or at the Cannes Film Festival. But when he read that, following the showing of *BUtterfield 8*, Arte was broadcasting a documentary about the true events on which O'Hara's novel was based, he decided to stay at home. Because since the previous night he had not been able to shake off the story of Gloria Wandrous, who drowned in the Hudson River and had the same handwriting as Starr.

For his novel, O'Hara had been inspired by a lurid news item that attracted enormous attention in the press at the time, according to the documentary. On Monday, 8th June 1931, at around six o'clock in the morning, a beachcomber

called Daniel Moriarty finds the body of a young woman on Long Beach, New York, half-buried in the soft sand. Her drenched summer dress is clinging to her voluptuous body. She is wearing silk stockings but no underwear. Her nails have been painted bright red. Her expression is serene, as if she is asleep. The sight is both innocent and obscene. At half past nine Inspector Harold King and two detectives from Nassau County examine the body, but do not find any personal papers or jewellery that could reveal her identity. The only clue is an embroidered label in the collar of her dress: Lord & Taylor, an expensive fashion store on Fifth Avenue. King has the remains transferred to the mortuary in Mineola for an initial cursory autopsy. The coroner's findings can be summed up simply: death by drowning.

In the late afternoon a lanky man in a three-piece suit appears at the Mineola coroner's office. This man, Stanley Faithfull, claims to have read in the paper that the body of a young woman has been washed up on Long Beach. His stepdaughter has been missing since the previous Friday. Starr Faithfull, twenty-five years old.

Cox gasps when he hears this and reaches for the whisky bottle without taking his eyes off the screen. The model for Gloria Wandrous, who has the same handwriting as Starr, also has the same name. Spelt in the same unusual way. His last image of Starr Mortenson is of an innocent young girl walking into the sea. The sea that on 8th June 1931, exactly seventy-one years ago to the day, had cast up the body of Starr Faithfull on Long Beach. This is no longer fiction but solid reality. It's an absurd thought but perhaps the death of one Starr can explain the disappearance of the other.

Stanley Faithfull identifies his stepdaughter's dress. Inspector King asks the famous forensic surgeon, Otto Schultze, to conduct a second, more thorough, autopsy. The doctor

counts more than one hundred wounds over her entire body. Her lungs are full of sand. So she must have drowned in shallow water, more than forty-eight hours ago. In her stomach he finds the remains of a sumptuous dinner. The theory of an accident is abandoned.

On Tuesday evening Inspector King makes his way to 12, St Luke's Place, in Greenwich Village, where the Faithfull family occupy an apartment in a nineteenth-century building. He questions Starr's mother and younger sister Tucker, as well as her stepfather. When he leaves the apartment around midnight, he declares that he knows the identities of the murderers, adding that one of them is an eminent politician. That same night he takes the train to Boston.

Starr's real surname was Wyman. She was born in Boston on 27th January 1906. When her father left his family in 1918 to go and work in Paris, her mother found some comfort in her friendship with Martha, the wife of the mayor of Boston, Andrew J. Peters. From the start Peters displayed a rather unhealthy interest in the twelve-year-old Starr, whom he called Bambi. But everyone kept quiet, especially because Peters supported the Wyman family with a monthly allowance. When her parents divorced in 1924, Starr spent her holidays on the mayor's private island or on his three-master, the *Malabar VII*. Her mother married Stanley Faithfull in 1925 and the family moved to West Orange, New Jersey.

Had Starr Mortenson been living with a similar secret and was that the reason she was so different to the other students? Was that the reason too that she wore such striking make-up? She had often told him that her father called her Bambi when she was little. The father that he had never met, as if the man dared not come out into the open. The father who perhaps did not even exist.

* * *

145

On the screen appeared a blurred, yellowing photo of Starr Faithfull, playing as a child in the surf with her dog Congo. Starr Mortenson's dog had the same name! She was able to swim well from an early age, the narrator says, and proved to be an excellent swimmer later on. Just like my little Clara Bow, thinks Cox, drinking straight from the whisky bottle.

While passing through New York, on 26th June 1926, Peters invites Starr out to a Broadway theatre show and then spends the night with her at the Hotel Astor.

The last time that Cox saw Starr alive was at the Hotel Astoria. Astor/Astoria. It cannot be coincidence. Did Starr also have a double life, just like Shelley and Faithfull? A dark side that she had never dared own up to and that she had taken with her as an unspeakable secret? Why had all three women come to their ends in the water? Was Starr really called Mortenson or was she the reincarnation of that lost creature washed up on Long Beach like a piece of driftwood, and was that why she had walked into the sea again?

When Starr Faithfull, confused and befuddled, comes home the next morning, she tells her mother of the eight years of sexual abuse she has suffered. To prevent a scandal, Peters promises extra financial support for Starr's psychological care. In August 1927 he pays the sum of $25,000 into the Faithfulls' bank account. The family moves to Greenwich Village and Starr travels to Paris, London, the Antilles and the Mediterranean. She discovers Cunard's pleasure cruises, whose fleet of liners docks not far from St Luke's Place. By the spring of 1931 the money has run out, but Starr continues to attend the parties that the shipping company throws before its passengers embark on the luxury liners. She was often seen tottering around the quayside, looking

for another party on a Cunard cruiser. Everyone knew her at the docks.

Just as everyone knew Drunk Dixie in the bars around the Bonaparte Dock, thinks Cox, slumping down from the sofa. The bottle of J&B rolls over the floor. He tries to concentrate but everything is starting to spin inside his head. Starr Faithfull's murder has never been solved. Just like the disappearance of Starr Mortenson. She claimed to have spent the week before their last meeting in Sweden. She had called Cox regularly, apparently from Stockholm, but there was no proof she had ever left the country. Even her account of the Deborah Kerr retrospective was not convincing. Perhaps, while he was waiting for her in his hotel room, she had been spending the days with strange men in the bars of Ostend or on the Dover–Ostend ferry. And, the night that he had encountered young Fellini on the beach, perhaps she was murdered by one of her last lovers. Maybe by the mysterious man that she called Grandpa Mortenson. And perhaps that man had come to collect her clothes and other things from the room while he was listening to Lejeune in the Bogart Bar.

The Faithfull family did not let go of Andrew Peters. Their silence cost the politician more and more money, a comfortable and above all regular source of income. But Starr started to behave increasingly strangely. Once she was found almost dead in a hotel room close to Central Park, then the police found her again in a suite at the Montclair Hotel, dead drunk and beaten up. She was repeatedly taken by ambulance to Bellevue Hospital where she needed treatment for injuries and beatings. In London she was even detained one night for wandering naked through Kensington.

Someone rings the bell, and Cox limps, swearing, on his bare feet to the front door. Two uniformed policemen

are standing there, the older looking no more than seventeen.

"Mr Cox?"

"What are you accusing me of now!"

"Nothing, we… We have a package for you."

"A package?"

"From Superintendent Luyckx."

Blushing, the young policeman hands him a see-through plastic bag in which someone has stuck a folded pair of knickers, and says: "I don't know what it is."

"Starr Faithfull's underwear, young man," mumbles Cox, "which Inspector King has been looking for for days. He'll be pleased. Give Luyckx my best wishes."

"Is everything all right, Mr Cox?"

He shuts the door, runs back into the living room, drops on the ground in front of the television and wipes the sweat from his forehead with Starr's knickers.

Ten days after the death of Starr the police are still fumbling in the dark. Only a meticulous analysis of how she spent her time in the days leading up to the murder may yield some clues. But even that seems insurmountably difficult.

Had she somehow contrived to smuggle herself on board one of the Cunard liners in order to throw herself overboard and commit suicide once the ship had left harbour? That too was impossible. Her body had been in the water for ten hours at most and it was simple to ascertain that at the time of her death every Cunard ship was on the open seas. The fact that no traces of alcohol had been found in her blood also contradicted the statements of various witnesses. Nor was there any explanation for the numerous wounds and bruises on her body. Or for the spotless state of her clothes. Or for the sand in her lungs and the half-digested food in her stomach. In December 1931 the file on her case was closed.

Starr Faithfull had taken the mystery surrounding her death with her. Some beachcombers claim to this day to see her now and then at daybreak emerging from the mist, wandering over the beach in her blue-and-white summer dress and then stepping back into the sea as the foghorns of passenger ships resound in the distance, to vanish in the waves until her next appearance.

Cox turns off the television and stares at the cashmere pattern on the Persian rug. The same pattern as on the dress clinging to the shapely form of Starr Faithfull. He slumps to his knees, tumbles over in slow motion and falls asleep with his face pressed against her belly full of seaweed and gin and veronal.

24

John Agar

"In Hitchcock, every murder carries a sexual charge. Indeed, in connection with *Shadow of a Doubt* from the year 1943, the Master quoted a line of Oscar Wilde's which, in my opinion, contains much truth: 'Yet each man kills the thing he loves'. Thank you for your attention."

The hall echoes with applause. Cox bows politely, shuts his grey folder, switches off the reading lamp and steps down from the podium. Vincent van Lierde, president of the High Noon Film Club, is in raptures and hurries over to congratulate him.

"Brilliant, Professor! That was eloquence in the service of erudition. I don't know how else to describe it."

"I feel greatly flattered."

"No, I really mean it! My spine is still tingling when I think of your remarks on Grace Kelly and Cary Grant's kiss in *To Catch a Thief.* And you heard the applause yourself: the High Nooners must have enjoyed it as much as I did."

"How long did I speak for?"

"One hour and twenty minutes. Perfect timing."

"As long as that?"

Cox looks at his watch. It is half past ten.

"I do hope you can stay for the reception. I'm sure our members have lots of questions for you."

"Unfortunately I have another important meeting and…"

"You don't say! We did agree…"

"I know, Mr van Lierde, but I have to be in Koksijde by midnight. An unexpected family problem."

"What about the club photo?"

"Another time. I'm really sorry."

Cox disengages his hand and leaves the hall by a back door. A quarter of an hour later he is speeding down the Antwerp–Ostend motorway.

He had woken in the living room with cramp in his shoulders at three that morning. Then he lay in bed with a splitting headache, agonizing about what he had seen. Now that he knew all the details of the Faithfull case he was convinced that Starr – his Starr – had not dumped him for the hell of it and that a terrible story lay behind her disappearance, a story of which he had not had the remotest inkling. At about six o'clock he began to comb through the house, looking for her diary. She had once told him that since primary school she had written down her life in a secret code every day in grey clothbound notebooks and that whoever found them later would be stunned by their contents. He knew the diaries existed because he had often seen her, sitting in a corner of the bedroom when she thought she was alone, writing things down incredibly fast. Even he was not allowed to read them; it was an intimate diary and perhaps she would burn it one day. Sometimes it's better not to leave any traces behind, she said.

But he found nothing. Obviously the diary was not in his flat. He quickly drank a cup of coffee and set off for Starr's old address.

The shutters were open and the windows adorned with flower pots. He even thought the Mortensons had returned, until he read the name 'Lievens' on the doorbell. He rang. An elderly man in slippers opened the door. Cox was lost for words. He could not think exactly why he had come.

"What can I do for you?" asked the man. His clothes smelt of pipe tobacco.

"My name is Victor Cox and I used to give classes to the daughter of the previous tenants. I assume they no longer live here?"

"That's right. We rented our flat for a time to the Mortenson family. And they did have two daughters."

"Did you say two?"

"Yes. They had odd names. Their father was of Swedish descent."

"Starr and Tucker?"

"Correct. Starr was the older."

Starr had never told him that she had a sister. A sister who, what's more, had the same name as Starr Faithfull's sister.

"And when did they move out?"

"On the 14th of October last year, to be exact. The rental contract was still running. I think it was because Mr Mortenson was unexpectedly given a foreign posting."

"Did they leave a forwarding address?"

"No. My wife and I had almost no contact with them. But they were decent people who always paid their bills."

The old man's story seemed too neat, too simple. Why would Starr not have informed him that her father had been posted to a new embassy and that she had to leave the country with her family? For fear that he would follow her? Nonsense. Cox did not dare suggest they should let him in to look for the diary. It would appear at the very least rather suspicious. Anyway, he had the feeling that he would not find the answer to the riddle in Antwerp. If he could uncover where she had spent the week before she disappeared perhaps he would understand what had forced her to plunge, alone, into the ice-cold waves that evening. And for that he had to get back to Koksijde.

It is almost midnight when, exhausted after two sleepless nights, he parks his car on the promenade outside the

Meteor Cinema, which tonight is showing John Gilling's *The Reptile* as part of a week of science-fiction films. The performance has just finished, and a couple of dazed spectators with bloodshot eyes are leaving the cinema as the floodlights on the roof are extinguished, one by one.

Cox avoids the Astoria Hotel and slips down from the promenade. To his left, in the orange glow of the street lamps, he can see the row of bathing cabins where Riccardo and Federico had been waiting for their father. The tide is out and the beach looks like that beach of silver pools which he had seen Starr dance and skip over through his binoculars on 14th October last year, casting her bathing robe and towels aside. He still remembers the exact spot where she entered the water and with a radiant smile turned to wave at him one last time before disappearing into the foaming waves. It was not even a hundred yards to the left of the breakwater. Behind him, in the distance, he can hear the noise of the funfair. And from the Astoria Hotel loud dance music can be heard as if a party is going on. The air smells of fried food and sunburn. The tourist season has begun.

Before him stretches a heavy sea of pitch. Sluggishly undulating, inscrutable, black and menacing. A sea full of corpses, wrecks, shadows and secrets navigated by the silent monoliths of ghostly tankers. At his feet the surging water leaves a trembling fringe of foam. Cox considers the angle at which the waves are coming in. If Starr had drowned at this spot, the current would immediately have driven her body to the east.

He climbs on to the breakwater, overgrown with seaweed and moss, and ventures on to the backbone of the stone construction, which disappears into the sea like a giant dead reptile. The worn stones under his leather soles are slippery and he clings on to the wooden stakes that grow out of the back of the monster like spikes. A body wedged into this concrete and bluestone chaos

could serve as food for the crabs for months, unnoticed and slowly rotting away. Taking care not to slip off, he edges step by step towards the end of the breakwater. Suddenly, barely twenty yards from the end, he sees a strange apparition emerge from the eddying water. The creature is bigger than a normal man, and hops lithely from one rock to the other, stops, peers around fearfully, crouches down, bounces up again, freezes. It is as if it is searching for something between the heaped up blocks. Cox hides behind one of the wooden stakes. The moon breaks through the clouds and in the moonlight he catches a clear glimpse of the monster: its body is covered with scales, spotted with mussels and tiny snails. Its arms and legs are abnormally elongated. A spiky comb, running down its back to form a sort of tail, like an iguana's, is growing out of its slimy, earless egg-shaped skull. Its lanky fingers with their crooked light-blue nails are connected by a fluorescent web. The feet are like shiny fins. Its nose is no more than two small slits, the mouth resembles the beak of a sunfish and the lidless eyes are like the dead eyes of a snake. Its breast is protected by an immobile, horny plate. It breathes through gills where its cheeks should be.

Cox dares not move, but the creature has clearly smelt his presence. It bends at the knees, jerks its head from side to side like a lizard scenting danger, and then looks steadily in his direction.

"The Gill Man," whispers Cox, "*The Creature from the Black Lagoon.*"

He recalls discussing a fragment of Jack Arnold's 1954 film with his students as part of his course on the myth of Beauty and the Beast in American and European cinema. It was the sequence in which the monster, played by John Agar, swam like a torpedo to the surface from the unfathomable depths to carry off the beautiful Julie Adams, a scene of violent sensuality that Starr had watched with unconcealed

and morbid pleasure. Had the Gill Man ambushed her while she was swimming on the night of 14th October to chain her up in his underwater cavern filled with pearls and sea anemones? Was that why her body had never been found?

Cox ventures to take a step forwards.

"Mr Agar?"

The human reptile does not move a fin, ready to attack with a lightning leap.

"Mr Agar, I am a great fan of yours, I saw all your movies. Could we have a word together? It's about my fiancée..."

Instead of replying, the monster makes a hissing sound, flicking out its forked tongue. Perhaps it is not the actor at all that Cox is standing face to face with but the real Gill Man. If that is so it would be best to make for safety as soon as possible. He tries to turn and flee but slips on the damp moss and hits his head on one of the wooden stakes.

When he regains consciousness, shivering, the rising tide has half-covered the stone blocks and he is lying among drifting seaweed in shallow water. He is bleeding heavily from a deep cut above his left eyebrow. He can hear the voice of his mother who told him as a child not to play on breakwaters, and picks himself up with difficulty. For his lecture he had put on his best suit, which is now sticking to his body like a sodden rag, looking as green as the moss. In the distance he can make out the triumphal frontage of the Astoria, the only building on the promenade that is still illuminated, and where carefree people are noisily partying.

Cox stumbles towards the hotel where everyone knows him and he can have his injuries seen to. His right foot catches in a piece of material sticking out of the damp sand. He pulls it out of the sand and immediately recognizes the missing belt from Starr's bathrobe, which seventy-one years to the day after Starr Faithfull's body was discovered on Long Beach has finally been washed up on Koksijde beach.

* * *

When Cox enters the Astoria lobby he thinks he must be in the imperial palace on Planet Dagobah. Wherever he looks he sees hideous monsters, extraterrestrial creatures, man-apes and mutants. He moves reluctantly towards the bar, recognizing on the way Frankenstein's monster, the Mole Man, Fu Manchu, King Kong in conversation with Doctor Mabuse and the Alligator Man, a silent couple of Gamians, a group of murderous Diaphanoids, a couple of sloshed werewolves, a robot of silver-plated cardboard, Count Dracula, a platoon of chimpanzees from *Planet of the Apes*, some slimy Martians and a lonely Cyclops in polystyrene. With his blood-soaked shirt, the gaping wound on his forehead, his damp, bedraggled clothes, and the salt and sand sticking like mildew to his hair and skin, he does not look any more appealing than the rest of them. But no one looks round at him, as if his wilted exterior is just a clever disguise. Until the general manager, dressed as Emperor Ming in *Flash Gordon*, notices him and hurries over.

"Professor! What an honour! You are without a doubt the most successful and realistic zombie of the evening!"

Cox does not understand what is going on and looks around puzzled. Behind the reception desk a man with a fly's head is sitting, waving at him with an arm covered in prickly hair.

"Monsieur François," says the general manager. "Didn't you recognize him?"

"No. Could you possibly explain the meaning of all this?"

"I don't understand your question, Professor."

"I mean, who are all these people? And why is everyone dressed up?"

"But you are dressed up yourself!"

"Not at all! This is a real wound, this is real blood! And this was my best suit! I fell over on a breakwater because one of these imitation monsters scared the life out of me!"

"Wait a minute… Didn't you receive our invitation?"

"What invitation?"

"To our first science fiction ball. Sponsored by Nutella and the Meteor Cinema."

"No I did not! I was in the area for a lecture and after the reception went down to the beach to enjoy the breeze," Cox says, lying. "And because it had got too late to go back to Antwerp I thought I would spend the night at the Astoria."

"And you were right. There is always a room for you here. But first we need to clean up that nasty cut above your eye."

A Godzilla-like figure waddles up to Cox and says: "Your make-up's fantastic. Minimalist but powerful. As far as I'm concerned you deserve the Nutella prize."

While Cox is having his wounds seen to in the general manager's office by a doctor in a Yoda mask, he asks if Superintendent Lejeune happens to be there.

"He's spent the whole evening in the bar. Perhaps he's still there," replies the general manager.

"I'll go with you," says the doctor, "otherwise they won't let you in."

The Bogart Bar has been rechristened the Lucas Bar for the occasion. It is an exclusive area admitting only members of the Ostend Star Wars Fan Club, who would not mix with the other guests for anything. Behind the bar, Nick is mechanically mixing cocktails in a shaker in his gilded C-3PO suit. Opposite him, Lejeune is chatting with Princess Leia. Cox recognizes him immediately, despite his Jabba the Hut costume, which unfortunately barely differs from his everyday appearance. In the corner where the card players usually sit, Darth Vader, Darth Maul, Darth Sidious, Chewbacca and Boba Fett the bounty hunter are deep in conversation around an ice-cold magnum of Veuve Cliquot, illuminated by the glow of their fluorescent light sabres. John Williams's soundtrack to *Return of the Jedi* is blaring from the loudspeakers.

"The gentleman is with me," says the doctor on encountering a suspicious look from Luke Skywalker.

"The usual, Professor?" asks the unchanging C-3PO.

"Yes please, Nick. Good evening, Superintendent."

"Mr Cox!" cries Lejeune, without moving his plastic pustule-covered drooling lips. "Who would have thought it. May I introduce Princess Leia?"

Cox turns to the young woman whose hair is plaited over her ears with two round combs. He recognizes Inspector Fontyn under a thick layer of white make-up.

"Have you been in an accident?" asks Fontyn in his high voice.

"I slipped over."

"On the Ice Planet Hoth, no doubt! It can be dangerously slippery there sometimes!"

The superintendent bursts into loud laughter, shaking his shapeless foam-rubber body up and down.

Cox realizes that this is a bad time and place to have a normal conversation with the superintendent. In fact he is so exhausted and confused that he no longer remembers what he had wanted to tell him so urgently anyway.

"I found this on the beach," he says for want of anything better, and shows Fontyn the wet belt from the bath robe that he still has in his pocket.

"What's that?" asks Lejeune.

"I don't know."

"I may be mistaken," says the doctor, "but it looks like the ribbon used to tie up Queen Padmé Amidala when she was captured on planet Naboo."

"You should know," says Cox.

Ten minutes later he is lying in his own room on the bed where Starr had never slept. When the doctor noticed that his legs were about to give way and he was clinging on to the bar for support, he had helped him up to the first floor and given him a sleeping pill.

"If you still feel dizzy in the morning, give me a call. It could be light concussion."

The last thing Cox sees before he falls asleep is the friendly Yoda bending over him and tucking him in with a comforting look, as if he were a sick child.

25

Gloria Grahame

Sunday, 9th June 2002

When I awoke this morning in a bed stinking of rotten seaweed and dead crab, looked at the balcony door and saw, framed in a sky-blue rectangle, the ghost of Starr standing there inviting me to go swimming, I realized that just like Debbie Marchal she had been murdered. Her gaze, before she disappeared from my life, was that of a woman in love and nothing in her behaviour indicated that she had been planning to leave me or, even less, commit suicide. I must thank Starr for the most brilliant, intense moments of my grey existence and if, despite my grief and confusion, I am still alive today it is because I think of her every day and experience those sunlit hours again in my thoughts. When I was in the car driving back to Antwerp I thought of confessing everything to Luyckx. But I realized that my story would sound incoherent and incredible. He would probably not give it any consideration but show me politely to the door. "Your women don't bring you any happiness, Mr Cox," I could hear him say, "but we have a rule: no corpse, no murder. Go home. Believe me, women come and go. I'm willing to bet that your girlfriend will show up sooner or

later." Whatever the case, I ran the risk of becoming a suspect again. I decided I would first set everything down on paper, which for me is the only way to get some order into the chaos in my head. All the way back to Antwerp I listened to the soundtrack that Gato Barbieri composed for *Last Tango in Paris*.

I now possessed enough clues to confirm my hypothesis. The confusing resemblance with the tragic figure of her namesake, the parallel with the murky character of Gloria Wandrous in *BUtterfield 8*, the date of 8th June, when both the body of Miss Faithfull was washed up on Long Beach in 1931 and Starr's belt was found seventy-one years later on the beach at Koksijde, the two words on my bathroom mirror: perhaps these did not amount to scientific proof, but for me there could no longer be any talk of coincidence. The logical explanation would therefore be that her murderer secretly knew her and copied the mysterious murder of Starr Faithfull for her murder. As if he had dreamt up the end of an unfinished story. Stan Larsky, who had confessed to the many murders he was accused of but had never admitted the Marchal case, had already been arrested the night that Starr disappeared. I am therefore certain that Debbie Marchal was disposed of by the same individual, who during that fatal weekend of 13–14th October was roaming the empty streets of Koksijde like a bloodthirsty predator. But why Debbie first? Was it just coincidence or was this death too part of the killer's macabre screenplay? Unless, once again, he was inspired by a film, just as with the earlier murder of Marion Mees, which clearly referred to Hitchcock's *Psycho*. If, with a little luck, I can prove this, then I will probably have established a link between the three murders. And once I know for sure that this link exists, I shall consider whether to go to Luyckx or not.

Cox switches off his computer and walks into the bathroom to tend the wound on his head. He feels a sense of relief

now that he has accepted the death of Starr. And excitement too at the thought that he is going to conduct his own investigation without being embroiled in the pointless boasting of a show-off like Luyckx.

He opens the window, waves at Mrs Kountché, who as usual is spying on him from her balcony, and sits down at his desk with a blank sheet of paper.

Just as you try to remember a sequence of film with your eyes shut – an exercise at which he never fails – he now endeavours to recall the images of his encounter with Debbie Marchal.

It was terribly dark in the bar that evening and she was sitting in a ray of cold light that formed a kind of crown around her hair. That typical effect of contrasted lighting at which the great names such as Walter Lang, Joseph Biroc or Guy Roe excelled. Her behaviour was seductive, haughty, irresistibly artificial. She barely moved – and when she did move it was with that calculating lethargy with which the deadliest femmes fatales strike their prey. Now he can see it again clearly before his eyes. It was as if he had landed in one of Hathaway's films and a Gilda-like goddess had stepped down from the screen to take her place beside him, like a diabolical angel, at the Bogart Bar. He sees her draw a Winston from an ivory cigarette case. He sees himself slide off his barstool and take a couple of steps to offer her a light. Just as clearly he perceives her face in the glow of the flame of his lighter. She does not look like Rita Hayworth but has her allure. So whom does she resemble? He remembers saying something at that moment. Something about the way she smokes. "You smoke just like Gloria Grahame," he hears himself mumble: that was it – "You smoke just like Gloria Grahame."

The problem is that Gloria Grahame never shot a film with Hathaway.

In the Fifties she was one of the icons of film noir. She worked with great names like Josef von Sternberg, Maxwell

Shane and Elia Kazan. Her last role on the big screen was as Debby Marsh in Fritz Lang's *The Big Heat*. Cox opens his eyes and stares at the patch of sun falling on his blank piece of paper. That was the film in which he saw her smoking years ago – in that distinctive sultry way, in Walter Lang's chiaroscuro lighting, during a Fritz Lang retrospective in Brussels. With eyes half-shut, blowing smoke rings through pursed lips, her head thrown back. The only film in which her character has the same name as Debbie Marchal. Now he understands why that beguiling, timeless vision, that evening in the Bogart Bar, made him think immediately but unconsciously of Gloria Grahame.

But that still proves nothing, and because he no longer knows the plot by heart, he decides to look up his old course on film noir. He finds what he's looking for on page forty-six:

THE BIG HEAT, 1953

DIRECTOR	Fritz Lang
SCREENPLAY	Sydney Boehm
BASED ON THE NOVEL BY	William P. McGivern
CAMERA	Walter Lang
MUSIC	Daniele Amfitheatrof
SETS	William Kiernan
EDITING	Charles Nelson

SYNOPSIS: Detective Sergeant DAVE BANNION, played by Glenn Ford, is leading the investigation into the suspicious suicide of his colleague, TOM DUNCAN. But he is ordered by his boss to let the case drop. LUCY CHAPMAN, DUNCAN'S mistress, played by Dorothy Green, is nevertheless convinced that his widow BERTHA, played by Jeanette Nolan, wants to use her late husband's fake farewell letter to blackmail the gangster MIKE LAGUNA, played by Alexander Scourby. When LUCY'S body is discovered,

163

BANNION decides to pursue the investigation despite his orders. He visits LAGUNA, who with his gang holds both the local congressman and the police in his power. He accuses him of LUCY'S murder and threatens him. LAGUNA'S response is swift: he blows up BANNION'S car with a bomb, causing the death of his wife KATIE, played by Jocelyn Brando. BANNION demands an investigation into his wife's murder. When this is refused, he accuses his boss of shielding LAGUNA and is dismissed.

He hides his daughter with his wife's parents and returns to town to avenge his wife. He discovers that the sadistic killer VINCE, played by Lee Marvin, and his girlfriend DEBBY, played by Gloria Grahame, are involved in the case. He is about to get her to talk when VINCE, furious with jealousy, throws boiling coffee in her face. BANNION takes care of her and learns that VINCE and LAGUNA are the perpetrators of the three murders of DUNCAN, LUCY CHAPMAN and his wife. DEBBY murders BERTHA DUNCAN in turn to get hold of her husband's fake farewell letter in order to bring down LAGUNA. Then she lures VINCE into a trap and throws a jug of boiling coffee at his face, but misses. Without hesitating, he guns her down. BANNION appears at that moment and arrests Vince after a violent fight. DEBBY dies in a corner of the room, covering the burns on her scarred face with her mink in a last fit of vanity.

NB: The film was produced for Columbia by Robert Arthur and was premiered on 14th October 1953.

Cox stares dumbfounded at his notes. Before him is the proof that could just about reconcile his craziest theories with the absurd truth. He gets up and stands by the open window. He stares out into the emptiness, as if the white-washed garden walls, the late-budding beech tree, the clouds in the thin air, the backs of the houses opposite

had all disappeared. Only Mrs Kountché, who seems to live on her floating balcony, waves at him like a bright flag for the second time that day. She must be wondering why he is running around with a plaster on his forehead. One day I will take her with me to the elephant, he thinks, because I've made that woman much too inquisitive. Then he goes back to his computer to note down his astonishing discovery. To leave behind a trail, in case anything should happen to him. Just as in the classic thrillers, anyone who has stumbled across the truth – like James Stewart for example in *The Man Who Knew Too Much*, must learn to live with the idea that they could be eliminated at any moment as an inconvenient witness. The truth, when it threatens to emerge into daylight, can sometimes be dangerous.

Sunday, 9th June 2002 – continued

I must and will avenge Starr. After my discovery, Luyckx and his incompetent police force would just be in the way. This much is clear: Starr, Debbie Marchal and Marion Mees were all murdered by the same individual. I can imagine no more fascinating adversary than a cinema-loving psychopath who knows as much about film as I do. Perhaps a former student that I treated unfairly. Or a frustrated director, who in revenge for his failed career restages spectacular murder scenes. My life makes sense once again because I can finally put all this useless accumulation of knowledge to some good use. I am playing the leading role in a film of which I do not know the screenplay. I am playing the hero who gropes in the dark for a faceless enemy.

Debbie Marchal was not only murdered because she had the misfortune to resemble Gloria Grahame, but above all because she smoked in the same way as Debby, the gangster's moll in *The Big Heat*, and wore the same fur coat. Perhaps her murderer had been following her

for some time from one hotel bar to another and waited until 14th October to strike. This date does correspond to the date when the film premiered, and the whole world saw Vince's mistress die on-screen, forty-nine years ago. Perhaps he was walking around the hotel lobby, although I do not remember bumping into anyone that evening that looked like Lee Marvin. Unless he was waiting for her in the car park in order to strangle and then burn her.

The resemblance to Marion Mees's murder is striking. In both cases the victim has the same name as the character murdered in the sequence that is being mimicked. But in the Mees case the murderer went further in his disgusting staging. The choice of the abandoned motel, the room number, the number of stab wounds, the shower – everything fitted.

If he also murdered Starr, it shows that despite the show of force by the gendarmerie and the Ostend police the next day, he was still hanging around the neighbourhood of the Hotel Astoria. He had probably heard that she had come to see me, and the opportunity was too good to miss. Because just like his other victims, she must have long been on his list. He knew everything about her, things of which I had no idea, details that I still do not know. Well before me, he was familiar with the resemblance to Starr Faithfull, and today I find it hard to come to terms with the notion that he knew her better than I did.

Who were her best friends? She had no friends. At least as far as I know. It wasn't worth the trouble, she said, as if she was just passing through and our love was enough for her. Just now I realize how little I knew her, despite the passion that united us. Who in our circle knew as much about film as we did? No one. Perhaps it was someone she had known in the United States who had followed her surreptitiously to Europe. A childhood friend who knew the story of Starr Faithfull, and her sister Tucker and her dog Congo, and – who knows – the unspeakable secret

that tied her to her invisible father and explained her penchant for older men. Or an American fellow student whom she admired for his knowledge of film when she played strip quiz in New York. Unless...

Cox gets up and goes to the bathroom, avoiding the window so that he does not have to wave at Mrs Kountché. He looks through the words NO SALE on the mirror at a lonely, clapped-out old man, at the stubble on his sunken cheeks, at the purplish bags under his eyes, at the plaster on his forehead. Then he bends over and kisses the letter A, licks the dried lipstick and tastes the lips of Starr. Unless...

He goes back to his desktop and types with sorrowful fingers:

Unless Starr herself did away with the other two women out of jealousy. She knew better than anyone the films that served as the model for both murders. I remember that the pushy way that Marion Mees pursued me in the corridors of the Institute got on her nerves. The night that Marion was murdered, she was not with me. She even lied to the police, apparently to protect me, when she declared that we had been in bed together. And as far as Debbie Marchal is concerned, perhaps Starr had arrived one day earlier in Koksijde to surprise me and had seen us chatting in the bar. Mad with jealousy, she attacked the singer as she made her way to her car. She knew *The Big Heat* and set up the murder to put the police on a false trail: the trail of the cinema-loving serial murderer. The next day she staged her own murder and promptly disappeared, utterly and completely, from my life.

Cox rereads the last few lines that he has written down. It is an absurd theory. His imagination is running away with itself. How can he suspect Starr of such abominable deeds?

Wincing, he deletes the paragraph. He feels dizzy and there is an acid taste in his mouth. He has eaten nothing all day and decides to go to Docklands. Perhaps his regular table at Ma Mussel's is free. The table next to the group portrait with Dixie on the wall.

26

Clint Eastwood

It was one of those sensuous spring evenings when every-
thing seemed possible; the café terraces were buzzing like
bee hives and the young women on bikes were showing off
their legs again after the endless winter. Safe and sound
beneath its blue dome, the city dawdled before night-
fall. It was the first time since Starr's disappearance that
Cox had left his flat to explore the world with no other
purpose than to breathe in the scent of spring and enjoy
an evening stroll. A three-dimensional world in colour,
inhabited by carefree people of flesh and blood. It was
as if he had awoken, pale and weak, from a nightmare,
a bloody nightmare that smelt of celluloid, popcorn and
Chanel No. 5.

As he crossed the Groenplaats, he thought back to that
evening when he had paraded arm-in-arm with Louise
Brooks among the fluttering pigeons. When they got into
the taxi everyone was looking at them because she was so
beautiful and he was so old. Later that evening the body of
Marion Mees was discovered in the Babylon Motel and...
Stop! He had promised to forget the ghosts of the past
this evening.

As he walked along the Oude Mansstraat and smiled
pleasantly at the whores ogling him from their pink co-
coons, he decided it would not be such a stupid idea,

after eating, to come back and be pampered by one of these ladies; if only to wipe the memory of his nights with Starr from his mind once and for all. He turned into the Verversrui to have a look at the windows of the new Eros centre, and bumped into Luyckx, who was coming out of one of the brothels. Perhaps because he felt he had been caught out, The Sponge immediately launched into an attack.

"Who do we have here! Out hunting, Mr Cox?"

"I would not dream in the slightest of trespassing on your hunting reserve, Superintendent."

"Just joking. Someone lucky enough to have a stunning young girlfriend like you do wouldn't come looking for anything here. How is she?"

Venomous bastard, thinks Cox and replies: "She gets prettier by the day."

Just then Luyckx's Polish girlfriend Katia appears in her display window. She sits down on the black imitation leather barstool in her golden bikini and starts to put on purple lipstick.

"Just like Katia. You met her some time ago at Ma Mussel's. In Docklands."

Luyckx taps with his signet ring on the window and motions to Katia to greet Cox. She waves like a pale automaton bathed in blacklight. Cox waves back and says: "Actually I was just on my way to Ma Mussel's."

"That's what I was planning too. I'm parked over there. They wouldn't dare give me a ticket. Do you want a lift?"

"Why not?"

Less than a minute later Cox is sitting in the police car, while Luyckx, to create the right impression, clenches his jaw, puts on his Ray-Bans and races over the Falconplein with siren screaming and blue lights flashing. Through the windscreen Antwerp looks just like San Francisco.

* * *

The restaurant is full, but his table is still free.

"Hi, Spongey!" cries Ma Mussel, planting her lips like two sticky suckers on Luyckx's. "It's a real pleasure to see you! Table for two?"

"Three. Katia's coming along after work. Or should we make it four?" he asks over his shoulder.

"I'm alone this evening."

"Left on our own by the young ones?" laughs Ma Mussel.

"It's my evening off," laughs Cox feebly in reply. "But if you could I would like our regular table over there in the corner."

"No problem, darling. Blokes who come without their women can do anything here. How about a nice little aperitif?"

"The usual shampoo," replies Luyckx, sitting down on Starr's chair. "Been in an accident?" He points at Cox's forehead.

"I fell over on a breakwater on Saturday night."

"And what were you doing on Saturday night on a break-water? Sorry – professional instinct."

"Every year on the eighth of June I commemorate Shelley's death and throw a wreath of white lilies into the sea at midnight. They were her favourite flower. And I think it's more dramatic than the Bonaparte Dock."

"More romantic, anyway. But didn't she die on the sixth of June?"

"For me she was only dead once I knew. And that was the eighth."

"Four years ago… I can still see you writing in my office… Christ, how time flies!"

"Two mussels *à la provençale*?"

Ma Mussel sets the champagne down on the table in a plastic ice bucket.

"I would rather have them straight," says Cox.

Luyckx fills two glasses.

"Me too. Recovered from our little drive?"

"Most impressive. I thought I was in Dirty Harry's car during that chase in *Magnum Force*."

"San Francisco PD Inspector Harry Callahan! My hero! A true cop on the beat who wants only one thing – results. In the force they say I'm a bit like Clint Eastwood."

"That would be the glasses."

"And the method, Cox, the method. And what's more we're the same height and I often wear light-grey tweed. I don't often go to the pictures, but I've seen all of his."

Luyckx forms a pistol with his hand, sticks his extended forefinger between Cox's eyes and says, barely moving his lips: "This is a forty-four Magnum, the most powerful handgun in the world…"

"Good imitation," says Cox, taking a sip from his glass.

"I know what you're thinking: did he fire six shots or only five? Well, to tell you the truth, in all this excitement I've kinda lost track myself. But this being a forty-four Magnum, it would blow your head clean off… You've got to ask yourself one question: do I feel lucky? Well, do you, punk?"

"Don Siegel's *Dirty Harry*, a Warner Brothers-Malpaso production from 1971."

"You're unbeatable. Cheers."

They clink glasses. Ma Mussel places two steaming pots on the table with great to-do and says: "If those aren't the biggest and best mussels you've ever eaten, I'll shut this place down tomorrow."

"Could I have a chilled pint of beer, please?" says Cox.

They start eating in silence. Gloria Gaynor's *Walk On By* is playing on the jukebox. Ma Mussel hands Cox his beer.

"The difference between Callahan and you," he says calmly, emptying his beer glass in small sips, "is that he always manages to catch the murderer."

"That's the difference between the pictures and real life," snaps Luyckx. "Two things that you mix up."

"Two worlds that complement each other, I would say. But that's enough theory. How's the investigation going?"

"Which investigation?"

"The murders of Louise Vlerickx, Virginia Steiner, Marion Mees, Debbie Marchal, Sandy Misotten..."

"We'd have made more progress if we could prove there was a connection between the different cases. But we are making progress, real progress... I heard from my Ostend colleague Lejeune that you knew Ms Marchal personally. Is that right?"

"'Know' is putting it strongly. I met her in the bar of the Astoria in Koksijde the night that she was murdered. But I was not the only one."

"Out of ten million Belgians I only know one who ran into three of the five victims. And that's you. I don't know why, Mr Cox, but since we got to know each other I have the impression that you know much more than you let slip."

Luyckx fills his glass, empties it in one go and lights a cigarette.

"You know what Callahan would do in my place?" he continues. "He would take out his Magnum and stick the chrome barrel down your throat. He'd take you by your hair into the kitchen and hold your head above the frying pan and scare the living shit out of you until you dropped to your knees among the potato peel and begged for forgiveness and choking and sobbing confessed everything. That's what Dirty Harry would do."

"That's the difference between the pictures and real life," says Cox with excessive composure. Luyckx breathes deeply to calm down. He puts out his cigarette in a mussel shell and looks through his shades at the group portrait on the wall without recognizing Shelley.

"But if you ask me a question I'm prepared to answer to the extent possible."

Cox is playing the game. He is certain that Luyckx did not have the slightest intention of coming to eat here tonight, but is taking advantage of their chance encounter to give him an informal grilling.

"Why didn't Starr come with you? The last time I was at your place she wasn't there either."

Cox hesitates. Is it to his advantage to continue lying or has the moment come to tell the truth? The only problem is that he does not know what the truth is.

"The situation is more complicated than you think. I haven't seen Starr since the fourteenth of October last year."

Luyckx takes off his sunglasses. Callahan would have done that too. At this point in the conversation, eye contact is called for.

"Did you enjoy them?" asks Ma Mussel, who could not have chosen a worse moment.

"First class," says Cox.

She looks sternly at Luyckx's half-full pot.

"Well, Spongey, no appetite?"

"I'm on a diet."

"Trying to look like Clint Eastwood," laughs Cox.

"He does look like him," says Ma Mussel. "Especially with those cool shades. How about a nice digestif?"

"I'll just have another pint."

Ma Mussel clears the table. Luyckx fills his glass again, lights another cigarette, and says: "I'm listening."

"Well on the fourteenth of October we were together at the Astoria Hotel. It was already getting dark and Starr proposed going for a swim together."

"The day after Marchal was murdered?"

"Yes, but that has nothing to do with my story. I was under suspicion and could not leave the building. I went on to the balcony and watched through my binoculars as she dived naked into the waves. I have not seen her since."

"Why didn't you tell Lejeune about this right away?"

174

"Because it did not cause me any immediate concern. Starr was an excellent swimmer. I went to have a drink in the bar and when I got back to the room her things had disappeared."

"And you never thought it necessary to inform me?"

"Of course not… I still hoped that she would come back. Because who else would have taken her clothes from the room? Nothing suggests that she is no longer alive. No one has reported her disappearance. And her body has never been washed ashore."

"That doesn't mean a thing."

"Last Saturday I found the belt from her bathrobe on the beach."

Cox does not mention the eerie resemblance to Starr Faithfull's story. That was his personal information and it was too soon to share it with Luyckx.

"Eight months later?"

Luyckx pours the last drops of champagne into his glass.

"Here's our pint," says Ma Mussel.

"Thank you. I hadn't been there for eight months."

"I'll have a cognac, Ma. And you've heard nothing of her since the fourteenth of October? No letters, no phone calls, nothing?"

"Nothing."

"Funny that you didn't go and look for her. I assume she did have an address?"

"She had an address. But she's moved. No one knows where to."

"Why didn't you tell me about this the last time I came to see you?"

"Because I did not want to burden you with my sorrows."

"By the way, the lipstick on your bathroom mirror is not the same lipstick that we found on Sandy Misotten."

"I don't understand."

"That night when I was in your bathroom, I scraped off some lipstick from the word '*NO*'. To have it analysed."

"Why?"

"And a cognac for our Spongey!" cries Ma Mussel from behind the bar.

Luyckx gets up and takes the pear-shaped glass.

"The face and breasts of your good friend Sandy Misotten had been crudely smeared with lipstick. And on one of the windows of the greenhouse where we found her there was a text in English. Which had also been written in lipstick."

"What did it say?"

"Catch me or there will be another murder."

The night is bright and the sea breeze blowing out of the purple north over the bay of the Scheldt smells of iodine. The coloured lights of the bars and restaurants opposite are reflected like thousands of trembling serpents in the inky waters of the Bonaparte Dock. Cox strolls along the terraces that are still packed full at this late hour and looks almost tenderly at the festive crowds. They all seem so happy and innocent, he thinks, despite the fact that one in three of them voted for the fascist morons of the VB Flemish nationalists. Who knows what blind hatred and ignorance, what excruciating vacuity is concealed behind those glittering masks? Who knows what immeasurable stupidity and suppressed violence is hidden by their forced bonhomie? They are not who they appear to be and their hollow laughter prevents us from understanding how rotten the world is, and how sick the chanting wraiths who populate it are.

On the Nassau Bridge he stops and stares at the motionless water, at the tar-smeared jetties along the gangway where Shelley's corpse drifted among dead rats, empty plastic bottles and rotting vegetation. He can see her again, like in a silent film, lying under a palm tree at the Chateau Marmont swimming pool, unscathed, laughing, at the threshold of life. What a lonely, inevitable decline.

When he walks down the Verversrui past Katia, who is still sitting in her display window like an icon, she waves at him like an old friend. He stops and turns back. She laughs, baring her Polish teeth, and beckons him in. He finds it hard to explain, but the mischievous idea of screwing the sweetheart of Clint Eastwood's declining years excites him. Less than five minutes later she is lowering herself on to him like a bawdy angel with her ivory legs spread and asking in broken Flemish what she can do to make him happy.

27

Leo Lejeune

One week later Luyckx and Lejeune are strolling along the whitewashed pier at Ostend after an excellent lunch. They are old acquaintances and have been working together regularly since 1990. That has led to a couple of great successes, including the arrest of the paedophile priest of Missegem in 1991 and the dismantling of the drug-trafficking ring led by Dr Vozen of Zeebrugge in the same year. Since then they have been sharing both their appreciation of the fresh sole meunière at the Belgica – the old restaurant on the promenade where Lejeune used to go and eat as a child with his parents on Sundays – and their dislike of endless, useless official gatherings. In any case, the weather is too fine to be stuck in an office. In the little bay to the left of the pier a couple of brave swimmers are even defying the ice-cold waves. To the right of the promenade the masts of the fishing boats are dancing in the port. In the distance the Dover ferry is approaching the coast of Belgium.

The day after their conversation at Ma Mussel's, Luyckx had picked up a photo of Starr from Cox. He seemed completely relaxed and obviously had no idea with whom the old professor had spent part of the previous night. Relieved, Cox gave him the portrait that stood next to the

photo of Shelley on his desk. Luyckx had a good copy made that he faxed to his colleague in Ostend with the question whether he had ever heard anything about the unexplained disappearance of a certain Miss Mortenson.

Lejeune put five detectives on the case. Four people recognized her from the photo. From what they said, it appeared that she had spent the three days before her disappearance in Ostend, not Sweden, as Cox surmised. She had stayed for three nights at the Grand Hôtel des Thermes. Alone. The last witness to see her, in the late afternoon of 14th October, was the first mate on the *Seastar II* ferry. She had attended the on-board reception that the shipping company gave each year for family of the victims of the *Princesse Astrid*, the ferry that sank off Fort Mardyck in 1949 after striking a mine.

"We checked the passenger list of the *Princesse Astrid* from the twenty-first of June 1949," says Lejeune, "and there really was a Gustav Mortenson on board."

"That still doesn't explain why she was lying to old Cox," says Luyckx.

"I fear it wasn't the first time. If she really looks like she does in that photo, I think it would be quite normal if she had more than one lover."

"They were completely in love with each other..."

"That's what he says. I've met him three times. That fellow isn't normal. You should have seen him last week – a complete wreck, a zombie. He claimed to have seen a monster on the breakwater in front of the Astoria at Koksijde. Don't ask me what he was up to out there at midnight."

"He was commemorating the death of his wife, he told me."

"On a breakwater? Come on, Fons, pull the other one. You know the old rule: nine times out of ten a murderer returns to the scene of the crime."

"I thought he wasn't able to leave the hotel after Marchal's murder."

"That's right. But I only had two men who had to be everywhere at the same time. But fine. He showed me the belt from her bathrobe that he'd found on the beach. You only find something like that if you're looking for it."

"He told me about that too. But according to him it was just a coincidence and she's still alive."

"Two months ago, a fishing boat pulled up a skull in its nets. The skull of a young woman with a perfect jawbone. It doesn't prove a thing, but apart from Starr only a couple of Alzheimer's patients have gone missing in that period."

"Get me a cast of the jaw."

"Will do. What bothers me most is that he was in the area when Marchal was murdered and that Larsky, who's confessed to every other murder, continues to deny that one."

"Personally I don't think he could hurt a fly. He's running around in a parallel universe, a phantom world which he's totally absorbed in. He knows everything about the cinema but it seems as if he's never been touched by real life."

"The barman at the Astoria did confirm that. Nick told me that he has an enormous collection of film props."

"You see? What reason would he have to bump off all these women, anyway?"

"Films can sometimes have a malevolent influence on certain individuals. Last week I arrested a gang of hooligans who had rented *A Clockwork Orange* and that same evening they raped the wife of a handicapped councillor right in front of him."

"There's no business like show business."

28

Sandy White

<div align="right">Monday, 17th June 2002</div>

It matters little to me if someone reads this one day. Since it is the truth. I realize that these disclosures will be painful for some people, that my candour will shock those hypocrites who keep their silence behind closed doors.

For one week now I have been seeing Katia every day. It is not without some shame that I may state that I am in thrall to her. Perhaps because between us there is no talk of love. Katia and I are conducting a transaction. I pay her for services rendered, just as one pays a nurse. What I experience with her I have never known before. Neither with Shelley, nor with Starr. On each of my visits she takes me a little further on the journey. A belated, unexpected voyage of initiation. Our relationship is abstract and at my age I cannot imagine a more perfect one. For me she is and she will remain a mysterious being, of whom I know only the skin, the scent, the taste and her first name, and with whom I barely exchange a word. Because words are redundant next to her saliva, her sap. She is a woman without a past, without a story, without wishes. A soft, warm cocoon that refuses nothing, makes no plans, does not want to know anything and makes my wildest dreams

come true. When I am with her only one thing counts: pleasure – immediate, raw, vertiginous pleasure. She is my opium, my last, enervating romance, and I am her regular customer. Luyckx has no idea of this. She says he never asks questions, but it is better that way. That way I feel a little like her lover.

It is half past ten in the morning and the red-light district is waking up in its soiled sheets. Behind Katia's window, the pale green curtains are still drawn, but Cox knows that she is waiting for him. She has put on the coffee and is sitting in her wicker chair opposite the bed. The chair with the rounded backrest, like the tail of a peacock in display. The chair on which Sylvia Kristel exposed herself in *Emmanuelle* and conquered the world. She is naked under her unbuttoned broad imitation fur. Her lips are painted bright red. A thick layer of make-up keeps her eyes open. Cox falls on his knees like a votary before a heathen Virgin. She says: "From today you may kiss me."

Whores don't kiss, except their lovers and their pimps. Cox feels this is a kind of promotion. Henceforth he is no longer an ordinary customer, even though he continues to pay. The money that he deposits in the glass hand on the bedside table is part of their desperate but unavoidable ritual.

After having sex, Katia and Cox share a cigarette, while he gazes in the mirror above the bed at their languid bodies like at the remains of a feast. Outside, people are crashing into each other, war is raging, and the city is making ready for the coming dog days of summer. He zooms in on her weathered features. Her lipstick has been worn away by the kisses, as if she has eaten strawberries and wiped her mouth with the back of her hand. In a flash he recognizes the face of an actress whose name he cannot recall but whom he can place clearly in a film noir, perhaps a film by Fritz Lang that he recorded years ago off the television. He remembers Luyckx's story about the lipstick on Sandy

Misotten's body and goes and sits on the edge of the bed. Katia puts her arms around him and nestles her head against his shoulder. She is sweating and her fragrant skin is sticking to his. He can feel her nipples like little rubber buttons in his back.

Outside the sun has dissipated the lingering morning mists. The city looks peaceful. Cox is struck forcefully by how all these nameless individuals have continued their little lives indifferently, apparently unaffected by anything in the outside world. Antwerp is the capital of false romanticism, of carefree stupidity. This is where the dramas erupt at night. Petty dramas that smell of stale beer and poorly digested nostalgia.

On the Grote Markt he decides to have breakfast on the terrace of the Café Noord and watch the incomprehensible theatre of the world. Then he sets off for the Nationalestraat where he keeps his archives and collection of video tapes. It's an old warehouse that he rents for a pittance from the OCMW, a kind of municipal Citizens Advice Bureau, and that you reach through a passageway and hidden courtyard. He moved his collection of curiosities here when Shelley remarked at one point that she had no room to breathe at home and that what's more she had no intention of dusting all this junk every week. This secret place was his ultimate refuge. Apart from him, no one else had ever set foot inside. Not even Starr. She had vanished from his life too soon for that.

In his will the entire collection was bequeathed to the Antwerp Film Museum. After all, his collection really deserved to be housed in a museum.

In the middle of the packed room stood the pièce de résistance: a twenty-seven-foot high elephant squatting on its haunches while rearing up to the glass dome with its trunk erect. Originally designed by Walter L. Hall for the Babylon segment of D.W. Griffith's cinema epic

Intolerance, the elephants flanked Igmur Bel, the mightiest city gate of Babylon at the time of Belshazzar in 539 BC. This megalomaniac set was not broken up after the film had been shot, and served as a shelter for the numerous homeless people wandering around the studios and hills of Hollywood after the great depression of 1929. When Cox heard in 1985 that the Babylon Motel in Londerzeel might be demolished, he bought up the pieces of one of the elephants that had been shipped there for the 1958 World's Fair, and had it transported to his storehouse at his own expense. There he restored it with the help of a Moroccan plasterer. The giant beast was hollow, and big enough for him to set up a table and chair inside its belly. Whenever he studied there alone, isolated from the mediocrity and insidious dangers of the outside world, Cox felt that he was truly sitting at the heart of cinema. Years ago, when he was desperately seeking Shelley, he had described this to Mrs Kountché. She had not really understood what he meant but it had just made her even more inquisitive than she already was.

The rest of the collection was less striking but no less precious for that. A couple of hundred original posters, of which one for Paul Wegener and Henrik Galeen's *Der Golem* from the year 1914 was the showpiece. Some fifty props, carefully wrapped in tissue paper, that he kept in cardboard boxes. Apart from the zebra-skin coat of ZaSu Pitts, which was displayed on a tailor's dummy from the Thirties; an old 35mm film projector that he had snapped up when the Berchem Palace cinema had closed down; over one hundred reels of film, mostly fragments of forgotten pictures, apart from Phil Karlson's *Kansas City Confidential*, which was complete; countless film props, wigs, shoes, fake jewels, trinkets, weapons and masks filling the steel wall-racks, folders full of press clippings, film magazines and a complete set of *Ciné Revue*, photos of sets, signed portraits of film stars, directors' manuscripts, original scripts and

screenplays and two pages of the storyboard for *Ivan the Terrible* illustrated by Eisenstein himself.

Cox opens the glass door of the bookcase where he keeps his videotapes. They are mainly films he has recorded off the television or old classics that he has bought. The tapes are arranged alphabetically by director. Between Lamorisse, Albert and Langdon, Harry he finds what he is looking for: *You Only Live Once* from the year 1937, *The Woman in the Window* from 1944, *Scarlet Street* from 1945, *Clash by Night* from 1952, *Moonfleet* from 1955 and *While the City Sleeps* from 1956. The last of these was broadcast on Flemish television in 1978 with the title *Het vijfde slachtoffer (The Fifth Victim)*. Perhaps it was once again only coincidence, but Sandy Misotten had been the fifth victim in the series of unsolved murders. Furthermore, he reads on the cover that Lang's film was premiered on 16th May 1956, and, if he remembers correctly, Sandy was murdered on 16th May.

Cox slides the cassette into the video player to check whether his theory is right. He vaguely recalls the plot, but when he reads in the opening titles that the character of Judith Felton is played by the B-movie actress Sandy White he fears that the manner in which she meets her end will not differ greatly from the way in which Sandy Misotten was murdered.

Cox needs to watch only a few scenes to remember the entire story.

Youthful Walter Kyne Jr, played by Vincent Price, inherits one of New York's leading daily newspapers. So, a press magnate, just like Baron Misotten de Landshove. He promises the job of editor-in-chief to whichever of his employees succeeds in having the serial killer arrested who is terrorising the populace. The psychopath, dubbed the lipstick murderer, because he smears the bodies of his victims with red lipstick, has already killed four women when the film begins. His fifth and final victim is called Judith Felton. Before leaving her apartment, he leaves a message

as usual on the walls in large, scarlet block letters: CATCH ME OR THERE WILL BE ANOTHER MURDER.

Cox goes into the elephant, sits down and starts to think. It is now clear that all the murdered women were the victims of one and the same crazed cinema-lover. It is as if the murderer is addressing him directly, as if he has hidden among the film props to spy on him, as if he is challenging him to test his knowledge of the cinema in some kind of morbid game. Cox knows less about the murders of Louise Vlerickx and Virginia Steiner, but Luyckx can help him there. Then he will be able to make the link with the films that inspired the two remaining murders. But first he must bring the superintendent up to date with his recent discoveries before the man strikes again, as his message on the window of Baron de Landshove's glasshouse gives cause to fear.

29

Henri C.

As he walks home in the pale afternoon sunshine, Cox thinks back to the murder of Louise Vlerickx seven years ago. She had studied for a few months in the department of theatre studies at the Institute but was expelled for misconduct. He never taught her himself and cannot really remember her clearly.

She was found dead in the garage of Jos Donders, a notary and vintage automobile collector in Puurvelde, behind the wheel of one of his cars, on 16th December 1995. How and why she had ended up precisely in his garage was never clarified. But Cox knows that the solution to the mystery is concealed in that question. Perhaps Luyckx is in possession of new details that could put him on the trail, because Cox does not know of a single film in which a young actress is killed or commits suicide in that way.

Outside his door, Mrs Kountché is chatting with the postman.

"Anything for me?" asks Cox.

The postman hands him a bundle of letters he was about to put in his mailbox.

"*C'est l'amour qui passe* – Love is passing by," sighs his neighbour, quoting the title of the Belgian film.

"*L'amour, l'amour...* At my age it's only bills that pass by," replies Cox. "Guess where I've just been."

"The elephant!"

"Exactly. And next time I'll bring you along too."

"You've been promising that for years."

Cox glances absent-mindedly at the post. As expected, it's just the telephone bill, the half-yearly motor insurance, some bank statements, advertising for the sweetbread festival at the local supermarket – and one normal letter in an oblong white envelope without a logo that he opens at once.

The text has been typed by computer in Times New Roman, his favourite font. He sits down at his desk and starts to read.

Friday, 14th June 2002

Dear Professor Cox,

I know that you have been in regular contact with Superintendent Luyckx of the Antwerp Criminal Investigation Department since the death of your wife on Saturday, 8th June 1998. I also know that you were questioned by The Sponge and his equally stupid Ostend colleague Lejeune in connection with my other magnificently staged executions. I also know – and this will probably interest you – exactly what happened to your girlfriend Starr. But that you will only learn when our paths finally cross.

In our fair city there are but two geniuses who have understood the true magic of the cinema – and that is the two of us. So it would amaze me if, thanks to your phenomenal knowledge of film, you have not yet discovered the link between my various creations. In the meantime it is obvious that Luyckx and his useless assistants will never succeed in deciphering my message. No one but you possesses the necessary intellectual development to unmask me. So whether I will be able to carry out my remaining

awe-inspiring projects is up to you. Or rather, up to your lethargy. "Stop me, or there will be another murder."

You don't know me, but we have more in common than you think. To put it simply, you are the light while I am the shadow, the darkness. So consider me your latest playmate. I think you now possess enough clues to continue the search, and wish you much success.

"I allow myself to be understood as a colourful fragment in a drab world" – Errol Flynn.

"A man should control his life. Mine is controlling me" – Rudolph Valentino.

Cordially,

Henri C.

P.S. One final additional hint: I do not draw my inspiration exclusively from films.

Cox's hands are trembling as he reads the letter. He does not have the slightest idea who is hiding behind the name Henri C. But it seems this man knows him well. A former student? He has taught more than a thousand in his time. He would have to search through the student rolls at the Institute for the last thirty years. But it seems from the letter that Henri C. is no fool and has surely predicted that Cox will look at the student rolls. So that would just be a waste of time. In any case, he cannot recall a single Henri. Perhaps someone who was in the hall when he gave his public lecture on Hitchcock? Or is it just a feeble joke? The sort of joke that Starr was all too capable of.

Cox puts the letter to one side, calls the number of the High Noon Film Club and recognizes at once the voice of the chairman.

"High Noon Productions, good afternoon."

"Good afternoon, Mr Van Lierde. This is Victor Cox speaking."

"Professor Cox! You must be ringing for your fee. My apologies, but our accountant stepped on a sea urchin while on holiday in Corsica and…"

"To be honest, I had forgotten all about the fee."

"Then it must be the group photo."

"Not that either. Do you have a member whose first name is Henri and whose surname begins with C? I have just received a letter from a Henri C. who had some questions about my lecture and…"

"I'll have to look it up on our mailing list."

"If you could. You can reach me at home."

A quarter of an hour later Van Lierde rings back. He has not found anything.

Cox puts the letter with its envelope in a transparent plastic folder so as not to leave behind any unnecessary fingerprints. Then he calls Luyckx and gets Lannoy at the end of the line. They agree to meet at six o'clock at the Macumba, Jos the Screw's bar.

30

Thelma Todd

Katia smells of coconut milk, a penetrating, sweet smell that clings to Cox's skin and clothes all day long. For fear that Luyckx will immediately recognize her scent, he has showered long and hard.

What really bothers him is that Henri C. knows so much about him while claiming that Cox is ignorant of his identity. Is he one of Starr's friends and has she given him information? Impossible. In all probability, Starr was his sixth victim. No, it can only mean that the mysterious author of the letter has been spying on him for years with the sole aim of implicating him as a silent witness, an unconscious accomplice in his crimes. As if he needs someone who understands and admires him. Like an unrecognized artist in despair because no one appreciates the refined subtlety of his murders, he asks his alter ego to publicize and explain his oeuvre to the world. What he craves is recognition. And only Cox can provide that. Which also explains why Cox had met most of the victims at some point and had been questioned by the police after almost every crime. That even applies to Louise Vlerickx, the soap star who had taken classes for a couple of months at the Institute. In fact it would not surprise him if he had also known Virginia Steiner in one way or another.

Cox dries himself, throws his clothes into the laundry basket and puts on clean underwear, cotton summer trousers and a fresh shirt. After shaving he douses his cheeks with aftershave. Even if Luyckx kisses him he won't be able to smell the scent of his girlfriend.

Two murders remain unexplained for Cox: Vlerickx and Steiner. But in his postscript Henri C. had written that he was not always directly inspired by a film. That is why Cox is still fumbling in the dark. But it is obvious that even in these cases the cinema is the source of his correspondent's inspiration. If it is not a character in a film it can only be an actress, or a tragic episode in her private life. Probably the violent way in which she met her end.

From the terrace of the Macumba, Luyckx and Lannoy watch as Cox parks his car up the street by the floating hotel, walks to the Nassau Bridge where he leans sunk in thought over the railings and stares at the drifting rubbish on the still waters of the Bonaparte Dock, then crosses the road and waves at them when he sees them sitting there.

"Hello, Victor!"

Luyckx's bonhomie sounds exaggerated, thinks Cox, he must have something to hide. Perhaps Katia has been talking. Perhaps because Luyckx has just left her: the whole terrace smells of coconut milk. In the distance, over the reclaimed landscape of the polders, threatening storm clouds are approaching and Cox asks whether it would not be better to go inside.

"If it starts to rain we can always move," replies Luyckx.

Cox pulls over a chair and says: "I still don't understand why no one noticed anything when Shelley was thrown into the water that night."

"Some people would prefer not to be implicated in that kind of drama and sometimes are unwilling to talk about it, but there are witnesses, rest assured, Mr Cox, there are witnesses," says Lannoy.

"Why have you kept this from me for the last four years? What did they see?"

"Nothing you don't know, Victor," interrupts Luyckx. "A grey car that collided with her head-on in the middle of the bridge. The driver got out, picked her up, chucked her into the dock and disappeared into the night with a broken headlight."

"Who deliberately ran her over," says Lannoy, correcting his boss, "embraced her and even kissed her before throwing her into the water. That's something completely different."

"That's the version according to Gin Joe, who hasn't been sober since Bernard Thévenet beat Eddie Merckx in the Tour de France in 1975. And as you know, it was bucketing down that night and you could hardly see a thing. Anyway, tell us why we're here, Victor."

Cox takes the plastic folder with the letter and envelope out of his trouser pocket and hands it to Luyckx.

"This is what I received this morning. I wrapped it up to protect it from fingerprints."

The Sponge takes off his Ray-Bans and starts to read. He clenches his jaws together like Clint then hands the letter over to Lannoy without a word.

"Any idea who Henri C. is? A long-lost twin brother, for example, who's called Henri Cox?"

"No. My father's middle name was Henri but he died over twenty-five years ago."

"A former student, perhaps?"

"That's what I thought at first, but I fear that's not the case. You could always have it checked out, of course. Perhaps you know someone with the same initials?"

"Apart from the chief commissioner of the vice squad, Henri Cools, I don't know anyone," says Lannoy.

"Let's stay serious, Lannoy. Take this to the lab. And while you're there, have a DNA check done on the saliva on the back of the stamp."

Lannoy gets up, casts a concerned look at Cox and walks to the police car. Jos the Screw comes out with two Duvel beers and puts them down on the table.

"Looks like there's going to be a storm. Is your colleague already off?"

"I'll have his one," says Cox.

"And is what's in the letter true?" asks Luyckx, his upper lip covered with foam.

"Undoubtedly."

"There's no business like show business."

"This fellow has the same encyclopaedic and, I admit, quite useless knowledge of the cinema that I have. I had already got to the bottom of this some time ago but I wanted to be a hundred per cent sure before I spoke to you about it. That is to say there are two murders for which I have not yet found the cinema version."

"Which ones?"

"The first two: Vlerickx and Steiner. In my view they are not based on films but on true events."

"Why?"

"Because otherwise I would have found the answer."

"It's time we put our heads together and went after him. What exactly do you mean by true events?"

"Perhaps Henri also draws his inspiration from the ways in which well-known actresses died."

"That would be child's play for you to figure out, wouldn't it?"

"The problem is that not many of them died in their sleep in peaceful old age."

"Perhaps… But how many of them suffocated in a choc-olate-coloured Lincoln Convertible 1935?"

"Just one," says Cox, who can suddenly see it before his eyes. "Thelma Todd."

"How come you didn't think of that before!"

"I didn't remember the make of car, the year or the col-our. But now I do."

"What was her name?"

"Thelma Todd. On Monday the sixteenth of December, 1935."

"Sixty years to the day before Louise Vlerickx…"

"Correct. On the 16th of December her maid, Mae White-head, found Thelma bent over the steering wheel of her Lincoln. At first she thought the actress had fallen asleep in her car. But she soon realized the gruesome truth that Thelma was dead."

Suddenly it starts to rain, just like it rains in a film: too loud, too hard and with no warning. Luyckx and Cox run, bent over against the storm, into the crowded bar.

"As far as I'm concerned the similarities with the murder of Vlerickx are beyond question," says Luyckx, handing Cox a fresh Duvel. "Actually, what it boils down to is that if Mr Donders the notary hadn't had a 1935 Lincoln in his collection our young actress would still be alive, right?"

"Indeed."

"What we must do now is go through every murder again, detail by detail, and compare my information, which for argument's sake we'll call reality, with your information, which we'll name fiction. And who knows, maybe Henri C. will write some more letters. I suggest we meet tomorrow at the station."

"I've got a meeting tomorrow at ten o'clock. But I'll be free in the afternoon."

"Two o'clock then. In any case, thanks for the letter. I feel we're on the right track now."

Luyckx calls for a taxi and leaves the Macumba at about half past seven. Cox remains at a table by the window and watches the downpour falling on Docklands through the misted-up glass.

Two Duvels later he sees himself crossing the Nassau Bridge next to Shelley. Two faint shadows behind a sparkling

curtain of rain. The racket of the falling water on the steel structure is deafening. They stand still. Is he embracing her? Strangling her? It's hard to make out. A grey car with headlamps like yellow flames drives on to the bridge. Cox watches as Shelley tries to wriggle free from his grip, falls over in front of the car, flies through the air and flops on to the shining tarmac like a ragdoll, sees how the unseeing car continues on its way and vanishes into the darkness like a fish in muddy water. In horror he watches as he picks her up, drags her over to the railings, cradles her for a time in his arms like a crushed child, and strokes her shattered skull. Then throws her like a sodden bundle into the Bonaparte Dock and runs off.

31

Roscoe "Fatty" Arbuckle

The next day at five to two, Cox walks into the police station in high spirits. Not to be questioned this time, but to work with The Sponge. It is as if he has stepped through the looking glass. The eternal suspect has finally landed in the world where he belongs – the world of investigators and avengers. He left home early that morning and drank a milky *koffie verkeerd* on the terrace of a Greek café on Sint-Paulusplaats. After the previous night's storm the steaming pavements smelt cool and the trees looked green again. Then he paid Katia a brief but refreshing visit. She reassured him that Luyckx did not know a thing. He feels he is walking on air.

"Bang on time for your first day at work," laughs Luyckx as Cox comes into his office. "Take a seat."

Cox opens his leather satchel, pulls out a bundle of handwritten notes and says: "I have found some more information about the Ice Cream Blonde."

"About who?"

"The Ice Cream Blonde. That's what they called Thelma Todd in Hollywood."

"In my opinion we already know enough about Thelma."

"Fine by me. I've also found the explanation for Steiner's murder."

"That sounds more interesting! Another copy of a film?"

"No, based on facts."

"Good. I prefer facts."

"Ever heard of Fatty Arbuckle?"

"No."

"He was a plumber and weighed nineteen stone. The lad had incredible comic talent and was hired by Mack Sennett in 1913 for three dollars a day to appear in his famous Keystone Cops farces. He quickly worked his way to the top and one year later appeared with Mabel Normand in *Fatty's Flirtation*, with Charlie Chaplin…"

"I've heard of him!"

"… in *The Rounders*, and with Buster Keaton in *The Butcher Boy*. In 1917 he signed a contract with Paramount bringing him $5,000 a week. He was an incorrigible party animal who spent money like it was going out of fashion, and a heavy drinker to boot."

"And now the facts."

"Arbuckle fell in love with the brunette on the cover of the sheet music for the song 'Let Me Call You Sweetheart'. He arranged an introduction to the young starlet on the set of *Joey Loses a Sweetheart*. Soon after that she was noticed by William Fox and won the Best Dressed Girl in Pictures contest, and things started moving for her. Meanwhile Arbuckle signed a contract with Paramount for the colossal sum of three million dollars. To celebrate he organized one of his most notorious parties. To escape the Beverly Hills paparazzi, he decided on the St Francis Hotel in San Francisco, taking three adjacent suites. On Saturday the third of September 1921, he drove down the Pacific Coast Highway in his brand-new Pierce-Arrow with Lowell Sherman, Freddy Fishback, the mysterious beauty with whom he had fallen in love and her friend Bambina Maude Delmont. A second car followed with a dozen girls to spice up the party if necessary. On Monday the fifth of September – Labour Day – the party was still in full swing. More than a hundred guests had shown up. Most of the

women were wandering around the rooms half-naked, the men were wearing pyjamas and everyone was blind drunk."

"There's no business like show business."

"At about half past three on the Monday afternoon, Fatty finally locked himself up with his prey in suite 1221. The big chance of his life. A little later the guests heard the young woman screaming from the suite next door. After that only groaning could be heard through the closed doors. Bambina Maude Delmont was about to go and see what was going on with her friend when Fatty appeared in the doorway, his clothes torn, and asked her to dress the young woman who was still calling for help and take her to another hotel. The room looked like a battlefield. 'She's making too much noise,' he said, 'and if she carries on screaming I'll chuck her out of the window.' The poor girl is brought to the Pine Street Hospital where, before sinking into a deep coma, she finds the strength to whisper that Fatty Arbuckle did this to her and must be punished. She died on the tenth of September without playing the starring role promised her in *Twilight Baby*. She was twenty-five. Her name was Virginia Rappe."

"Virginia. Just like Virginia Steiner. And the date: the tenth of September. It really fits. What was the cause of death then?"

"Her sexual organs had been mashed up and her bladder perforated, causing fatal peritonitis. Arbuckle had violated her with a champagne bottle. Exactly the way that Steiner was murdered."

"First of all, I'm going to check out whether anything suspicious occurred in one of Antwerp's hotels on the night of the ninth to the tenth of September 1996. If Henri C. followed this to the last detail when he staged the murder then perhaps we have a clue."

"Waste of time. He did it at home, or who knows, in the hospital car park where she was found."

"Victor, I'm still in charge of this investigation, right? His profile is more or less clear. But as long as we can't put a face to the name we're nowhere."

"It's as if I can see him in front of me."

"Well, describe him then."

"I can't. It's hard to make out. It's like… a vague silhouette… in the rain or mist."

"Steiner is the only victim you didn't know personally, or am I mistaken?"

"Steiner and Vlerickx."

"But Vlerickx attended classes at the college where you lectured?"

"Yes, but I didn't know her."

"Look, I've really got to be off now. Let's meet up tomorrow to carry on working on this. Same place, same time?"

"Fine by me."

"Can I drop you off anywhere?"

"Don't let me put you out. Which way are you going?"

Luyckx blinks guiltily and says: "Verversrui."

32

Virginia Rappe

It is midnight when I leave the little neighbourhood cinema where I've been watching a showing of *Bound*, the lesbian thriller by the Wachowski brothers. The auditorium was barely half full and the film had just started when a young woman with a razor-sharp profile and wavy raven-black hair came over and sat down right next to me. There was so little room between the seats that our knees were touching throughout the film. I don't know whether she was doing it deliberately, but during the hottest scenes she pressed her left leg against my right and through my corduroy trousers I could feel her thigh glowing.

Outside, on the pavement in front of the cinema, I finally catch sight of her features in the light of the red neon sign above the box office. She looks like an actress who, together with Pola Negri, was one of Mack Sennett's Bathing Beauties but whose name eludes me. An old-fashioned beauty: thin, darkly painted lips, bright white teeth, smouldering eyes emphasized with black eyeliner, heavy eyebrows. The sort of woman that, inexplicably, I fall for. She takes out a cigarette and looks at me enquiringly. As if by a miracle I find a lighter in my coat pocket. That same gold Dupont with which I can see myself lighting Debbie Marchal's cigarette too in the Bogart Bar.

"Did you enjoy it?" she asks.

I don't know what she is referring to. Does she mean the film or the way in which she pressed her thigh against mine?

"At times I found it particularly erotic," I reply.

"Me too, and that doesn't happen often. My name is Virginia."

"Virginia Rappe!"

"No, Steiner, Virginia Steiner."

"I mean you look like Virginia Rappe. Ever heard of her?"

"No."

"An actress. She didn't get very far."

"Thanks."

"Despite her incredible beauty."

"That's a bit better. Do I really look like her?"

"Like two peas in a pod. And you have the same name."

"Then I want to know all about her. You got time for a drink?"

"On the Grote Markt?"

"Fine by me. And what is *my* new friend called?"

"Victor."

A little later I am walking silently besides her along the Suikerrui with my hands in my pockets so as not to touch her hand. She is an unknown woman with whom I have shared the thrilling intimacy of the cinema in the half-dark for two hours. Now and again she turns to me and laughs, radiating the danger of innocence. And I smile back, as if I have awoken after an indistinct night beside a woman I do not recognize. I am ready to follow her like a dog wherever she may lure me.

On the Melkmarkt we go into the Keystone Café, a bar I did not even know existed. On the faintly illuminated stage at the back of the room, a few chalky-white couples are dancing to a sentimental song from the Thirties that I have never heard before but immediately recognize: 'Let Me Call You Sweetheart'. She sits down at a table

with a cracked marble top. I ask her what she would like to drink.

"Water," she replies, "because of my medication."

I order two bottles of sparkling Spa mineral water at the bar and bring them over to the table. She has removed her coat. She is wearing a deep-cut summer dress in a black-and-white houndstooth pattern. The same dress as Virginia Rappe on the sheet-music cover that made her famous, a dress that I suspect conceals the Milky Way.

"What a sad voice," I hear her say.

I reply, without knowing where the information is coming from: "The voice of Ruth Etting. She recorded it in 1931. But the song dates from 1910. The lyrics are by Beth Slater. The music is Leo Friedman."

She takes my hand and leads me to the dance floor. As we dance on the spot, pressed closely against each other, she whispers the refrain in my ear:

Let me call you "Sweetheart", I'm in love with you.

Let me hear you whisper that you love me too.

Keep the love-light glowing in your eyes so true.

Let me call you "Sweetheart", I'm in love with you.

I shut my eyes. I have heard that voice before.

"And now for Virginia's story!"

We sit down at the little marble table facing each other. I start the story. It is I who speak but it is a voice deep inside me that is dictating the words.

"Her real name was Virginia Caroline Rapp. She was born in New York City on the nineteenth of September 1895. Her mother was an unmarried prostitute. She never knew her father. She was eleven when her mother died. She moved to Chicago, where distant relations took care of her. By the time she was sixteen she was earning her living as a model. Her picture appeared

on the sheet-music cover of the song that we were just dancing to."

"I don't believe you."

"Maybe it's purely coincidence, but that's life. At least, my life. You can still see her in some film roles. But it was the tragic manner in which she died rather than her acting achievements that earned her a place in the history books. She was a few days short of her twenty-sixth birthday when she was buried in the Hollywood Memorial Park Cemetery on the thirteenth of September, 1921."

"My age exactly. But how do you manage to remember all these names?"

"No idea. It's as if I know them all personally. They live in me like parasites, like ghosts from the past."

"How exactly did she die?"

"That's no story for sensitive little girls."

"If I look so like her it's my right to know. And I would love to see a photo of her, if that's possible."

"I happen to own a couple of beautiful original prints."

"Would you let me see them one day?"

"You may. Tonight if you like."

When we leave the Keystone Café, Ruth Etting is singing 'What Do We Care If It's One O'Clock' and the dance floor is empty. On the Nationalestraat, Virginia takes my arm and asks where we are going.

"To the elephant," I reply.

She laughs, unaware of any danger. Now it is her turn to follow me. First down the narrow passageway, then over the courtyard under a rectangle of starry sky, with, in the exact centre, a wafer-thin crescent moon.

Once inside, I switch on the spotlights, one by one. Like a child in Disneyland for the first time, she stares around her with her mouth wide open. I let her get on with it, not without some feelings of pride, and while I look for the photos of Virginia Rappe in a cardboard box labelled

Silent Movie Female Stars – original prints 1915–25, I do not let her out of my sight.

"Look, here," I say once I've found the carbon prints. She follows me into the elephant, too confused to ask any questions. She looks at the photos as if they are her own reflection.

"How beautiful she is," she sighs.

"You must admit that there's a strong resemblance."

"Even her dress is like mine…"

"Wait a minute…"

I take a hanger with an ivory-coloured cocktail dress bordered with pearls and sequins off a copper rail and lay the valuable piece of clothing on the table.

"This was the dress she wore in *The Foolish Virgin*."

"The actual one?"

"Of course."

"How do you come by all this stuff?"

"Passion and patience."

"How soft," she says, stroking the shimmering material with her fragile fingers.

"Pure silk."

She flings her raincoat into the corner, unbuttons her dress and lets it slip to the floor. She is wearing transparent underwear, and nylon stockings with black lace garters. My suspicions were correct. Her bra cradles two milky-white, tender breasts. She puts on the silk dress, which looks as if it had been made for her. Virginia Rappe is standing there in front of me in the cold rays of an old spotlight. She says: "And now I want to know how I died."

Sitting at my desk, her legs slightly apart, she listens with obvious excitement to the story of the fatal party that took place on Labour Day, 1921, in room 1221 of the St Francis Hotel in San Francisco. When I've finished, I produce from one of the display cabinets a champagne bottle with a photo of Fatty Arbuckle on

the neck and a label bearing Rappe's portrait and the word SCANDAL.

"Look what they sold in Hollywood's souvenir shops at the time."

Breathing heavily, she presses the champagne bottle against the inside of her thigh, just above the garter, strokes the neck and whispers: "Fuck me."

I don't know how I can resist this vision, but I say in a strangled voice: "Come, come, Miss Steiner, you are young enough to be my daughter."

"With the bottle, I mean. Do you know what my medicine is? Tritherapy – triple antiretrovirals. Sex signed my death warrant long ago. Come on... Victor..."

Just then there's a ring at the doorbell.

Cox starts up, bathed in sweat, groping for his clock on the bedside table: it is a quarter to nine. The bell rings again. He rolls out of bed in a daze, pulls his dressing gown over his shoulders and stumbles down the corridor to the front door.

"Did I wake you up, Professor?" asks the postman.

"To be honest, you did."

"Is anything wrong?"

Cox looks terrible.

"No, no..."

"I couldn't fit this parcel in your letter box."

"Oh yes, the biography of Barbara Stanwyck that I ordered from Amazon."

"And a letter."

He puts on the coffee and opens the letter. It is a new message from his mysterious correspondent:

> "Now you be a good girlie, or I'll lock you in the garage!"
> Groucho Marx to Thelma Todd in *Horse Feathers*.
> Good luck,
> Henri C.

33

Peggy Rose

Cox calls Katia to say that he will not be coming around that morning because he has another appointment. She finds it both nice and a little odd that he lets her know. She is not used to that kind of old-fashioned consideration from her clients.

He stays in his study, pacing up and down until noon. He cannot shake off the previous night's dream. Some of the details are so realistic that he starts to question himself. It is as if he has a double memory: a selective memory where he files away his knowledge and important events from his past and from which he can draw particular pieces of information when he wants, and a second, unconscious memory that preserves, in a twilight zone of his brain, hidden facts, sublimated visions, concealed emotions, names and dates that he does not normally recall. The zone of repressed feelings, of unspoken consciousness. A perfect example is the name of the singer Ruth Etting, which he has never heard before but which appears as something self-evident in his dream. Perhaps he has accumulated too much information over the years and now, in order to free up space, is beginning to suffer from a kind of uncontrollable and programmed memory loss.

He places the Barbara Stanwyck biography between Terence Stamp and Anna Sten on his bookshelf, puts Henri C.'s

new letter in a plastic cover and leaves the house at around quarter past twelve. Before going to the police station, he makes a detour along the Nationalestraat in order to test the most disconcerting details of his nightmare against reality.

To the uninitiated, his depository looks like disorder and chaos. But he knows the place of every object, and heads straight for the display cabinet where he keeps the souvenir bottle from Fatty Arbuckle's trial. He bought the bottle in a junk shop on Rodeo Drive during his honeymoon. He remembers that Shelley found the object rather tasteless but it cost only a few dollars, and who knows what a collector would pay for it nowadays. But the bottle, which used to stand between a plastic bust of Mae West and a bronze Bugs Bunny, has vanished. A dark ring in the material on the shelf still clearly indicates the place. Cox feels dizzy and holds on to the cabinet to catch his breath. Then he enters the elephant and switches on the desk lamp. Everything seems normal, just as he left it on his last visit. In September 1996 there was an attempted break-in but the neighbours heard the noise and the thieves had no time to take anything. Perhaps he overlooked the disappearance of the bottle at the time. And come to think of it, was it not in September 1996 that Virginia Steiner was murdered?

With something approaching relief he goes up to the shelves where he keeps his collection of costumes in large flat cardboard boxes. Opening the box labelled *V. Rappe – 1920* he carefully removes the ivory-coloured dress that Virginia Steiner put on in his dream. Aghast, he sees that the dress has been torn in various places and is now displaying a dozen dark-brown, dried bloodstains, like a bouquet of sinister roses. Cox knows for certain that the garment was as good as new when he acquired it at Sotheby's Hollywood Collectors' Items auction in 1986. But after the previous night's horrible dream he has begun to doubt everything.

Perhaps, without knowing it, he bought the very dress that Virginia wore to Fatty Arbuckle's party in the St Francis Hotel. He falls into a panic, uncertain what he should do with it. Burn it or tell The Sponge? The second solution appears too risky, especially as he has no logical explanation for the bloodstains. He takes a third option and stuffs the box provisionally back into the cupboard under a pile of rusty cases of reels of Joseph H. Lewis's film *So Dark the Night* after removing the label with the name Virginia Rappe from the lid.

His dream is continuing to dog him with intense clarity and in fact seems more like a vision than a dream. He decides to walk down the Melkmarkt to find the bar where he saw himself dancing to an old tear-jerker with Virginia Steiner because he has never noticed it before in his wanderings.

He has no difficulty recognizing the narrow brick building with its door framed in bluestone. Everything is just as it was the previous night, except for the neon sign on the front. *The Keystone Café* has been replaced by *Pita Arno*. Cox had been was so unsettled that morning that he forgot to have breakfast, and the aroma of the cylinder of meat, dripping with fat as it revolves in the window, makes his mouth water. He goes into the restaurant, sits down at a Formica table, orders a shawarma wrap and looks round. The place appears familiar but the decor has changed. Where the dance floor was there is now a big round table with eight plastic chairs. A kitschy portrait, its frame decorated with gold leaf, hangs among the glasses behind the bar, showing a platinum blonde staring dreamily at the sky over her bare shoulder.

A suntanned fellow with combed-back, shining black hair brings him his sandwich and a beer. Cox asks how long the restaurant has been there.

"You're not from Antwerp are you, Mister?"

"I am," replies Cox, slightly irritated, "but it's been a long time since I was in this area."

"I can see that. We opened in summer 1997. At the height of the kebab craze."

"Wasn't there a bar here before?"

"More like a kind of dance spot for seniors. The Keystone Café. They used to play oldies. We took it over from Peggy Rose when she decided to give it up. She was eighty-seven."

"Peggy Rose?"

"Never heard of Peggy Rose the singer?"

The man gestures at the picture behind the bar.

"That's her at the height of her glory, in the Forties. After the Liberation she married an American, and even performed for a week in Las Vegas. 'Arno,' she said when we were at the notary's, 'promise me one thing: keep my portrait up there in the bar.'"

"I think I must have been here before," says Cox.

"Anyway, enjoy your meal," says Arno.

34

Henri Cassin

"How long have you been waiting for him?" asks Lannoy.

"Over quarter of an hour."

"Is it OK if I stay?"

"Sure. Why not?"

"I've got a feeling something's not right with this guy. The fact that he knew all the victims more or less, his wife's so-called accident, that anonymous letter sent to him and not to us, the so-called disappearance of his girlfriend and now these breakthroughs linked to old films no normal human being has ever heard of…"

"I know, I know. But if anyone is innocent…"

"His sudden need to cooperate with us…"

"It was me who suggested that. By the way, have you heard anything yet about Miss Mortenson? He's bound to ask me."

"According to the foreign ministry her father was posted back to New York. As PR for The Belgian House – a sort of information centre promoting Belgian tourism and culture in the Big Apple. I'm waiting for more details from our ambassador over there."

"So maybe Starr is still alive and went with them. I can't see the family moving away without their daughter just for the hell of it."

"That's for sure. I also managed to trace her dentist. The cast of that jaw that Lejeune sent out doesn't match hers."

"Good news."

"But I wouldn't let Cox know. I don't want him tearing after her like a randy dog and leaving the country."

There's a knock at the door. It's Cox, covered in sweat and out of breath.

"Where did we get to yesterday?" asks Luyckx.

"The resemblance between Debbie Marchal and Debbie Marsh. But first I have to show you something."

Cox pulls the letter out of his pocket.

"I've received another message from Henri Cassin."

Luyckx and Lannoy look at each other in astonishment.

"So you know who he is?"

"Who?"

"Henri C.! You just said Henri Cassin."

Cox stares in confusion.

"Did I say that?"

"I heard you clearly," says Lannoy.

"Who is Cassin?"

"No idea."

"Come on, Victor. Who is Cassin?"

"I really don't know. This is happening to me more and…"

"What?"

"Remembering names that I have never heard before. Visualizing situations that I cannot place."

"You've been watching too many films," says Lannoy, leafing through the telephone book.

"Found anything?" asks Luyckx.

"Four Cassins whose first name begins with H. I'll start calling around."

"This morning," Cox continues without emotion, "I thought for no reason of the title of a song from the Thirties: 'Let Me Call You Sweetheart'. I swear that I had never heard the song, and did not know the words or tune. But I did know that the song was recorded by Ruth Etting in 1931, that the composer's name was Leo Friedman and that the lyrics were by someone called Beth Slater Whitson."

212

"This isn't really getting us anywhere," sighs Luyckx, rubbing his eyes behind his Ray-Bans.

"Did Virginia Steiner have AIDS?"

"What?"

Cox calmly repeats his question.

"How did you know that? Yes, she tested positive. But that came under professional secrecy, and what's more it was kept quiet at the personal request of Dr Verdonck."

"Don't ask me how I know. Perhaps because Virginia Rappe suffered from syphilis. A logical deduction, I would say."

"To be frank, Victor, I haven't seen much evidence of logic since you started interfering in this case."

"It was your idea."

Lannoy shuffles in and sits down dejectedly on the corner of Luyckx's desk.

"Nothing. A Hector, a Hilde, a Herman and a Helga. But no Henri Cassins."

"I'm not surprised," says Cox.

"What do you mean?" asks Luyckx.

"Mr Cox, you're really beginning to bug me," interrupts Lannoy.

"Let him finish, Luc."

"I don't know anyone personally with that name. As I uttered the name unconsciously, it must logically be the name of a fictitious character, a character from a film."

"Here we go again!" cries Lannoy. "I'm sorry but I've wasted enough time here! I've had enough!"

He barges out of the room, slamming the door.

"Don't take any notice of him. The warm weather always makes him funny. Just try and remember the film in which Henri Cassin appears."

"Have you heard anything yet about Starr?"

"Nothing in particular. The last time anyone saw her was at a reception on a mailboat in Ostend, the day she disappeared, if I remember correctly."

"So she wasn't in Sweden?"

"No, Victor. She went to a reception on board the *Seastar II* in the late afternoon of the fourteenth of October."

"Just like Faithfull…" sighs Cox.

"Just like who?"

"That's another story."

Luyckx gets up and claps him encouragingly on the shoulder.

"The important thing now is to find out who is hiding behind the name of Henri Cassin."

"Let me sleep on it."

"Of course. Call me tomorrow. You really need some rest."

Instead of returning home, Cox goes like a sleepwalker back to his storehouse on the Nationalestraat, as if it is the only place where he can find the answers to the disturbing questions he has been asking himself since the previous night. There, and there alone, surrounded by the divine objects and souvenirs that he had accumulated over the years, he lived in spiritual kinship with the gods and demigods to whom he had devoted his life. On the way he tries to concentrate on the name Cassin. Why had he uttered that name today of all days? What was the cause? The answer is clearly to be found on the steel racks or at the foot of the hollow elephant that watches in silence over his shades and spectres. Henri Cassin… It sounds so French that it is probably a pseudonym chosen deliberately by the author of the letters. Not an innocent choice, but an important tip – a pawn on the chessboard, an element in the riddle – that he is dishing up to Cox.

Cox closes the door behind him and goes and stands in the middle of the room. He looks around to check whether he can see the name Cassin anywhere, on a poster, an object, a magazine cover or a photo. On the top shelf two swollen crows from Hitchcock's *The Birds*

are perched, ready to swoop down on him lethally and peck out his eyes.

Discouraged, he goes and sits at his desk in the elephant and tries to order his thoughts. Perhaps Cassin is an unknown French actor or director whose name he heard long ago. But even in his *World Encyclopaedia of the Cinema* the answer is not to be found. What could have prompted him that morning to come out with the name Cassin? Nothing, apart from Virginia Rappe's dress. Had he been so shocked by the bloodstains that every other detail escaped him?

He decides to get out the box again and inspect the contents once more. In any case the dress must disappear. Luyckx is right when he says that logic is absent from the investigation, and Cox does not have any logical explanation for the stains. Taking the eighty-year-old, bloodstained dress to the dry-cleaners would simply create even more suspicion and distrust, Cox thinks, and if I light the stove and burn the dress, the neighbours will wonder why smoke is rising from my chimney on such a hot day. The only solution is to take the dress home and dissolve it in a bath of sulphuric acid in the cellar. But I haven't the faintest idea where to buy sulphuric acid.

As he removes, one by one, the cases of the reels of *So Dark the Night*, beneath which he has stuffed the incriminating evidence, an image suddenly occurs to him. It is the closing scene of that film: a man has just been gunned down by the police in a country hotel and is dying in a pool of blood in the hallway. He looks for the last time through the window and sees himself as a smiling police inspector arriving at the little hotel and looking inside. His face, twisted with pain, is superimposed on his earlier carefree features, blending with them. Gathering his last strength, he clutches an obscure object and hurls it at the window, shattering the image

of his double. With his last breath, he mumbles: "Henri Cassin is no more. I've caught him and killed him."

In his notes for a lecture on 'Deviant Films Noirs' that he gave at the High Noon Film Club in 1996, he finds all the facts and a synopsis of the film. He reads everything, word by word, taking his time, safely shut off from the outside world in his elephant, afraid of what he will discover.

The film was produced by Ted Richmond for Columbia and premiered on 10th October 1946. Henri Cassin, an inspector with the French Sûreté in Paris, goes on holiday after working for eleven years without a break. He travels to the godforsaken village of St Margot and stays at the Michaud family's hotel, where the daughter, Nanette, played by Micheline Cheirel, immediately attracts him despite their difference in age. Madame Michaud, played by Ann Codee, encourages this tender relationship despite the fact that her daughter is already engaged to a young farmer from the area, Léon Achard, played by Paul Marion. She hopes that marriage to a police inspector will give her daughter a better standard of living in Paris. Naturally, Léon does not agree to this and threatens Nanette that if she marries Cassin he will pursue her and never leave her alone. Nanette is moved by her boyfriend and decides to stay with him. Cassin is inconsolable.

Soon afterwards, Nanette's body is discovered in the river. She has been strangled, just like Léon, whose remains are found in his farmyard. Cassin offers to help the local police in their investigation by making casts of the footprints left by the murderer in the mud. The next morning he receives a letter in which the killer announces a new murder. That same day, Madame Michaud is strangled. Cassin returns to Paris to bring his boss, Commissioner Grande, played by Gregory Gaye, up to date. When he provides a description of the murderer that he has deduced from the footprints, the Sûreté find that the suspect strongly resembles Cassin.

He begins to have doubts about himself, and writes down a few sentences to compare them with the messages he has received. There can be no doubt: the two letters were written by one and the same person.

Henri Cassin wants to be arrested. According to the forensic surgeon, he is suffering from a form of acute schizophrenia. He escapes from the police station and returns to St Margot, this time to do away with Nanette's father, played by Eugene Borden. But the police are one step ahead of him and gun him down in the hallway of the hotel.

Cox closes the folder and stares blankly through the round opening in the elephant's belly. Is he, without being aware of it, the author of the two messages? If so, then he must have committed the murders too. However, that is so impossible to accept that he decides to say nothing for now to Luyckx, but wait until his dark friend, growing like a fungus inside him, prompts him again with something that will bring him closer to the truth.

35

Shelley Winters

After Luyckx has still not heard from Cox the next day at two o'clock, he calls him himself. But there is no answer. Two hours later he tries again, without success.

"He's made a run for it," says Lannoy. "I warned you."

"Don't be so naive, Luc. Why would he?"

"Because he murdered his wife."

"That was four years ago! Why would he have waited so long?"

"I'll prove it."

"You're just jealous because he's finding the answers to the questions you've been asking for years."

"Nonsense. Your nice professor has been screwing us around and that's starting to bug me."

"He was totally knackered yesterday and I know why. I'm sure he's just at home out for the count."

"Want a bet?"

Cox is standing outside his door chatting to Mrs Kountché when the Opel Vectra appears round the corner. Luyckx and Lannoy get out, and Mrs Kountché says:

"Those two don't leave you alone."

"Well, Victor," says Luyckx, "what about our agreement?"

"What agreement?"

"You were going to call me."

"If I found anything."

"And you've found nothing," says Lannoy with a broad grin.

"Nothing worth bothering you about."

"Professor Cox has spent another night in the elephant."

Cox glares at her and says: "May I introduce my neighbour, Mrs Kountché?"

"We already met four years ago," says Luyckx.

"The day of Shelley's accident. And Mrs Kountché was talking about an elephant then too," says Lannoy. "I've never forgotten."

"And I still don't know where he keeps it. Mr Cox has promised to take me along next week, but he's been promising me that for years. Isn't that right, Mr Cox?"

"A promise is a promise," replies Cox curtly.

"Shall we go in?" asks Lannoy.

While Cox is fetching some drinks, Luyckx and Lannoy ferret around the living room. They are not looking for anything in particular, but you never know. Lannoy notices how Mrs Kountché is keeping an eye on everything from her balcony and draws the curtains.

"Why are you doing that?"

"That neighbour is much too nosey."

"We don't have anything to hide."

"We don't, no."

Lannoy finds an envelope with an unfranked stamp on the desk and puts it in his pocket.

"What's that?" asks Luyckx.

"The cheque for his car insurance, I think."

"What do you need that for?"

"For the stamp, Fons, the stamp."

"When did you start collecting stamps?"

"Goodness, it's dark in here," says Cox as he comes back into the room.

"Tell me, Cox, what exactly does your neighbour mean with all this talk about an elephant?"

"It's just an innocent joke between us. She always wants to know everything. And when I don't feel like telling her where I've been, I say that I'm coming from the elephant. It's been going on for years."

"Why did she say that you'd spent the night in the elephant, and not on it or with it?"

"Perhaps she thinks it's a café, for all I know."

"And what is it really? A big fat girl on the Verversrui?"

"Good God, no!"

"Victor never visits whores," says Luyckx, "it's not his style. Right, Victor?"

"It's just code for 'none of your business'," continues Cox, as if he has not heard Luyckx's remark.

"And how did you settle on that... code word?"

"Perhaps because it sounded African."

"You think elephant sounds African?"

"Come on, Luc," interrupts Luyckx again, "that's enough harping on about the bleeding elephant. Let Victor tell us instead what else he's found out about Henri Cassin."

"As I said, nothing special."

"Mr Cox has been too busy, I imagine," says Lannoy.

"Where have you been all this time, Cox? And please don't tell me it was 'in the elephant'."

"Are we working together on this or we going back to the way things were before? But anyway, I spent the whole night by myself – yes, by myself – wandering through the empty streets trying to think. Everyone has his own methods."

"Another irrefutable alibi!"

"Alibi for what? Has Cassin struck again?"

Luyckx cannot understand what has got into Lannoy to make him needle Cox in this way. Luyckx, who feels a growing sympathy for the muddled, helpless professor, is almost sorry for him, and says: "I think we should let Victor get some rest. We know he's safe at home and that's the only thing that counts."

"Sorry, Fons, I'm not yet through," says Lannoy, settling back into the sofa. "I have my methods, and I've been quite busy for the last few days. I admit, Mr Cox, that I only have a supporting role in this film, but as you know, insignificant characters can suddenly turn dangerous. In fact, all I've done is apply your system. I've had another thorough look at your declaration of the ninth of June 1998, when you came to report the disappearance of your wife. Can you remember what you replied to the question what you had been doing on the night of Saturday the sixth of June?"

"I was at home watching a film."

"And can you remember which film?"

Cox thinks for a moment, shakes his head, and looks at Luyckx as if imploring for help.

"*The Big Knife* by Robert Aldrich, on a German channel. It's there in black and white in the report."

"It could…"

"No, Mr Cox, no it could not. I've been through the schedules of every channel and that particular film was not on anywhere."

"I probably mixed up two films because of the German."

"But *The Big Knife* does mean something to you?"

"Of course! Aldrich was inspired by a play by Clifford Odets and asked James Poe to write the screenplay. The film came out in November 1955."

"That doesn't interest me at all. What I want to hear from you is the plot. Listen to this, Fons, you're going to enjoy it."

Cox shuts his eyes to reach as clearly as possible into the deepest layers of his memory. He starts to speak like an automaton, barely audible. With a monotonous, soft voice, a little absent, like Wylie Watson, Mr Memory in Hitchcock's *The Thirty-Nine Steps* from the year 1935.

"One common feature of films noirs is that the characters are themselves part of the world of film. These pictures allowed the writers and directors to denounce the dark side of Hollywood, while continuing to benefit from the system.

The Big Knife is one such film, just like the textbook example of *Sunset Boulevard*. It is the story of Charlie Castle, a former Broadway actor played by Jack Palance, who refuses to renew his contract with Hoff International Pictures, because the roles they are offering do not interest him. As a result Charlie is seriously depressed. He drinks too much, which threatens his marriage with Marion, played by Ida Lupino. Charlie asks his agent, Nat Danziger, played by Everett Sloane, to inform Stanley Hoff, played by Rod Steiger. Stanley lets Charlie know through his assistant Smiley Coy, played by Wendell Corey, that he does not appreciate his star's attitude but is willing to offer him more money if he will reconsider. Charlie refuses again, drinks even more than before, and seeks solace in the arms of Connie Bliss, the wife of a colleague, played by Jean Hagen. His wife is in despair and walks out on him. Stanley reminds Charlie that years ago, when he was drunk behind the wheel, he killed a pedestrian. If Charlie does not renew his contract, he will not hesitate to leak his secret to the press. Charlie has no choice and agrees. All the same, he informs Smiley Coy that he is worried about a young starlet, Dixie Evans, played by Shelley Winters…"

"Stop!" cries Lannoy in triumph. "What did you say? Shelley played the role of Dixie? What do you think, Fons, sounds familiar, right?"

"Carry on, Victor," says Luyckx calmly.

"She had witnessed the accident. Coy reassures Charlie and tells him that he will take care of the matter. He gets Dixie to drink until she's no longer able to stand straight, then pushes her under a car…"

"I think we've heard enough," says Lannoy.

"Don't you want to hear the end?" asks Cox.

"I do," says Luyckx.

"Charlie finally commits suicide by slitting his wrists."

"Mr Cox, I think you didn't watch the film that night. I think you were with your wife on the Nassau Bridge."

"You must admit, Victor, that this is more than a coincidence," says Luyckx. "Shelley's nickname was Dixie and she was blind drunk when she was run over…"

"That just proves that it was not an accident, as I have been insisting for years, and that she too was murdered by Cassin."

"My question remains why you referred specifically to that film."

"Because you're mistaken when you say it wasn't broadcast that night," says Cox with a sigh.

"And how come that you never saw the resemblance between a film that you obviously know by heart and the death of your wife?"

"Sometime entire sections of my memory disappear, and then resurface in the tiniest detail without explanation. Sometimes I think that Cassin is reading my thoughts and prompting me to say things."

"For instance?"

"His name, for instance."

"Why would your Cassin murder her anyway? He didn't have the slightest motive. You, on the other hand…"

"Because Dixie was a slut. Just like the other victims. Cassin is nothing but an exceptionally refined and cultured avenger, who restores morality and upholds justice."

"Do you realize what you're saying," asks Lannoy, appalled.

"I'm not saying that, Inspector, *he's* saying it," whispers Cox, motionless in the middle of the room.

Luyckx gets up and makes a sign to Lannoy to follow him.

"He's finished. I think we'd better leave him alone with Cassin and then carry on talking tomorrow at the station."

"No way! We should take him in now and keep him in detention until he tells the truth."

"If we lock him up, he'll clam up, trust me."

"And if we leave him free, we'll lose him. Fons, now that he knows that I'm on to him we can't run that risk."

223

"He trusts me. What I suggest is that you carry on and I'll stay here. Either he'll sleep until the morning, or we'll chat all night and sooner or later he'll be in the bag. Assuming that your theory is right, of course. I'll call you if I have to. Otherwise come and pick us up tomorrow morning at eight."

"I don't know what you see in the guy," sighs Lannoy as he opens the front door.

"His frailty, maybe."

36

The Cripple

When Luyckx reappears in the living room, Cox is sitting on the sofa with his head in his hands. He is so sunk in thought that he does not even notice that Lannoy has gone.

"Something isn't right," he says. "If Cassin also murdered Shelley, she wasn't part of his master plan."

Luyckx fetches two Heinekens from the fridge, lights a cigarette and sits down opposite Cox in a sagging brown-leather armchair.

"Why not?"

"Because Judith is the fifth victim of the lipstick murderer. If he had also murdered Dixie, then Judith would have been the sixth one."

"Who's Judith?"

"Judith Felton... I mean Sandy Misotten."

"I think it would be best if you got a few hours' sleep before we go any further."

"Everything seemed to fit, don't you see? Walter Kyne Jr was a press baron, just like Baron Frans Misotten de Land-shove. And Lang's *When the City Sleeps* came out in Flanders as *Het Vijfde Slachtoffer – The Fifth Victim*... Sandy White and Sandy Misotten... They both have the same name... Of course, Vincent Price doesn't commit suicide at the end, but that's not relevant... Dixie Evans didn't look like Shelley and Shelley Winters looked even less like Dixie... and Cassin..."

"Victor, you're just talking gibberish. Go to bed. I'm going to watch TV for a bit and then I'll sleep on the sofa. If anything occurs to you, don't hesitate to wake me."

Luyckx watches an episode of the series *Wedding* on Channel 2 with Louise Vlerickx in the role of the young hellcat who makes her parents' lives a misery. He finds it hard to concentrate on the story because the image of the dead actress's broken body in Notary Donders's Lincoln keeps popping up in front of him, and at about eleven o'clock he switches off the television. Then he calmly looks round for the first time without anyone else watching. It's the indescribable dreariness of Cox's flat that strikes him. How could a film genius survive here all those years in such empty, depressing surroundings? This petty bourgeois apartment is nothing like the lair of an obsessive collector, still less that of a bloodthirsty monster.

The pale daylight is just beginning to shine through the curtains when Luyckx hears, in his sleep, someone shutting the front door. He leaps up, swearing, and runs into the bedroom. The bed has been slept in, but it is empty. Lannoy was not mistaken: Cox has escaped.

Luyckx opens the front door a few inches. The street is quiet and empty. The façades opposite are coming to life in the rosy glow of the rising sun. Early birds are singing loudly in the gardens. With relief, The Sponge notices that the grey Ford is still parked outside the door. Cox has left on foot, God only knows why. Luyckx sees him just disappearing round the corner and runs after him. He follows him at a distance across the square in front of the supermarket, still closed at this early hour. He loses sight of him when a dustcart stops in his line of vision to scoop up a pile of blue plastic sacks. He runs across the square, listening to the echo of his footsteps, hides behind the kiosk and sees Cox climb into a taxi.

Luyckx gets in next to the driver in the next taxi, shows him his police ID and tells him to follow the first one.

"OK, but there's no smoking in my taxi."

"There is in mine," growls Luyckx, opening the window.

"Seat belt!"

"Just make sure you don't lose them," says Luyckx, fixing his belt.

On the Italielei, the first taxi goes through an amber light that then turns red. Luyckx's driver slows down, hesitates and looks at him enquiringly.

"What are we waiting for?" asks The Sponge excitedly.

"I'm not driving through red. More than my job's worth!" protests the driver.

"Not with me on board. Give it a bit of fucking welly or I'll take the wheel myself."

"Why do these things always happen to me?"

They skid over the crossroads, missing a car coming from the left by a miracle and catch up with the first taxi on the Leopoldplaats. In the Nationalestraat, Cox's white Mercedes slows down and stops outside number 121. Cox climbs out. Luyckx waits until he sees him disappear into the small passageway between the houses and opens his door.

"Wait a minute! We're not in the cinema. Who's going to pay for this joyride?" asks the driver, damp with sweat.

"Not me, for sure," answers The Sponge, handing the stupefied man his visiting card. "Send the bill to the station."

Luyckx climbs out of the car. "Practically fucking killed me," he hears the driver grumble.

The passage into which Cox disappeared opens into a small courtyard full of beer barrels, bin bags and empty crates. There is just one rusty steel door in the blank wall ahead of him, and it turns out to be locked. No bell, no name. Cox must be behind that door.

Luyckx decides to wait in the café over the road until he comes out again. He calls Lannoy on his mobile.

"Did I wake you?"

"No way. I'm coming. Did he say anything?"

"Come as quick as you can to the Nationalestraat. I'm sitting right opposite number 121 in a café… What's the name of your bar again?"

"The Bad Conscience. But just say The Cripple… Everyone knows me round here," replies the owner, mopping the floor at the back of the room.

"The Bad Conscience Café."

"Oh, The Cripple? He works for me. How did you end up there?"

Ten minutes later Lannoy strides into the bar.

"Hi Cripple," he calls out as he sits down opposite Luyckx at the table by the window.

"Lucky Luc, Jesus. It's been a while. Coffee?"

"Just the job."

Luyckx bends forwards and asks quietly: "One of your informants?"

"A gold mine."

"Interesting."

"Well, didn't your chum come with you?" asks Lannoy, teasing and nervous at the same time.

"He's locked himself in the building at the end of the passage on the other side. I followed him here."

"You let him get away?"

"We were both asleep and…"

"Obviously not in each other's arms. That's a relief."

"Luc, please! I can do without these idiotic comments."

The landlord shuffles up to their table in his slippers and slops two coffees across the burnt crimson plastic surface.

"You know my boss?" asks Lannoy.

"Of course. Superintendent Luyckx, also known as Fons The Sponge. I recognized him as soon as he came in."

"Come and join us," says Luyckx. "I know that you sometimes help Luc out and I've got a couple of questions."

"I could tell. The price depends on the question."

"No. The price depends on the answer and I don't have a penny on me."

"Lucky's good for an advance."

"Who lives opposite?"

"Above the launderette? Abdul and our Monique."

"No. The steel door at the end of the passage."

"No one lives there. It's a sort of storeroom, think it belongs to the council, where the old guy keeps his junk."

"What sort of junk?"

"Antiques, I think. I've never been in there. In fact no one has."

"And the old guy, any idea who he is?"

"Some kind of wheeler-dealer. Not exactly friendly. Never speaks to a soul."

"Do you see him often?"

"He comes and goes. I've noticed that he sometimes comes late in the evening and stays all night."

"Always alone?"

"Mostly. Although I've seen him go in a couple of times at night with a woman."

"Is there another way out of the warehouse?"

"No way. It's completely surrounded by other buildings."

"Great. Ever heard of the elephant?"

The Cripple looks at Lannoy in surprise.

"Elephant?"

"Forget it. Thanks anyway, not that the information was worth much."

"Like I said: depends on the question."

"Have a drink on me," says Lannoy.

It is half past nine when Cox finally appears with a flat rectangular cardboard box under his arm.

"Here he comes," says The Sponge excitedly. "I'll do the talking."

Luyckx and Lannoy run across the street and stop Cox in front of the launderette's steamed-up window. He jumps out of his skin, turns pale and stares at them wordlessly.

"Well, Victor, did you sleep well?"

"What… What are you doing here?"

"We could ask you the same thing."

"Me? I, er… I was about to…"

"About to show us what you hide behind that steel door."

"What steel door?"

"At the end of the passage."

"You don't want to bother with that. Just a lot of old junk…"

"But I'm curious. What about you, Luc?"

"I'm squirming with impatience."

"Listen, Fons, I have a meeting at ten o'clock and…"

"I know, Victor."

"How do you know that?"

"Mr Cox," interrupts Lannoy impatiently. "Either you open that door for us right away or I'll do it."

Cox's hand is shaking so violently that he has trouble inserting the key into the lock.

"Come on, give us that box," says Luyckx.

"What's inside?" asks Lannoy.

"An old dress."

"A dress?"

"One of Virginia Rappe's. I was just taking it to the launderette."

Cox opens the door and steps into the warehouse, followed by Luyckx and Lannoy, who can scarcely believe their eyes.

"Jesus Christ. What the fuck is that?"

"The elephant," says Luyckx calmly.

"My temple," says Cox with tears in his eyes. "Do you know what Jean Cocteau said about it?"

"'The cinema: that temple of sex with its goddesses, its guards and its victims,'" replies Lannoy.

"How did you know that?" asks Luyckx.

"Because it's written up there over the door."

"That is, to a certain extent, the motto of my collection."

"How did you get that thing in here?" asks Luyckx, stepping out of the elephant and looking at the erect trunk thirty feet above his head.

"It's a long story. In 1916 D.W. Griffith had twenty of these beasts built for his epic *Intolerance* as part of a gigantic set to represent Babylon at the time of Belshazzar."

"Don't tell me you bought it at an auction in Hollywood."

"It seems kind of familiar to me."

"It could well be," says Cox. "You may have seen it in the garden of the Babylon Motel in Londerzeel on the Antwerp–Brussels highway. I saved it from being demolished in 1985. It's the only surviving copy in the world."

"When Marion Mees was murdered in bungalow no. 17, just like… Who was it again?"

"Marion Crane, played by Janet Leigh…"

"Right… When she was stabbed to death, you forgot to inform us that you not only knew the victim but also the motel."

"No idea."

"Bullshit!" growls Lannoy. "You knew very well that the motel resembled the one in the film. You had been there to pick up this ridiculous thing!"

"All motels look the same."

"But at the time you yourself pointed out the connection with Hitchcock's film!"

"No, that was Starr. But you're right," sighs Cox. "I no longer know what to think. I'm mixing everything up. The closer I come to the truth, the less I understand it. The more I… start to doubt myself."

Luyckx opens the cardboard box and takes out the silk dress.

"Is that Virginia Rappe's dress?"

"Yes. But I don't know where the bloodstains come from. I swear it."

"What bloodstains?" asks Luyckx.

"On the front…"

"That's not blood, Victor… Those are wine stains."

"Why did you think they were bloodstains, Cox?"

"Fons," stammers Cox. "I think I need help."

37

Carla Wuyts

That same day, Cox was transferred at his own request to the psychiatric department of Stuivenberg Hospital, where he was confined under police supervision in a single room. In view of his mental exhaustion, Dr Carla Wuyts, head of the Schizophrenia and Paranoia Department, prescribed a sleeping cure for him for the next forty-eight hours.

Meanwhile Lannoy was combing through the warehouse on the Nationalestraat with a dozen detectives and drawing up an inventory of the hundreds of pieces included in Cox's incredible collection. Lannoy was radiant. Anything with a conceivable connection to the films that had inspired the murders was put to one side and added to the various dossiers as potential evidence, including a pair of Thelma Todd's pale-green, satin evening shoes, signed photos of Shelley Winters and Sandy White, press clippings about the Starr Faithfull case, the grey wig used by Anthony Perkins in *Psycho*, Gloria Grahame's fake jewellery from *The Big Heat* and Liz Taylor's frock from *BUtterfield 8*. In this delicate task he drew on the assistance of Barton Poels, the projectionist at the Film Museum, whom he had already consulted over the possible cinematographic parallels between Shelley Cox's disappearance and Aldrich's film.

* * *

On Monday, 24th June 2002, Cox is sitting in light-blue pyjamas opposite Dr Wuyts, a little drowsy from the sleeping pills. Four framed diplomas and a couple of children's drawings hang on the gleaming walls of her plain white office. The light is falling in horizontal bands through the blinds. On the window sill, snake plants sprout from five plastic flowerpots like yellow-green petrified flames. Somewhere a clock ticks unseen. Outside, an ambulance is driving into Accident and Emergency, its siren echoing. Dr Wuyts looks through her reading glasses at the file lying in front of her on the spotless, glass desktop. She has Joan Crawford's lips, thinks Cox. Then she lights a cigarette, clears her throat, and asks: "Are you feeling a little rested now, Mr..."

"Cox, Victor Cox."

"Of course. You're a professor of film history if I understand correctly?"

"Retired. But I have the feeling I could sleep for years."

"That's quite normal. You were hospitalized voluntarily. Why was that?"

"Because I fear I have done things that I cannot remember and for which I am not responsible."

"Such as?"

"Have you spoken to Superintendent Luyckx?"

"He has told me one or two things about you."

"Good. That makes it a little easier for me. Fons is a great chap. Well... Sometimes I have visions that lead me to believe that I have murdered my wife Shelley and my girlfriend Starr. And not only my wife and girlfriend."

"You mean Louise Vlerickx, Virginia Steiner, Marion Mees, Debbie Marchal and Sandy Misotten?"

"I see that you are well informed."

"And why would you have committed these atrocities, Mr Cox?"

"I really don't know, that is precisely the problem. I am, I believe, the mildest of men. I cannot bear the sight of

blood – except on the cinema screen – and even then preferably not in colour. Be frank, Doctor, do I look like a serial murderer?"

"You look too normal not to look like one."

"It is as if there were someone else inside me who awakes when I sleep and without my knowing does unpleasant things of which I am subsequently suspected and which I myself am starting to believe in."

"A sort of dark, demonic, second Victor?"

"Yes."

"Which Victor do you see when you look in the mirror?"

"Myself."

"And this other Victor, can you describe him?"

"He looks exactly like me. But when he walks he is slightly more bent over. Like someone running through the rain."

"Or like a guilty man who doesn't want to be recognized. So you've actually seen him?"

"Once. Actually, he really was running through the rain. Across the Nassau Bridge to Docklands."

"And what was he doing on the Nassau Bridge?"

"He was pushing my wife under a car."

"Does he have a name?"

"Cassin. Henri Cassin. He writes letters to me signed Henri C."

"Handwritten letters?"

"No. Typed on a computer and printed on normal white A4 paper. The sort of paper that everyone has at home."

"What exactly was in these letters?"

"Only things that I could have written. With one small exception. C. disapproves of Luyckx, whereas I admire him. At times, Luyckx makes me think of Dirty Harry."

"Well, Mr Cox, that all sounds very interesting," says Dr Wuyts. "I think that's enough for an initial conversation. Let's talk some more tomorrow morning. The best thing you can do for now is to get some sleep."

* * *

Wuyts accompanies Cox to the door. In the waiting room, besides his nurses and three gendarmes, there are two men in uniform talking to Luyckx. Cox knows where The Sponge has come from: the whole place smells of coconut milk. But he does not care. The Verversrui is part of another life now.

"Morning, Victor, sleep well?" asks Luyckx with a reassuring smile.

"Everyone is asking me the same question."

"Could I have a word with you, Superintendent?" asks Dr Wuyts from the doorway.

"Sure. Victor, these gentlemen will accompany you to your room. They're going to take some fingerprints. It's part of the routine and won't hurt."

Cox stares ahead hazily, as if he hardly feels affected by what is happening.

"Good," he says. "That way you'll have Cassin's prints too."

"People smoke in here, I can smell it," says Luyckx, sitting down opposite the doctor and lighting a cigarette.

"All my adult patients are chain-smokers."

"I didn't think Cox smoked."

"One month in our institution and he'll be on two packs a day, trust me."

"You'll keep him here that long?"

"We've only had a short chat so far because he's still too tired, but I can tell you now that this is a complicated case. On the one hand he's displaying all the symptoms of a classic case of schizophrenia, on the other hand I have the impression that he's play-acting."

"Like I said yesterday, as far as I'm concerned he's innocent. But then I'm not a psychiatrist. I know him pretty well. He's living in another world. Cox is one of the loneliest people I've ever met in my career. Even when he was married, he would run off alone into his dreams of Hollywood, while living with a woman who he could see wasting away,

236

ravaged with drink. After she died he had a pretty strange relationship with a woman called Starr…"

"Who he's afraid he murdered…"

"And who I met a few times. She was much younger than him and actually looked like a Twenties film star. She knew it and really put it on. I think that what attracted him was this artificial, unreal character rather than the girl herself. With her he walked through the looking glass so to speak and his dream became reality. But I didn't buy their relationship. When she vanished from his life he buried himself in his studies and his collection in order to forget how lonely he was, and his passion for film ended up with him confusing fiction and reality. For me, Victor is just a pathetic, naive romantic."

"Nice analysis, Superintendent. But at the same time there really are some things that link him directly or indirectly to the murders."

"Right. But on the other hand he's got some pretty strong alibis."

"He's now personally convinced that he has the murders of his wife and girlfriend on his conscience."

"What do you mean? Since last night we know for certain that Starr is still alive. My colleague has been in touch by phone with the Mortenson family. Since she disappeared she's been living in the United States, and she's arriving at Zaventem tomorrow evening at a quarter to ten."

"I would prefer it if he didn't find out about that. For the moment he mustn't be subjected to any emotional shocks. It's possible he would clam up altogether and I want him to talk. If he is accusing himself of murders that he didn't commit I want to know why."

"Don't worry. I'll go personally to pick up Miss Mortenson at the airport. I want to be the first to have a chat with that young lady."

Part III

Starr Baker

38

Starr Baker

Luyckx is holding up a cardboard sign saying *Starr Mortenson* when the first passengers off flight AA 2176 appear in the crowded arrivals hall at Zaventem. It was a good idea. Because he wouldn't have recognized the platinum blonde beauty in her Armani dress, pushing a trolley full of Louis Vuitton bags and hiding behind her dark sunglasses, if she hadn't looked up in surprise at his sign in the crowd.

"Superintendent Luyckx? This is amazing! How did you know?…"

"It's my job to know everything."

"Don't tell me something awful has happened."

"Yes and no. I guess you're tired, but…"

"No way! The beds in first class are heavenly."

"Where are you staying?"

"I've booked a suite at the Antwerp Hilton."

"Do you mind if I take you there? I mean, you're not expecting a limo?"

"Not at all, it would be cool to be in a normal car again."

Luyckx sits down next to Starr at the wheel. It's never happened to him before, but he has to start the engine three times before it gets going. The car smells of Chanel No. 5. It would be stupid to light a cigarette now and spoil this sensual aroma from across the ocean.

"To tell the truth I wouldn't have recognized you," says Luyckx, as they turn on to the Brussels ring road.

"New life, new hairdo," laughs Starr.

"New life?"

"I've got married. To Joe Baker, the producer. A very influential man in the movies. It was in all the papers."

"There's no business like show business."

"Joe is a real teddy bear. Older men have always attracted me. He's starting next week on the new Clint Eastwood film. And then Joe will be so busy I'll hardly see him."

"So have you met Mr Eastwood personally?"

"I had lunch with old Clint yesterday at Zoe's. Why do you ask?"

"Just for the hell of it."

"So I took the opportunity to go away for a few weeks. After Antwerp I'm going on to Paris, then Milan and Rome. Shopping. But why did you come and pick me up?"

"It's Victor."

"Victor?"

"Cox, Victor Cox."

"Professor Cox? What's up with that old dreamer?"

Luyckx can't figure out why Starr is being so cold and distant. It's as if she barely remembers Victor.

"But you were more than just good friends, right?"

"That's what he'd have liked, sure. He was in love with Louise Brooks and Clara Bow, and Pola Negri and Theda Bara. He didn't realize it himself any more."

"I thought you were in a proper relationship and were living together."

"What? I went out with him twice to the cinema. And after I finished my studies we went out a couple of times together for dinner to talk about films…"

"When I called round, you opened the door."

"That was just a coincidence because I'd come round to bring back the books and DVDs that he'd lent me."

"And the black lace knickers?"

"My knickers? You must be joking!"

"I found a pair of your knickers in his bathroom."

"They certainly weren't mine. Cox was very popular with his students. You could just as easily have bumped into someone else."

"So there was nothing between you?"

"Where did you get that idea? Is he having you on?"

"Did he bother you?"

"No. Professor Cox always behaved like a gentleman. Which is more than you can say of some people."

"Even so, once you told me you'd spent the night of Saturday the nineteenth to Sunday the twentieth of June in bed with him – the night that Marion Mees was murdered in the Babylon Motel."

"That was a joke, of course. And a little white lie. I felt sorry for him. Sometimes he looked so helpless. I wanted to give him an alibi."

"And what happened last year on the fourteenth of October when you'd arranged to meet him at the Astoria Hotel in Koksijde?"

"Superintendent! I've never arranged to meet Cox in a hotel! I've never even heard of the Astoria in Koksijde. Before I moved to New York I did spend a couple of days on the coast. I had to go to a reception in Ostend on the *Seastar II* to stand in for my father because he'd already left the country."

"Why didn't you warn Cox that you were leaving?"

"Why should I? He wasn't that important!"

"Victor claims that you went swimming that night and never came back to the room. That you drowned. Or were murdered. Just like Starr Faithfull in 1931."

"Could I have one of your cigarettes? In New York I more or less had to give up, but after what you've been saying I really feel like one."

Luyckx takes one for himself with relief and hands her the pack. Just the way she takes a cigarette out of the pack

with her long blood-red fingernails gives her the air of a star. He thrills with pleasure to think that he is sitting in his car next to a woman who only the previous day had lunch with Clint Eastwood.

"Who exactly was Starr Faithfull?" asks Luyckx, exhaling.

"It's unbelievable that Cox stumbled across that. He's a living encyclopaedia. Starr Faithfull wasn't even an actress. She was a typical victim of American hypocrisy during Prohibition and the Depression. My parents called me Starr because Mortenson was also Marilyn Monroe's surname. Baker too, by the way. It's always pursued me, but that's fine. I was one year old when my father read an article about the unsolved death of Starr Faithfull. He developed a weird sympathy for this innocent creature that had the same name as his daughter, and when my little sister was born he gave her the same name as Faithfull's little sister: Tucker. Not exactly good taste. Later, when I got a dog for my eleventh birthday, we called him Congo, just like Faithfull's dog. But there the resemblance ends."

"What's behind the words NO SALE?"

"No sale? No idea. Not for sale, maybe? Why?"

"Cox claims you wrote that on his bathroom mirror in lipstick. I saw it because he never wiped it off."

"Oh that! Now I remember. I did do that, yes. One of the few times I called in on him. It was meant to be a game. He had to guess what film it came from."

"*Butterfly 8.*"

"No, *BUtterfield 8*. So what exactly are you accusing Cox of?"

"Me? He's accused himself."

"Of what?"

"A whole series of murders, including you and his wife. The doctors say it's schizophrenia."

"And do you think he…"

"I could imagine it. Does the name Henri Cassin mean anything to you?"

"It does remind me vaguely of a character in a film. But what film?"

Luyckx has forgotten the name himself, but her answer is enough. He stubs out his cigarette and says: "Doesn't matter."

"We'd all noticed our nice old professor was a little absent-minded. But I didn't know him well enough to imagine that things were so bad. Where is he now?"

"The psychiatric department at Stuivenberg Hospital."

"Poor bastard. Can I visit him?"

"He's not allowed any visitors for now."

"But if he sees me he'll realize that everything was just a fantasy. I'm living proof that he's innocent!"

"It's not as simple as that."

The car disappears into the Craeybeckx Tunnel.

"Are we already in Antwerp? You must have driven really fast."

"It's nothing compared with Harry Callahan."

"Who?"

"Clint Eastwood! Dirty Harry on the streets of San Francisco. That's something else!"

"That was stuntmen, not him."

So as not to be held up by the traffic lights, but mainly to impress her, Luyckx sticks the blue light on the roof of his car. Five minutes later he pulls up at the entrance of the Antwerp Hilton.

Luyckx signals to the porter to take care of the luggage and walks up to reception. He's known the concierge for years, but he's never seen the young man standing in for him tonight.

"Superintendent Luyckx, Antwerp Detective Branch. Ms Starr Baker has just arrived. We've escorted her here from Zaventem at the request of the Ministry of Culture. I hope you realize who she is. I'm counting on you to treat her with proper consideration."

"Her suite is ready, Superintendent. With the white roses and bottle of Dom Pérignon 1977 that her husband ordered."

Starr makes her entrance, and the few men still hanging around the bar at that late hour hold their breath.

"Your suite is ready," repeats Luyckx, who likes the sound of the words.

"Thanks for the crazy ride," she laughs. "And don't hesitate to get in touch with me."

"Pleasure," says Luyckx, bending over to kiss the hand that only yesterday had touched the cold talons of old Clint.

39

Barton Poels

"Luc, who's that overblown idiot pacing up and down outside who talks to me as if I'm the lowliest cop on the beat and claims to be working as the scientific adviser to Chief Superintendent Lannoy?" asks Luyckx as he walks into his office. "And what are you doing in my office, come to that?"

"I was waiting for you. Like always," replies Lannoy tersely, glancing out into the corridor. "That's Barton Poels, the man who's handed me the solution to the murder of Cox's wife. You know, the film by Aldrich. He's also helped me select all the incriminating material from Cox's collection. Free of charge, to boot! He's the projectionist at the Film Museum and knows just as much about films as our hero."

"Really? Get him in."

"Mr Poels!" cries Lannoy through the doorway.

Poels comes into the office. A plastic bag from the supermarket is hanging on his left arm. The Sponge guesses he's around sixty, but with his sparse white hair, zinc-grey eyes behind bulging glasses, sunken cheeks and wan skin he looks older. At first sight he looks like Cox – or rather like a hypocritical, vicious, poisonous copy of Cox. A Cox with scales, who has not seen the sunlight for years.

"Can I speak to you alone?" he asks Lannoy.

"Mr Poels," says Luyckx calmly, "you're on my turf here and if you have something to say you can say it to me.

Personally, I have no objection if Inspector Lannoy stays to listen."

"Chief Superintendent Luyckx," mumbles Lannoy irritably.

"It's all the same to me. I found something else in a rubbish dump in the courtyard on the Nationalestraat that will interest you."

"Let's see," sighs Luyckx.

Poels pulls the champagne bottle with the photos of Fatty Arbuckle and Virginia Rappe, that Cox had been looking for, out of his plastic bag.

"What's that supposed to be?" asks Lannoy.

"It's a rather tasteless souvenir that you could obtain at the time of Fatty Arbuckle's trial in Hollywood. As you can see, the neck is broken. It's probably the murder weapon used by Cox to fatally wound Virgina Steiner."

"The examination will determine that. You seem pretty well informed."

"Inspector Lannoy has brought me up to date with the latest developments. How else could I find what I needed in all that junk? Who could have thought that Cox would do something like that?"

"Do you know him?"

"Unfortunately. I'd started lecturing again at the Institute when on the sixteenth of February 1975 – I'll never forget the date – I was taken to hospital with kidney stones. Cox was my stand-in. When I came back three months later they'd given him my job. That's what happens in education."

"What did you do then?"

"On the dole for seventeen years. Until an acquaintance in the Ministry got me a job as projectionist in the Film Museum in Brussels. When the Film Museum opened here in '95 I was switched to Antwerp."

"You don't seem very fond of Cox."

"How would you react?"

"Have you seen him recently?"

"The last time was two years ago at his pathetic farewell drinks at the Institute, which, incidentally, I wasn't invited to. But since I'd seen him come into the place to slide into my job while I was croaking in hospital I couldn't honestly miss the chance to see him go. As usual he was showing off with all the prettiest students. He thought he was irresistible."

"Perhaps he was," teases Luyckx.

"I can see that you don't really know him. Cox is an arrogant pseudo-intellectual who's been running unsuccessfully around every woman like a randy dog since his wife died. He shouldn't have murdered poor old Shelley, though I admit that there wasn't much left of her by then."

"So you knew his wife too?"

"Who didn't know Drunken Dixie? She was a legend on the party scene. A sad legend. I don't go out much but even I'd heard of her. A Veronica Lake or Frances Farmer type, if you get my meaning."

"I know exactly what you mean," says Luyckx, making no effort to hide the fact that he can't stand this guy.

"What's worse is the way he disposed of Starr Mortenson. She was a wonderful kid in the prime of life."

"You know Starr too?"

"Just by sight."

"Seems like you know everyone."

"She often went to the Film-Museum cafeteria. She stood out because of her incredible resemblance to Louise Brooks. Once I saw her from the projection room sitting next to Cox during German Expressionism Week. He was behaving as if they were an item. Pathetic. Typical."

"Luc, how did you come across Mr Poels?"

"Via The Cripple. I was looking for someone who knew about films and The Cripple introduced me to him."

"It's a small world, isn't it? Do you go to the Bad Conscience often, Mr Poels?"

"Now and again for the quiz evenings and only when it's about films."

"So you know that Cox was renting a warehouse on the opposite side of the street to keep his collection in?"

Poels catches Luyckx's gaze and hesitates. Like a tightrope walker who stops to regain his balance. As if he is starting to doubt his answers for the first time, he says: "This conversation is beginning to sound more and more like an interrogation."

"Right."

"You've nothing to worry about," adds Lannoy. "It's the interrogation of a witness."

"You didn't answer my question," insists Luyckx calmly.

"The answer is yes and no. Yes, I knew that he had rented the place. No, I didn't know what it was for."

"You never wondered what Cox was storing there?"

"No concern of mine."

"So his collection came as a complete surprise?"

"I must admit I was impressed. Especially the elephant, which, as you probably know, used to stand at the entrance of the Babylon Motel in Londerzeel. By coincidence the place where Marion Mees was stabbed to death. How he managed to get hold of all that stuff and pay for it is another question. But at least we know now what it was for."

"And what was it for, in your opinion?"

"To lure young girls into the trap of course. The oldest trick in the book. Older man shows secret collection to future victim, drops a few famous names, makes an impression, wins her confidence and then he strikes... When exactly did you arrest him?"

"I haven't arrested him. He came to me of his own accord."

"Where is he now? In the Begijnenstraat jail?"

"He's being well taken care of. Did you know any of the other victims, Mr Poels?"

Luyckx could kick himself. The question is too brutal – and has come too soon. And he knows the answer already.

"No."

"Not even Marion Mees? She was one of Cox's colleagues."

"Only by name. There was talk that he was bothering her so much at work that she complained to the inspectorate. But I didn't know her personally."

"I thought as much."

"And now I've really got to go. I have to check the reels before the six o'clock performance. You've got no idea what state some of these old films are in when they get here."

"You must have seen quite a few films in your life."

"More than Cox, anyway. I think in my time I must have shown the entire history of cinema."

"Well, Mr Poels, thanks for your cooperation. I'll have the forensic lab examine that champagne bottle."

"Of course, my fingerprints will be there too. Like on all the other objects I've handed over."

"That goes without saying," replies The Sponge with a broad smile and picks up the phone. "Walter, could you come over for a second. For fingerprints. Yes. Thanks."

"What a loathsome fucking creep," says Luyckx, after Poels has left his office.

"Embittered is the way I would put it. Embittered but helpful."

"Too helpful. Looks to me like he's settling scores."

"In the final analysis Cox stole his life. You can understand why he wants revenge."

"That's the right word: revenge."

There's a long silence. Luyckx seems sunk in thought. At such times Lannoy knows better than to interrupt him and goes and stands by the window. He stares at the roofs and towers of the city and at the ant-like people far below. Then he hears Luyckx's voice.

"You were waiting for me, you said. Did you have anything to tell me?"

"Yes. It doesn't prove anything but it will cheer you up. I've got the results of the DNA analysis."

"And?"

"The saliva from the stamp on the envelope for the motor insurance that I took at Cox's flat matches the traces he left on his glass here."

"Well that's no surprise."

"But the saliva on the stamp on the letter from Henri C. is different."

"Couldn't you have told me that before?"

"You didn't give me a chance."

"And you don't think that proves anything?"

"All it proves is that he didn't send the letter to himself."

"And that what he's suffering from is at worst an understandable paranoia and not schizophrenia."

"He's not normal, no way."

"But he is innocent."

"I wouldn't bet on it."

"Did you compare his DNA with those samples we found on Sandy Misotten?"

"They're working on it. What I wanted to ask you... Er... How was it last night?"

"No problem. Her plane was on time," replies Luyckx absent-mindedly, looking up a number in the phone book. As he dials the number, Luyckx signals to Lannoy to keep quiet.

"Good morning. Is the curator there? Excellent. Could you put me through, please? Superintendent Luyckx of the Antwerp Detective Branch. Thank you."

Luyckx waits.

"Hello, yes? Luyckx, Antwerp CID. Could we meet for a chat today? Just a couple of routine questions in a very sensitive case, yes. No more than quarter of an hour. Right now? Good. I'll be there in ten minutes."

40

Renaat Walgrave

Luyckx strides cheerfully down the Meir to the former royal palace and crosses the courtyard to the stables that now house the Film Museum. Hoping he won't run into Poels, he follows the curator's secretary to a cool, austere office on the first floor.

A pale, shaven-headed thirty-something with rectangular black-framed glasses and a thin-lipped mouth cutting through two-day-old designer stubble walks over to meet him with outstretched hand. Silent black shoes with rubber soles, black jeans and T-shirt, soft black linen jacket. The uniform of the intellectual who takes his daily fix of news and views from *De Morgen*, can live nowhere but an empty loft, prefers Jeff Koons to Michelangelo, finds Straub and Godard the only comprehensible directors in the world and drinks ice-cold Perrier with a slice of lemon in beige cafés.

"Renaat Walgrave. Take a seat, Superintendent."

Luyckx drops into the leather Le Corbusier sofa and lights a cigarette; the curator immediately opens all the windows.

"How can I help you?"

Luyckx senses that time is limited and asks straight away whether the name Victor Cox means anything to him.

"Professor Cox? Of course. An eminent film expert. One of the greatest specialists in American film noir. He often attends our evening performances. And he often gives lectures that are illustrated with excerpts from films."

"Have you seen him recently?"

"I must admit it's been some time."

"And Barton Poels?"

"You mean *Barton Fink*, the film by the Coen brothers. But Barton Poels… Our projectionist is called Poels, but his first name is Rudy. Rudy Poels."

"That's him. Sometimes he likes to be called Barton, God only knows why."

"I didn't know that, but anyway… He's been working here since the Film Museum opened. A man of experience, in other words. But very introverted. I think he lives alone, but I don't know anything about his private life."

"When Professor Cox gives one of these lectures, does Poels handle the projection for the film excerpts?"

"Of course."

"Interesting. Who decides on the film programme here, Mr Walgrave?"

"I do. But for practical reasons we usually just take over the programme from Brussels with a week's delay."

"And is Poels the only projectionist?"

"He's got an assistant who stands in for him on his days off."

"Is he away a lot?"

"For certain periods. At most once or twice a year."

"Have you got the dates?"

"I can get the HR department to find out for you. But it will take some time."

"That's OK. And if I give you some film titles, can you tell me whether those films were shown here and when?"

"Everything's on the computer. Which films are you talking about?"

Luyckx takes a folded sheet of paper out of his trouser pocket.

"*The Big Knife* by Robert Aldrich, *Psycho* by Alfred Hitchcock, *The Big Heat* and *While the City Sleeps* by Fritz Lang, and *So Dark the Night* by Joseph Lewis."

"Bear with me and I'll check the dates for you. It'll just take a second. Would you like a drink?"

"In this heat I won't say no."

Renaat Walgrave sits down at his glass desk and calls his secretary.

"Two Perriers, please, Magda."

He switches on his Apple and logs on. Drawing on his cigarette, Luyckx stares through the window at the top of the chestnut tree in the courtyard, standing out against a cloudless blue sky. And then at the psychedelic Marilyn Monroe by Andy Warhol hanging on the plain white wall opposite him. The secretary comes in silently and places a glass and a bottle of Perrier in front of him on the low Plexiglas table. The Sponge can hear his heart beating, and then, after five minutes, the sound of the printer.

"Here's the list," says Walgrave. "*The Big Knife* on Thursday the twenty-eighth of May 1998, *Psycho* on Thursday the seventeenth of August 2000, *The Big Heat* on Thursday the fourth of October 2001, *While the City Sleeps* on Monday the fourth of March 2002, and *So Dark the Night* quite recently, on Wednesday the twelfth of June. What would we do without computers?"

"Bingo!" exclaims Luyckx, draining his glass and getting up. "Can I take the list with me?"

"Of course. I've enclosed two complimentary tickets to our Lubitsch evening as well."

"Thanks."

"You've made me quite curious."

"Sorry, I can't say a word. But you'll read all about it in a couple of days in *De Morgen*. Please don't say anything

about our conversation to anyone in the meantime. Especially not to Poels."

"Understood. But you've made me quite curious."

Luyckx walks to the Groenplaats with a broad smile on his face, his Ray-Bans on his nose and Walgrave's list in his pocket. With a little luck, Starr will have got up late to get over her jet lag and he can invite her to a light lunch in the Hilton's restaurant. As he walks whistling down the Meir, he reflects on the criticism he's had to endure over the past seven years. That he wasn't producing results because he didn't communicate enough, that he couldn't cope with teamwork, that his methods were out of date, that he brooded stubbornly in his corner while more than five hundred detectives, gendarmes, investigating judges, prosecutors, psychologists and criminal profilers were involved in the investigation. That he always wanted to solve everything alone and that was why the case was dragging on for so long. Just a couple more hours, he thinks, and old Sponge will make idiots of the lot of them, those smooth posh gits with their degrees and those glib guys with their so-called infallible modern methods. For the umpteenth time.

It's one of those days when life smiles on you. Ms Baker is still in her room, and half an hour later he is sitting, just like Clint two days ago in New York, at a table opposite her on the cool hotel veranda.

During their aperitif – a Manhattan for her and a Stella for him – the talk is exclusively about his famous double. Which is how Luyckx learns to his great surprise that Dirty Harry has acted in other films that have nothing to do with Inspector Callahan.

"His debut was in 1955 in *Revenge of the Creature*, the second part of Jack Arnold's *Black Lagoon* trilogy," says Starr, spearing the olive in her Martini.

It's as if he's listening to Cox. She knows just as many useless details of old films as he does, and Luyckx can imagine

their endless passionate discussions about cinema. Their relationship never went any further than that. Now that he is sitting opposite her himself, he is certain of it.

"I dropped into the Film Museum this morning," says Luyckx, "to get tickets for their Lubitsch evening the day after tomorrow. Would you like to come?"

"Why not. My husband Joe started his career as an assistant to Lubitsch. It was on the set of *That Lady in Ermine* in 1948. Lubitsch died while they were shooting it and the film was completed by Otto Preminger. Joe was only seventeen."

That means that Joe Baker must now be seventy-two, thinks Luyckx. She really does go for older men, especially if they're fucking rich.

"When you lived in Antwerp did you go much to the Film Museum?"

"Three or four times a week. Once even with Professor Cox. To see *Lulu* by Pabst. At that time my hair was dyed black and he thought I looked like Louise Brooks."

"That was the evening we met at Ma Mussel's after the performance."

"Of course! God, it all seems so long ago."

"You often used to go the museum cafeteria too, I heard."

"It was nice and quiet there to read or study. Did Professor Cox tell you?"

"No, the projectionist."

"That dickhead! What was he called again?…"

"Poels."

"Poels, that's right, Rudy Poels. Makes my skin creep just to hear his name."

"Why's that?"

"The slob was always trying to make out with me. I met him once briefly at the Institute at the farewell party for Professor Cox. He was convinced I had a relationship with Cox and he never left me alone after that. He kept inviting me to come and see his collection."

"What kind of collection?"

"Film props, stage decor, photos, posters, costumes, whatever. He had his own museum, he said."

"In the Nationalestraat?"

"Yes."

Luyckx could have jumped over the table and hugged her.

"Shall we order a salad," asks Starr. "I'm starving."

"Order whatever you fancy. Be my guest, but I've just got to make a phone call." Luyckx gets up and goes over to the reception desk to phone Lannoy.

"Luc, I need a search warrant in the name of Rudy Poels by midnight. That's his real name. In Wilrijk, I think, but look it up. Or ask Walter. He's opened a file on him. Now? At the Hilton… With Starr, in fact… If only. I'll be there in quarter of an hour."

He hangs up and walks back to Starr, who is talking to the waiter.

"I do apologize, but I have to get back to the station urgently."

"Just like last year in the mussels place. Not another murder, I hope?"

"Far from it. You'll be hearing from me. Perhaps even tomorrow. And keep the next evening free in any case. Lubitsch. Don't forget."

Luyckx puts on his Ray-Bans, clenches his jaw, pulls in his belly and waits for a reaction. Surely she can see the resemblance given that she knows the real thing.

"Put Ms Baker's lunch on my account, Bob," he says to the concierge as he leaves the hotel. "I'll come by tomorrow morning to settle up."

"Much obliged, Superintendent."

"There's no business like show business!"

"That's very true," says the concierge, who never contradicts anyone.

41

James Cagney

"Is that what you mean by a quarter of an hour?" says Lannoy mockingly as he runs into Luyckx in the corridor at a quarter to six. "Have you been at the Hilton the whole afternoon?"

"Unfortunately not. I went by the hospital to see how Cox was getting on. Have you got the search warrant?"

"It should be ready at six. How's your friend?"

"He's still under the influence of the pills. But I had a long chat with Carla Wuyts. In her opinion you can't talk about schizophrenia in his case. What he's suffering from is a mild form of what they call mythomania – confusing dreams with reality – which coupled with heavy depression can sometimes lead to psychotic behaviour. A strange combination which he has your friend to thank for."

"Poels?"

"Who else?"

"That's no reason to go bursting in on the guy tonight with all guns blazing."

"There are other reasons. Poels was obsessed by pretty, young women, but Cox unwittingly attracted them. Poels had a crush on Starr and was convinced that she and Cox had a relationship..."

"Didn't they?"

"No way. That's what Cox would have us believe. Perhaps to make his dreams seem more real. Do you know who she's got married to in the meantime? Joe Baker."

"Who the hell is Joe Baker?"

"The film producer! The producer of the next Eastwood, who incidentally she had lunch with a couple of days ago. She's a blonde now. You'll understand that a woman like that…"

"Go on."

"Poels has lived his whole life in Cox's shadow. Even when he finally got the projectionist job, he was sitting behind a little square window cooped up in the dark while Cox was there in front of the big white screen, on a podium, giving a lecture to an adoring public. The applause was always for Victor Cox. Never for Rudy Poels. Victor means winner. Rudy means nothing."

"It's pretty thin."

"Thin?"

Luyckx pulls out Walgrave's list.

"Here are the dates on which Poels showed the films that inspired his murders. *The Big Knife*, ten days before Shelley Cox's murder. *Psycho*, ten days before the murder of Marion Mees. *The Big Heat*, ten days before Debbie Marchal's murder. *While the City Sleeps*, ten days before Sandy Misotten's murder. And *So Dark the Night*, the film in which Henri Cassin accuses himself by letter of murder, on Wednesday the 12th of June, the evening before he sent his first letter to Cox. I'm still waiting for the list of his absences from work but I bet a bottle of Scotch they tie up with the murders."

"And what about Louise Vlerickx and Virginia Steiner?"

"That was just the beginning. He hadn't completely worked out his insane plan. He used various news stories out of Hollywood, which Cox would have to be aware of, as inspiration too, because he probably hadn't come across any other films that he could use."

"Why would he make it so hard for himself? He could just do away with them in the usual way without all this drama."

"Poels isn't a psychopath, he's a humiliated, degraded, envious man, who like a methodical, obsessive bureaucrat devised the perfect plan to avenge himself on Cox. He knew that sooner or later Cox would spot the connection with the films, especially after Shelley's death. He'd been spying on Cox for years and knew that he sometimes confused his dreams with reality. He also knew that we would treat Cox as a suspect because he selected victims who Cox had come across one by one in his own life. What he couldn't predict was that Starr would disappear and that Cox would start to cooperate with us. And then he had the ingenious idea: the letters that would make Cox doubt his innocence so much that he would accuse himself of the murders."

"Do you think he had other murders planned?"

"Starr, but she moved abroad unexpectedly. I wouldn't be surprised if he had shown *BUtterfield 8* and knew the story of Starr Faithfull."

"It does sound convincing. But if it's true he's a total genius. The Maradona of evil, the Elvis of revenge!"

"There's more, Luc. Poels had a key to the storeroom in the Nationalestraat."

"How do you know?"

"Starr told me that he tried several times to lure her to the elephant. Allegedly to show her his collection. Perhaps he lured the other victims into his trap in the same way."

"Does he know she's in Antwerp?"

"Of course not. He thinks Cox murdered her."

"Where is Poels now?"

"At the Film Museum. He's working until eleven thirty tonight and won't get home before midnight."

Poels lives in a cluttered studio apartment smelling of cat's piss on the eleventh floor of one of those blocks of council

flats thrown up in Wilrijk in the Fifties. The house search begins at nineteen hundred hours on the dot. A locksmith opens the door in the presence of a bailiff. Luyckx and Lannoy are accompanied by two members of the duty squad and four detectives from the technical service. Within a quarter of an hour they have collected all the evidence they need to arrest Poels: press cuttings about the various murders, especially Louise Vlerickx, articles about the five films, plans of Baron de Landshove's estate, photos of the garages and cars belonging to Notary Donders, handwritten notes about future victims, Virginia Steiner's torn clothes, books about Thelma Todd, a dartboard displaying Cox's photo, a biography of Fatty Arbuckle sent by registered mail, Polaroid photos of the corpses, a videotape showing Cox and Starr entering the auditorium of the Film Museum, and posters for *Psycho* and *The Big Knife* that were probably stolen from the warehouse in the Nationalestraat. And, in his computer memory, the two letters that Poels sent to Cox.

"Think that will do?" asks Luyckx, grinning.

"It looks like he was expecting our visit and got everything ready for us. I admit you're right, Fons. Lucky I found out about the existence of Poels."

Two hours later, the studio has been thoroughly combed through. Two gendarmerie vans are needed to take everything that has been seized to the station. By nine o'clock everyone has gone except for The Sponge, who decides to wait for Poels and arrest him when he arrives home. Down below four detectives are concealed in their cars. Lannoy hides in the emergency exit at the end of the corridor to take up position right outside the door once Poels has come in so as to catch him if he tries to escape. The neighbours are ordered not to let anyone in or out and not to leave their flats.

Luyckx removes the main fuse, so that the studio is illuminated only by moonlight. Then he pushes the stained, sagging, wine-red sofa up against the wall opposite the door

and sits there for three hours in the darkness under an enlarged portrait of Louise Brooks, with a cat purring on his lap, breathing in the deathly atmosphere. He realizes he is running a risk not arresting Poels directly at work, but this is more stylish. It's a final duel, the ultimate confrontation between good and evil, the dramatic denouement that Inspector Harry Callahan would have chosen.

At seven minutes to twelve the cat jumps to the floor and takes up position by the door, miaowing. A minute later Luyckx hears a key in the lock. The door swings slowly open and the bent silhouette of Rudy Poels appears in the weakly lit rectangle of the doorway. He pulls the key out of the lock, shuts the door, feels automatically for the light switch and swears. He picks up the cat and looks around confused in the semi-darkness without noticing Luyckx, who is sitting motionless on the sofa, his pistol in his hand.

Poels moves like a blind automaton towards the balcony. As his eyes begin to grow used to the darkness, he realizes that the room is almost empty. He barely even reacts, as if he had expected this, steps outside, leans against the railing and looks into the distance at the flickering lights of the city, as he whispers soft words of farewell to the cat.

"Poels! The game's up. The party's over!"

When Poels hears Luyckx's voice behind him, he does not even turn round, but hurls the cat, like a cast-off toy, into the void. The poor creature lands with a hard, dull thud on the bonnet of Lannoy's car. One of the detectives gets out, looks up confused, and sees Poels on the eleventh floor, balancing unsteadily on the concrete balustrade of his balcony."

"Jesus, he's going to jump!"

"Poels, don't do anything stupid," says Luyckx softly, approaching him step by step.

But Poels is not listening. For him, the movie's over. He stretches his arms in the air, turns his head, laughs defiantly,

baring his rotten teeth, stares Luyckx wildly in the eyes and cries: "Look, Ma, top of the world!"

Then he lets himself tumble forwards and flops down a couple of seconds later like a broken tailor's dummy next to the body of his cat on the Opel Vectra. In the distance the bells of the Christus Koningkerk strike twelve.

42

Starr Baker and Victor Cox

Monday, 15th July 2002

A week ago I could not have imagined ever sitting again at this desk in front of my computer as I used to, with the familiar beech tree full of thrushes at my back and, behind the beech, Mrs Kountché waving cheerfully from her balcony. She was so happy that I had come back. Tomorrow I shall take her with me to see the elephant.

I was discharged from the hospital on Saturday morning. According to Dr Wuyts I could not be held responsible for the fact that Poels had used those innocent victims as an instrument of his revenge. Despite the rain, Fons was waiting for me outside the main entrance. That's what I call a friend.

For the last three days the doctors had stopped sedating me, so I could read the papers and follow the news on television. I had known that Poels was not particularly fond of me, but not for a moment did I think that his hatred would drive him so far. It is no surprise that he took his own life. The lipstick psychopath in *While the City Sleeps* ended the same way after murdering his fifth victim. Poels played his macabre game to the bitter end.

According to Fons, before he jumped he cried: "Look, Ma, top of the world!"

Those were the last words of Arthur "Cody" Jarrett, the psychopath who suffers from a mother complex in *White Heat*, in a superb interpretation by James Cagney in Raoul Walsh's 1949 film. Poels too must have thought for a fleeting moment of ecstasy that he had reached the top, as he climbed on to the balustrade of his balcony and hurled a last, pathetic, defiant curse at the world at his feet.

When I noticed that Fons was not taking me home but was driving to the Groenplaats, I asked him what his plans were.

"I've got a little surprise for you," he mumbled with a mysterious smile on his lips. He dropped me off at the entrance of the Antwerp Hilton and told me that someone was waiting for me in the bar.

All the tables in the bar were occupied. She was sitting in a deep armchair with her back to the entrance. I walked past her and looked around. Then I heard her voice through the soft murmuring of the bar, that deep voice that had long vanished from my memory and that I recognized at once, like an unexpected caress, an impossible signal from the hereafter. "Good morning, Professor," she said, and I understood, I heard: "Good morning, Victor."

I turned round and she was sitting there in a dove-grey Armani dress, her eyes hidden behind dark glasses. I had to get used to her new hairstyle. Months ago I had seen Louise Brooks disappearing into the waves of the North Sea, and today Marilyn Monroe is arisen before my eyes in the bar of a luxury hotel. And yet, I knew it was her. I recognized her legs and the way she crossed them, her hands and the way she held her cigarette between the tips of her elegant fingers, her

perfume, Chanel No. 5. I knew that she was sitting there before me and yet there was something unreal about it. It was like one of those dreams of long ago in which a dead and departed film star stepped out of the screen and came to join me in the cinema. I was rooted to the spot.

"Starr?" I whispered. With a question mark. As if there were still some doubt that she had come back.

"Sit down," she said, as if we had seen each other only the day before. "I've delayed my trip to Paris especially for you."

She did not ask any questions. Probably because she already knew the answers and out of politeness did not want to rake up recent events. She told her story: the move with her family to New York, her marriage to Joe Baker. She described the mood in New York, how everything had changed since the 9/11 attacks. She said that she was happy to see me and asked if there was anything she could do for me.

"Yes," I replied, without thinking.

I realized that what I was asking her was madness. But she agreed without blinking; it was just like Starr.

"This evening, then," she said calmly, "because tomorrow morning I'm taking the nine-thirty flight to Paris."

At seven o'clock I came to pick her up to drive to the coast. But she had ordered a white limousine, and one hour later the chauffeur dropped us off outside the Astoria in Koksijde. In the car we drank chilled champagne as we discussed the impressive career of her husband.

It must have been the first time that a limo like that, twenty-four feet long with tinted windows, had stopped in front of the hotel, because François rushed out to open the door. When he saw Starr and me climb out, his mouth dropped open.

"Professor," he stammered, "I'm afraid we're fully booked. It's the middle of the high season…"

"Don't worry about that, Monsieur François, we won't be staying the night here. But I did promise to come by one day with my girlfriend. Is there anywhere Miss Starr can get changed to go swimming?"

"In my private bathroom," said the general manager, who had joined us with Nick, the barman. "Where else? It's not every day that we have a real star in the hotel."

They must all have been aware of the latest developments in the Poels affair. But no one alluded to it or asked any questions about the limousine. I felt I was living in the clouds.

"I've seen every one of your films," said Monsieur François to Starr as she mounted the stone steps. "I've been a fan of yours right from the start."

"I always said that Professor Cox knew everyone in Hollywood," said Nick. "What a pleasant surprise, Professor!"

As my usual room was occupied, I took a seat on the roof terrace, while Starr got changed downstairs. Nick brought me the usual dry Martini. He complimented me on my girlfriend then left me in peace. The sun was hanging low over the sea, colouring both sky and water red. Storm clouds were sliding ominously across the horizon like black trails of smoke. At this late hour and wary of the threatening storm, most of the bathers had left the beach. The tide was out and the sea was far. The set was as I had dreamt, in CinemaScope format.

I bent over the railings and saw her down below, crossing the promenade on her bare feet. She was wearing a soft white bathrobe from the hotel. Before descending the bluestone steps to the beach, she turned round – just as I had asked – and waved. Then she ran over the endless sands to the sea. When she reached the surf, I began to

follow her in close-up through the little pair of binoculars I had brought for the purpose. It was a thrilling picture. I watched as she let the bathrobe slide from her shoulders to the ground. She was naked and turned round as agreed one last time before walking into the water. On the bend by the square behind the hotel, the square with the king on his horse, the seaside tram screamed in its tracks. She was standing up to her hips in the water now, and I felt that I was beginning to die with her in the arms of my poor, poor sea. As if today did not exist, nor yet tomorrow, I imagined her thousand lovers and began to whistle softly, as you whistle along with the blackbirds in the distance. She was playing now in the waves and it was as if I could touch her through the binoculars. "Do not tell me," I whispered, "what I have come to know: that nothing survives time unchanged, everything shrivels and fades and turns to stone, but no one ever disappears entirely. Do not forget me, the little boy without dreams that I have become, the wicked child from the evil years that crawls away to weep."

I left the hotel by the emergency exit before she came back. In the taxi that took me to the station, I looked through the window at the sea of fire flashing by and thought:

What shall I – who have seen everything – entrust
to the cold earth, if not some shrill words
in a forgotten script, the stench of my burnt wings?

What shall I – in despair and no longer waiting for her –
spread over the low lands trampled underfoot,
if not the seed of the weeds that I sowed?

What shall I – my eyes full of the ages,
my lungs full of lead – leave laughing to the vultures,
if not the desire for one last flight, some rotten roses,
the shade of sorrows on wounded shoulders?

Or countless films from days of glory,
when celebrating sadness disguised as joy
helped me through the snares of the night.

Or six inconsequential words
like six dull balls in the damp and cold,
engraved in granite somewhere in a park:
Stars have no tears to cry.

Cabrières d'Avignon
14th July 2006